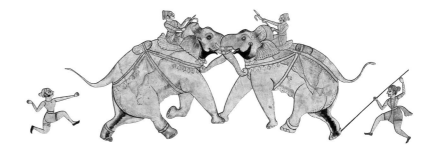

BUNDI FORT

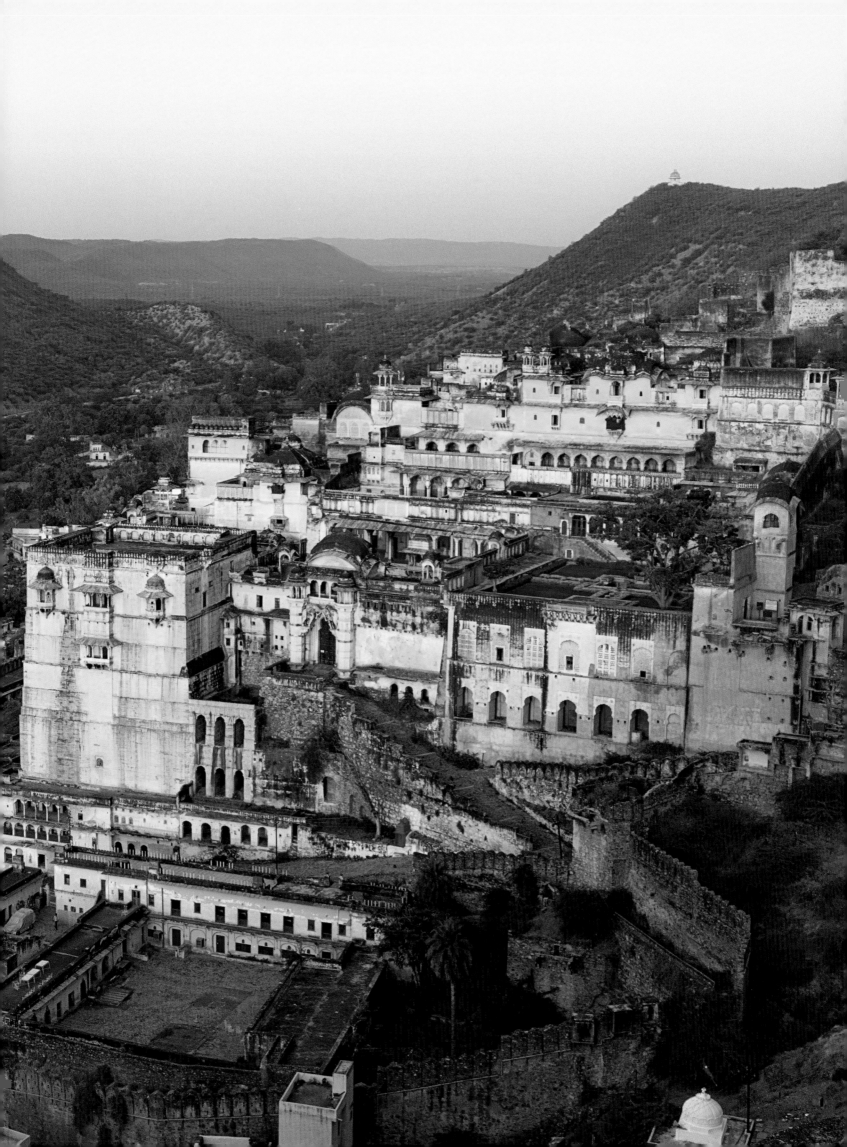

BUNDI FORT
A Rajput World

edited by Milo Cleveland Beach

Marg

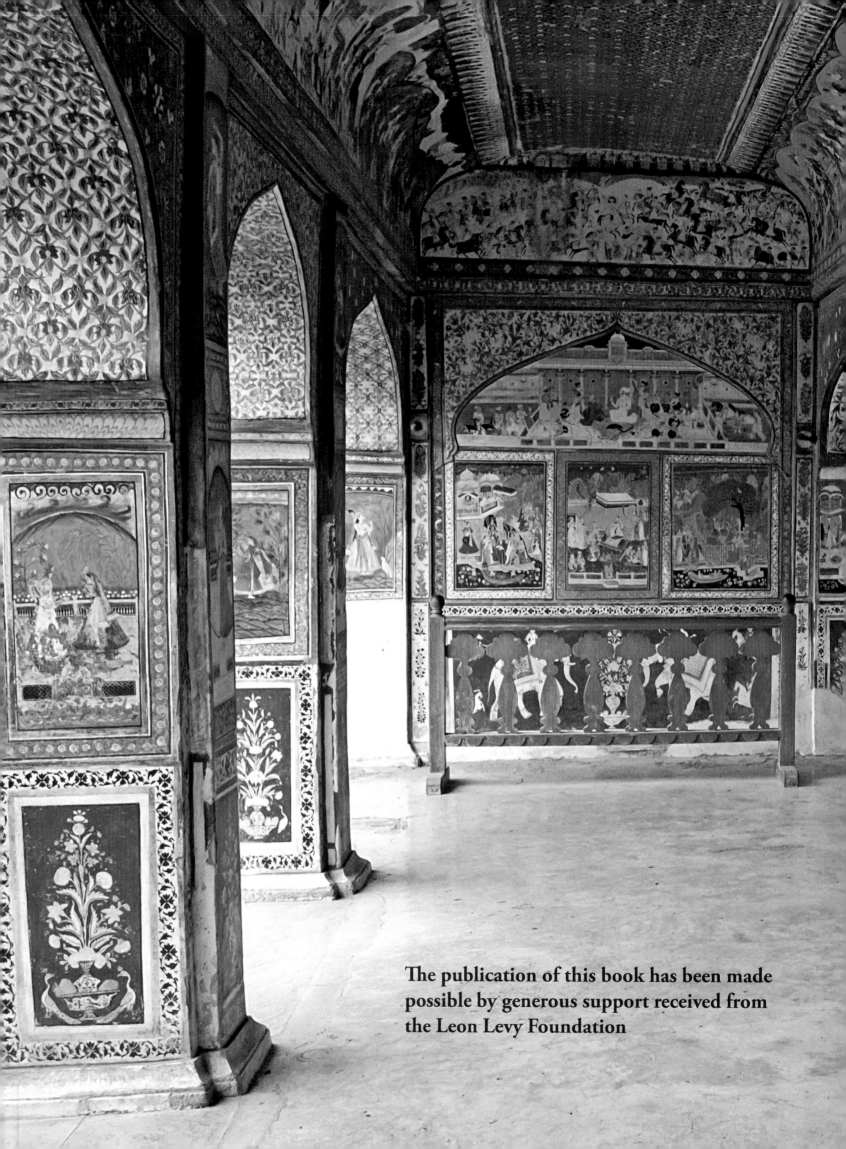

The publication of this book has been made possible by generous support received from the Leon Levy Foundation

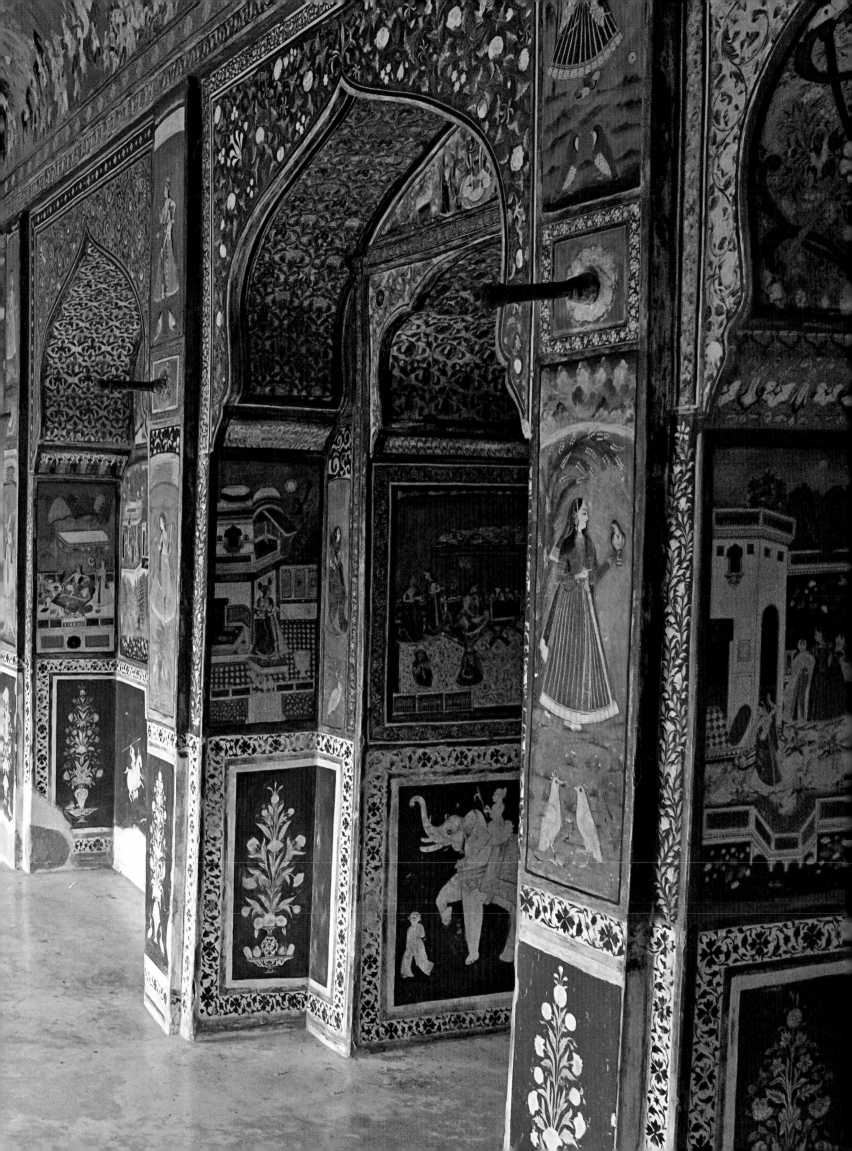

Editors
Jyotindra Jain
Naman P. Ahuja

Executive Editor
Savita Chandiramani

Senior Editorial Executive
Arnavaz K. Bhansali

Assistant Editor
Sucheta Chakraborty

Text Editor
Rivka Israel

Designer
Naju Hirani

Senior Production Executive
Gautam V. Jadhav

Production Assistant
Pradeep D. Musale

Vol. 67 No. 3 March 2016
Price: ₹ 2800.00 / US$ 69.95
ISBN: 978-93-83243-11-2
Library of Congress Catalog Card Number:
2015-306024

Published by Radhika Sabavala for The Marg Foundation
at Army & Navy Building (3rd Floor), 148, M.G. Road,
Mumbai 400 001, India.
Processed at The Marg Foundation, Mumbai.
Printed at Silverpoint Press Pvt. Ltd., Navi Mumbai.

Captions for pages 1–17:
Pages 1, 3 and 6: Details of wall-paintings from
the Chitrashala (Rang Vilas), Bundi Fort. ESY-
006280426, IBR-2176273, ESY-006280441/
Dinodia Photos.
Page 2: Bundi Fort, from the east. WE109215/
Dinodia Photos.
Pages 4-5: Chitrashala (Rang Vilas), Bundi Fort.
WE109214/Dinodia Photos.
Page 7: Detail of wall-painting in the Chhatar Mahal,
Bundi Fort. V10-1401403/Dinodia Photos.
Pages 8–17: Enlarged views of figures 3.1A–3.4.
Photographs courtesy of Shubha and Prahlad Bubbar.

A stylized variant of the Bundi tiger on this page is
the symbol of NGO Dhonk Crafts, Ranthambhore.
It is used at the top of the pages as a motif, with their
permission.

**The support of Shubha and Prahlad Bubbar has enabled several of the illustrations for
this volume, including the portfolio preceding the Introduction. Marg acknowledges
the initiative taken and the foresight shown by them in photo-documenting Bundi Fort's
Badal Mahal and in co-funding this publication.**

**Marg's quarterly publications receive support from the Sir Dorabji Tata Trust
– Endowment Fund**

Contents

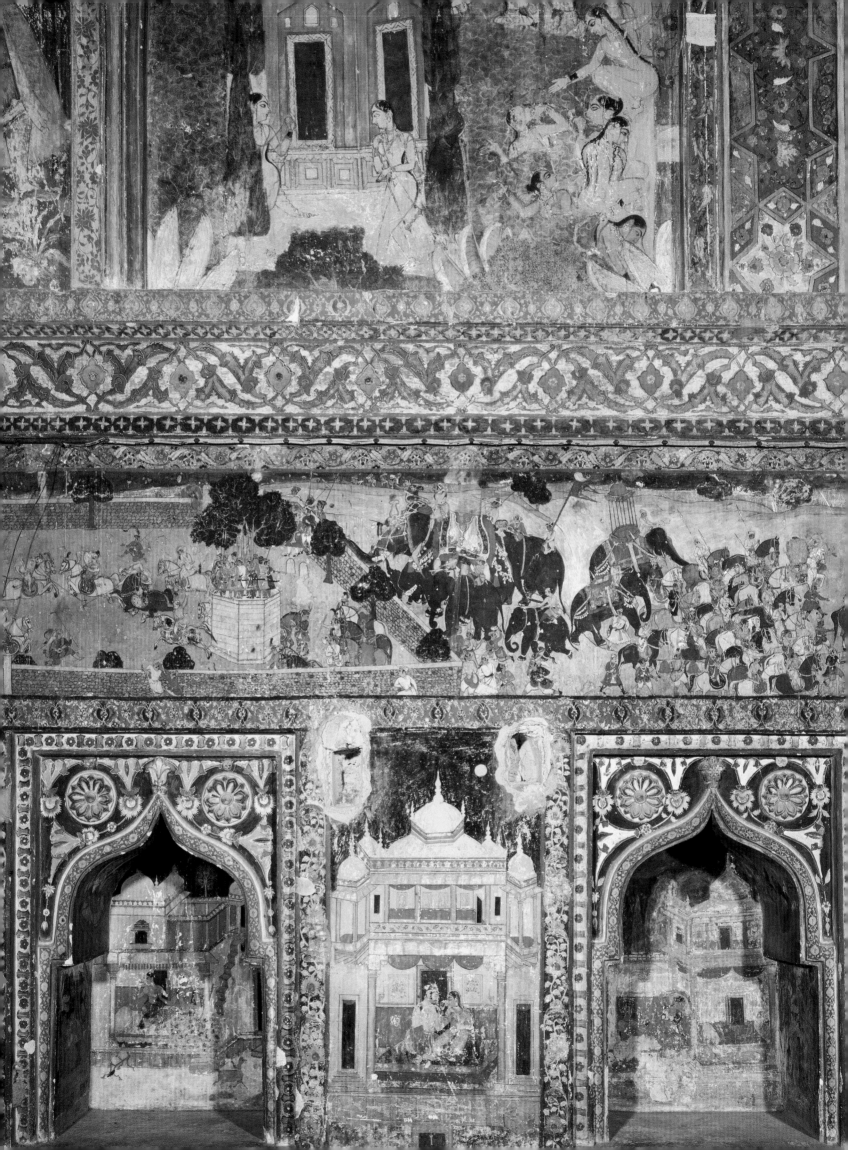

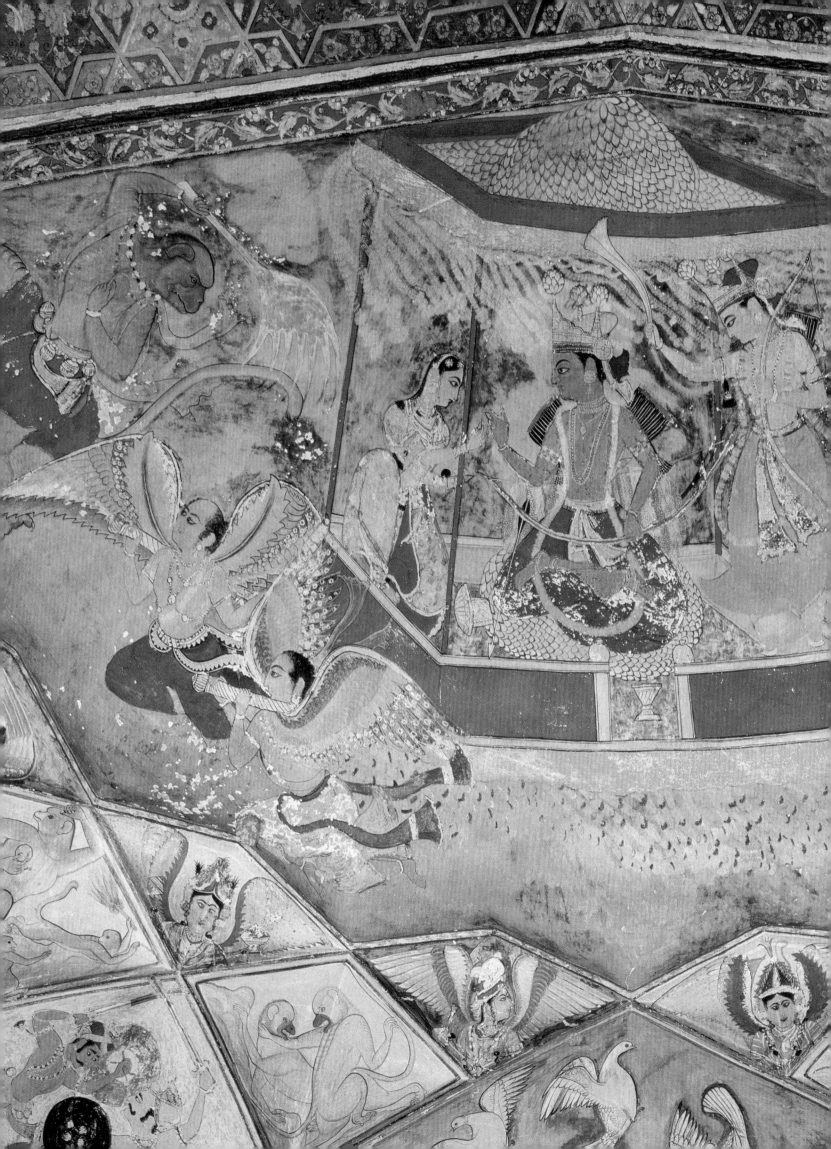

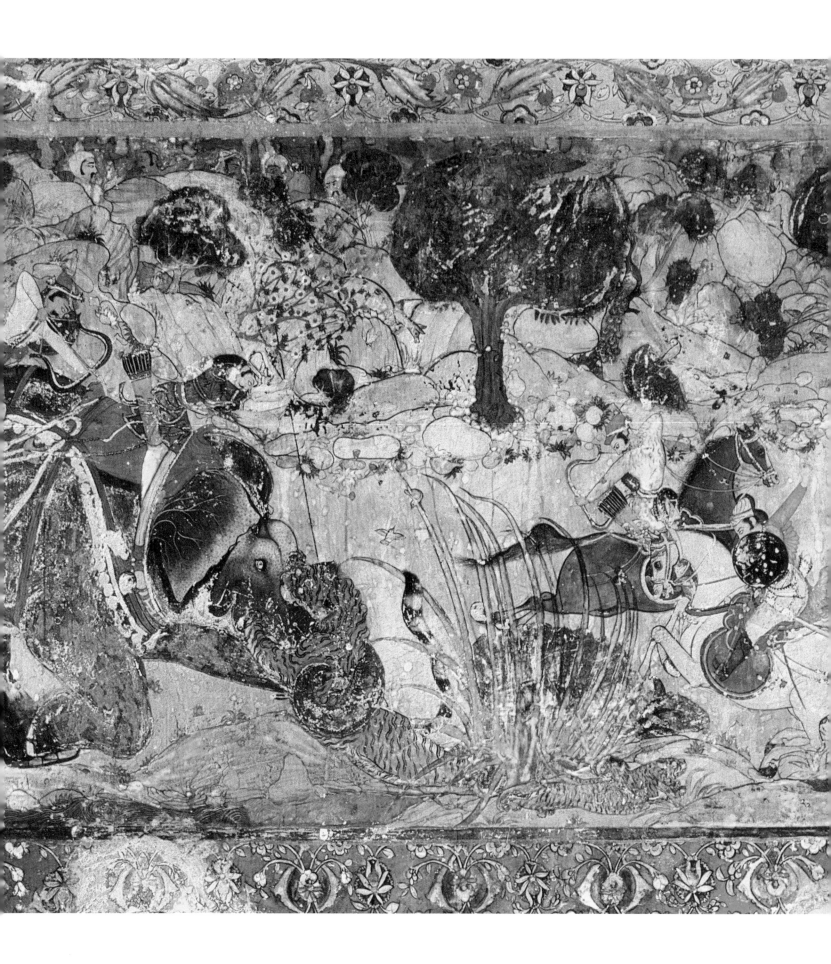

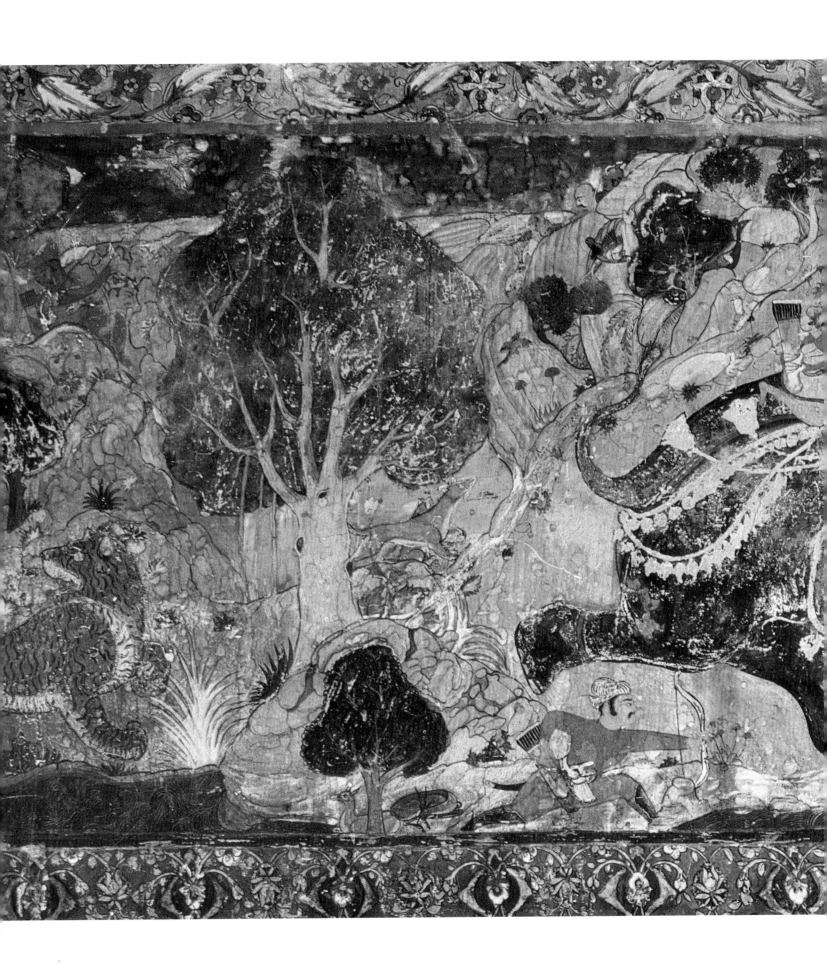

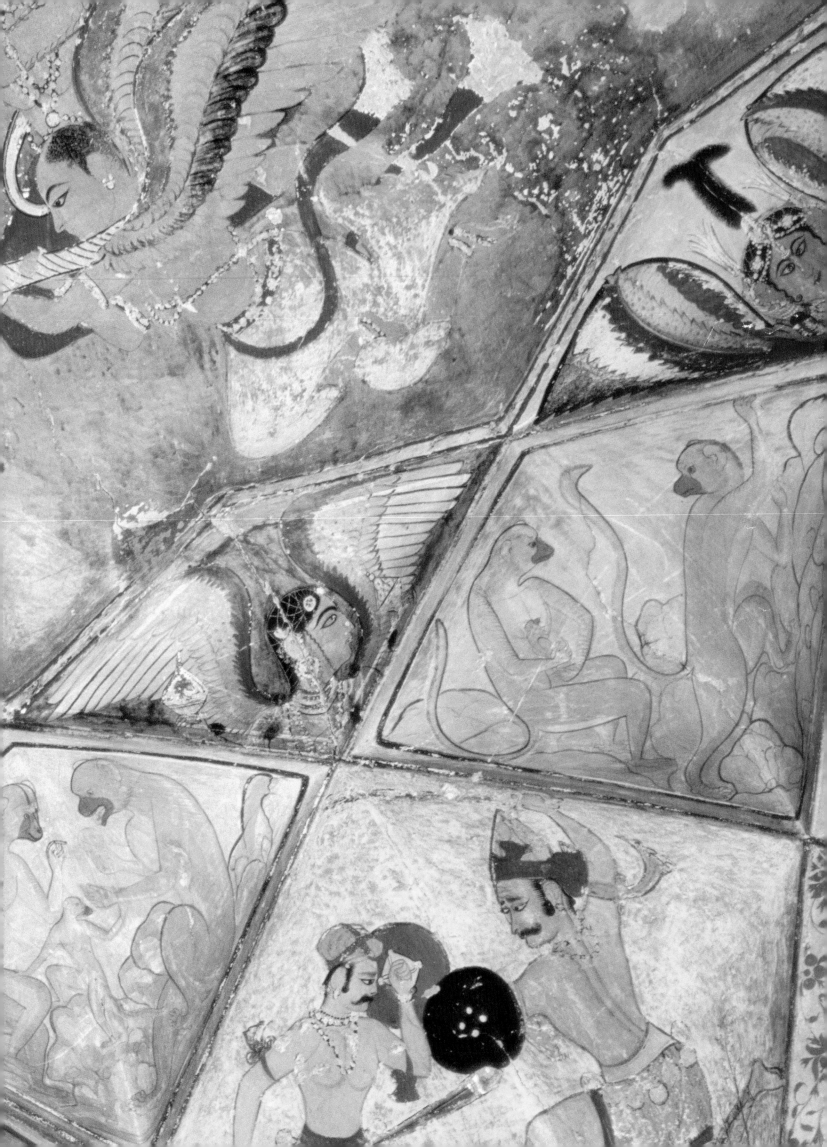

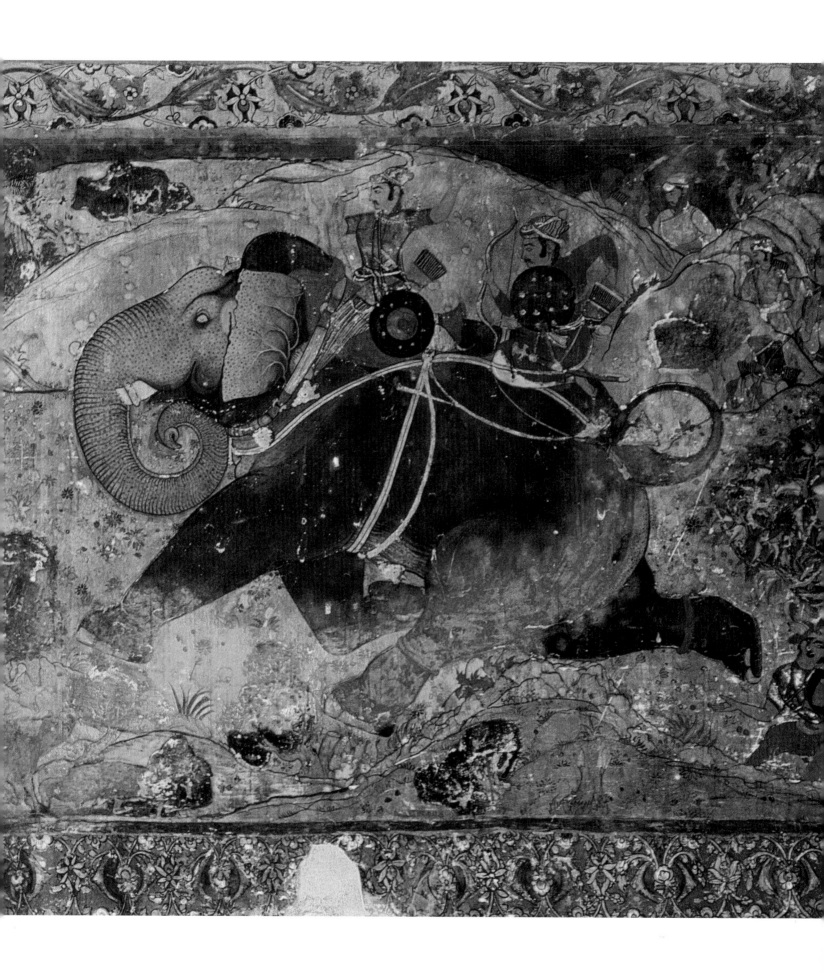

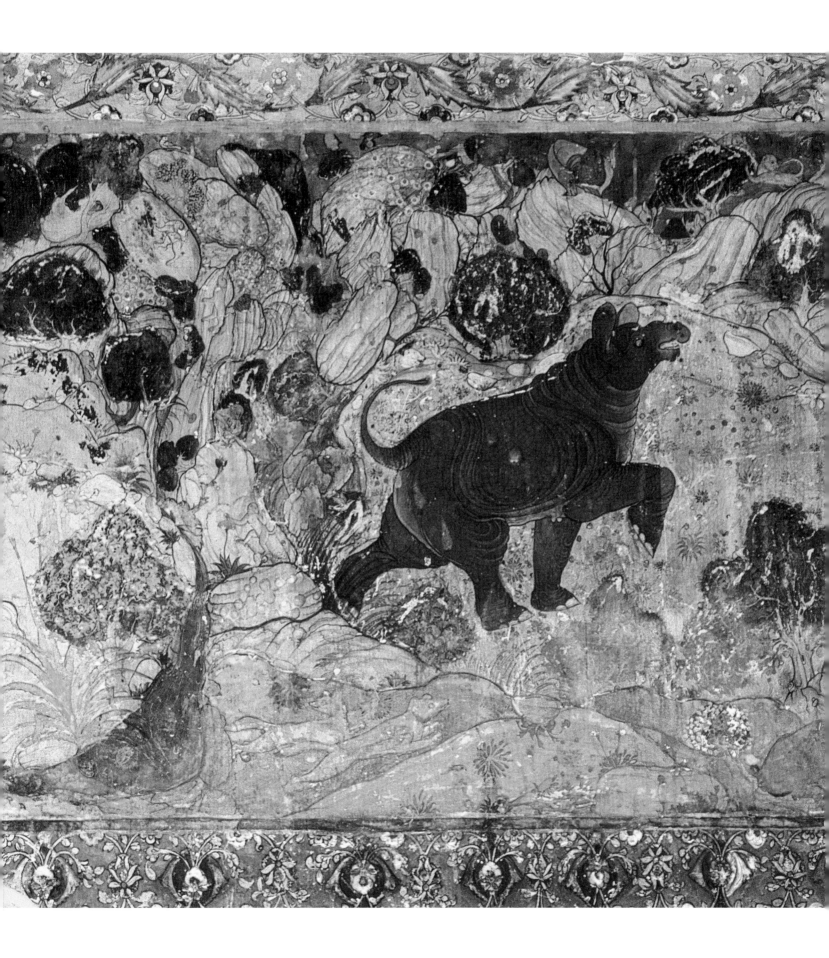

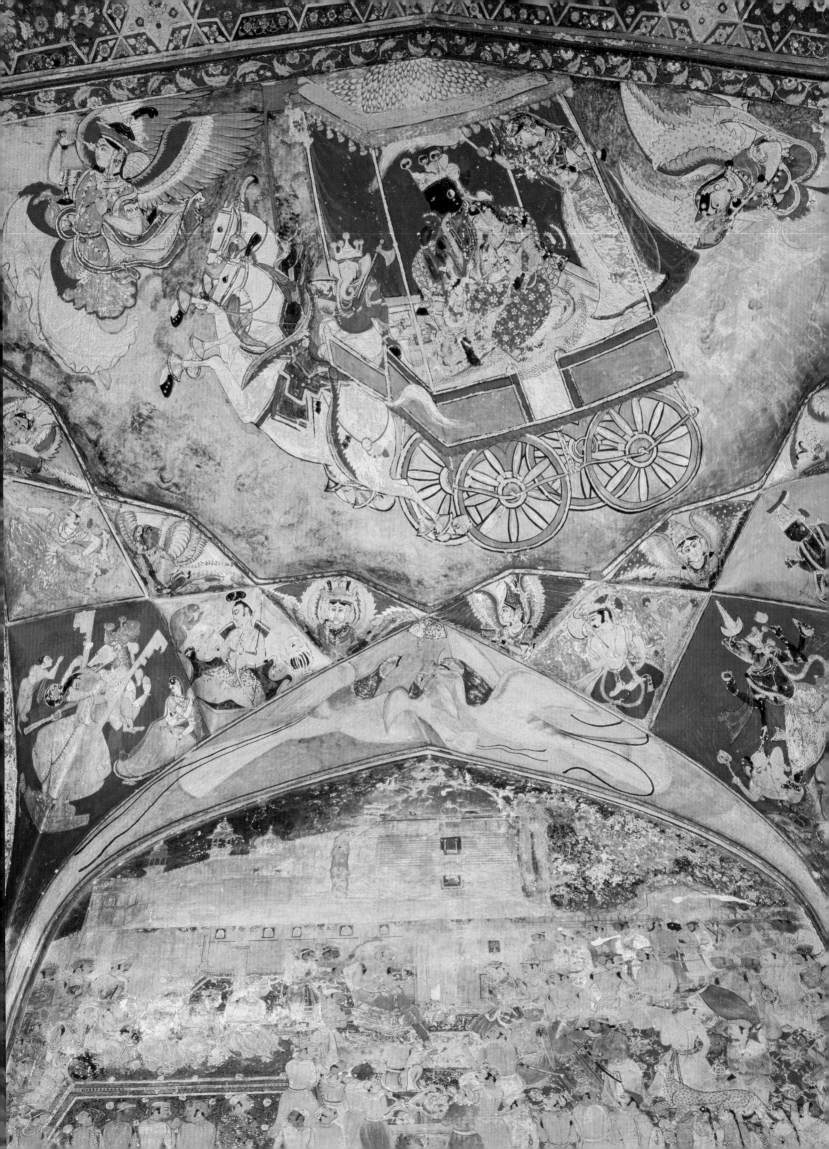

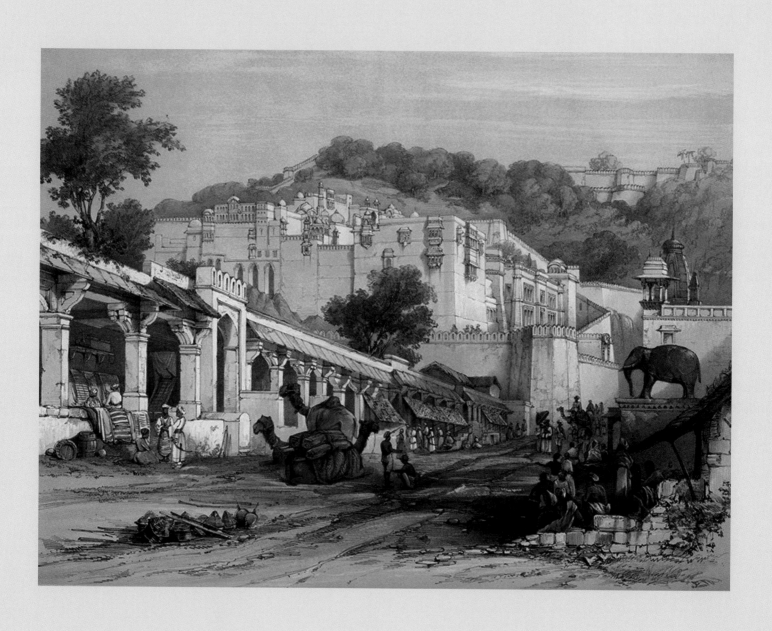

INTRODUCTION

MILO CLEVELAND BEACH

While it has now expanded well beyond its 17th-century walls, Bundi is a small town still; the lack of an airport or any major rail connection has certainly helped to preserve the traditional character of this once flourishing Rajput kingdom in southeastern Rajasthan. The territory was claimed and settled in the 13th or 14th century by the Hadas, a sub-group of the Chauhan dynasty that had emigrated from Nadol (in Pali district) following its defeat by Qutb-ud-din Aibak in 1197. By the 16th century, Bundi had come under the control of neighbouring Mewar/Udaipur, but the relationship was broken in 1569 when Rao Surjan of Bundi handed the keys to Ranthambhore Fort, which he was overseeing on behalf of Mewar, to the Mughal emperor Akbar (r. 1556–1605) following a fierce and extended siege (figure 1.3, see also figure 4.1).[1] By this act, he allied himself and his kingdom to the imperial power, and despite moments of friction, the importance of the Bundi rulers to the Mughal court was repeatedly proclaimed over the next century in imperial memoirs. When Emperor Jahangir (r. 1605–27) visited Ranthambhore in 1618, for example, he remembered the earlier battle, and wrote in the *Jahangirnama*:

> Rai Surjan surrendered and allied himself to the empire, and became one of the great amirs. After him his son Rai Bhoj was also a great amir. At present his grandson Sarbulandi Rai [Ratan Singh] is a great servant of the court.[2]

Different people have different viewpoints, however. The *Shatrushalya Charita* of Vishvanatha, a history written at the instigation of Rao Chhatarsal (or Shatrusal) of Bundi, the grandson of Ratan Singh, says of the events of 1569 that Rao Surjan, "while donating the fort of Ranthambhore to the respected Emperor Akbar . . . also gave him a sumptuous dakshina (gift) of his own friendship with pleasure".[3] Such texts allow no hint of subservience, and in their essays in this volume, Allison Busch and Cynthia Talbot explore further the complexity of this relationship.

As a result of their new alliances, the world of the Bundi rulers expanded: physically, politically and culturally. Surjan was immediately awarded prestigious governorships that took him far from Bundi, the most important being the Varanasi district, where he took up residence along the Ganga at Chunar (figure 1.4). He and his successors (figure 1.2) also served on Mughal military campaigns with assignments ranging from Kabul to Orissa (Odisha) and the Deccan. They built palaces for themselves—and other buildings too—in the imperial capitals and the towns they governed; they commissioned painters to decorate

1.1 Street Scene in Bundi. By Thomas Dibden (1810–93), c. 1847. Lithograph. © British Library Board – X472, pl. 16. The Chhatar Mahal is the closest corner of the distant fort.

Rao Raja SURJAN SINGH
r. 1554–85

Rao Raja BHOJ SINGH (born c. 1551)
r. 1585–1607
Second son of Rao Surjan Singh

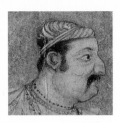

Rao Raja RATAN SINGH
r. 1607–31
Son of Rao Bhoj Singh

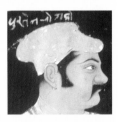

Rao Raja CHHATARSAL (aka SHATRUSAL)
r. 1631–58
Grandson of Rao Ratan Singh and son of Kumar
Gopinath Singh (born 1589; deceased before
accession)

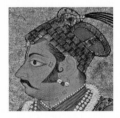

Rao Raja BHAO SINGH (born 1624)
r. 1658–82
Son of Rao Chhatarsal

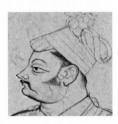

Rao Raja ANIRUDDHA SINGH (born c. 1667)
r. 1682–95
Son of Maharajkumar Kishen Singh, brother of
Rao Bhao Singh

Maharao Raja BUDDH SINGH (died 1739)
r. 1695–1729
Son of Rao Aniruddha Singh

1.2 The rulers of Bundi in the 16th–18th
centuries.
Portraits of Surjan Singh, Bhoj Singh,
Ratan Singh, Chhatarsal, Aniruddha
Singh and Buddh Singh are details from
figures 4.1, 3.8, 4.4, 5.9, 5.2 and 5.11
respectively; portrait of Bhao Singh,
c. 1670, private collection.
Note: Dates taken from Hooja 2006.
All portraits included here bear inscribed
identifications.

1.3 "Akbar Attacks Rao Surjan
at Ranthambhore Fort", from an
Akbarnama, designed by Miskin and
painted by Bhura, c. 1586–89. Opaque
watercolour, gold and ink on paper.
© Victoria and Albert Museum, London,
IS 2:74-1896.

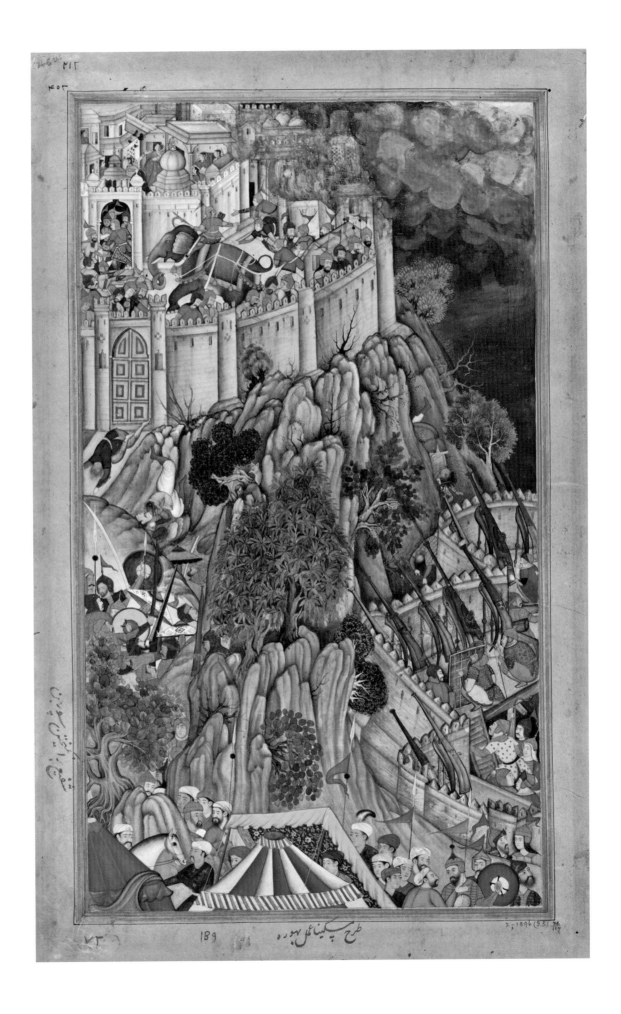

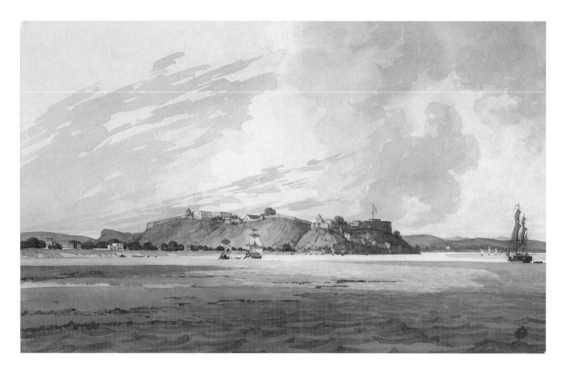

1.4 The southeast face of Chunar Fort (Chunargarh). By Robert Smith, 1814–15. Watercolour. © British Library Board – WD2088.

1.5 Palace of Prince Duda on the hillside at Bundi. Photograph: Milo C. Beach.

the walls; they bought tapestries from agents of the East India Company; and they patronized poets and court historians. They also built a web of marriage relationships: Ratan Singh, the son and successor of Bhoj Singh, married Rama Kumari, sister of Raja Man Singh of Amber (r. 1589–1614), one of the most powerful of all Rajput nobles at the Mughal court, and she was mother of his eldest son and intended heir, Gopinath; a daughter of Rao Bhoj married Raja Jagat Singh, the eldest son of Raja Man Singh Kachhwaha, and their daughter married Jahangir;[4] while Ganga Kanwar, a daughter of Rao Chhatarsal, married Maharana Jai Singh of Udaipur (r. 1680–98) and was the mother of his successor, Maharana Amar Singh II.[5] In the late 16th and 17th centuries especially, the ruling family of Bundi led a cosmopolitan existence that continually introduced them to new people, ideas, and ways of living. It often seems that these early rulers spent little time in Bundi itself, but this small town remained central to their lives and identity. The great British chronicler James Tod reported that following Bhoj Singh's bravery in the Mughal siege of Surat:

> the king [Akbar] commanded him to "name his reward". The Rao limited his request to leave to visit his estates [Bundi] annually during the periodical rains, which was granted.[6]

1.6 Palace of Rao Bhoj, Bundi Fort. Photograph: Milo C. Beach.

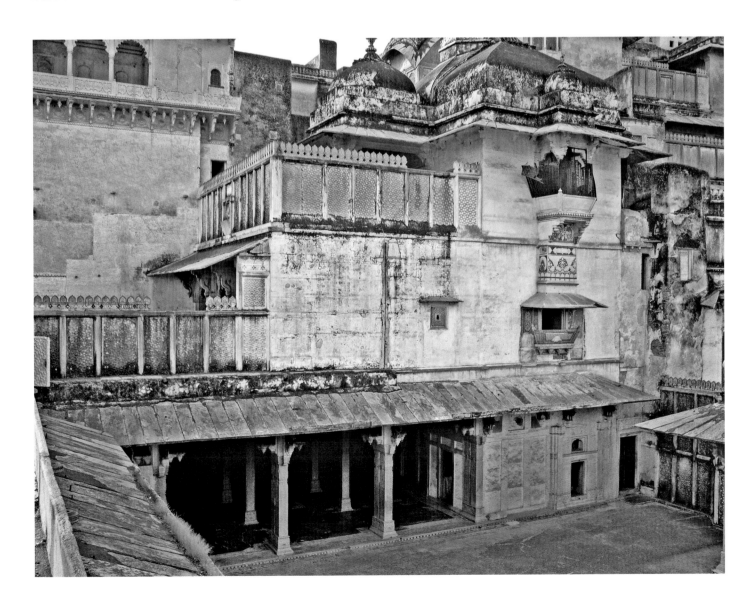

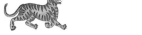

1.7 Hathiyansal, Palace of Rao Bhoj, Bundi Fort. Photograph: Milo C. Beach.

1.8 Detail of the pillar capitals in the Phul Mahal, Palace of Rao Bhoj, Bundi Fort, late 16th century. Photograph: Eric Schenk.
These mirror the distinctively black elephant capitals of the Hathiyansal, one level below.

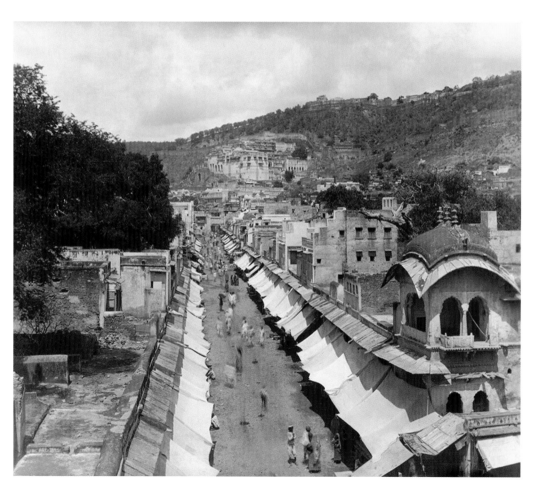

1.9 A Bazaar Street in Bundi. Photograph by Gunpatrao Abajee Kale, c. 1900.
© British Library Board – Photo 17/1(4).
Following its architectural expansion in the 17th century, Bundi Fort visually dominated every part of the town.

1.10 Approach to the Hathipol, Bundi Fort. Photograph: Milo C. Beach.

When the raos were on duty elsewhere, oversight of Bundi was regularly assigned to a son. In 1577, Surjan's eldest son Duda, then in charge of the territory, rebelled against the Mughal ties that his father had accepted. Akbar immediately sent troops, including Rao Surjan and a younger son, Bhoj Singh, to handle the situation, an event important enough to merit illustration in the *Akbarnama*.[7] Duda was exiled, and Bhoj became the official custodian of Bundi. According to local memory, a small, isolated building on a hill slightly east of the present garh (fort) palaces at Bundi had been Prince Duda's residence (figure 1.5). Once he held power, however, Bhoj began a new, free-standing palace structure that was also small, but far more aware of Mughal architectural fashion (figure 1.6).[8] The ground level of the Palace of Rao Bhoj was the Hathiyansal, an audience hall named for the elephants that crown its columns (figure 1.7); the middle level, known as Phul Mahal (Flower Palace), also has pillars with elephant capitals (figure 1.8);[9] while the uppermost level now holds the earliest and finest painted space in Rajasthan: the Badal Mahal (Cloud Palace), a focus for several discussions in this volume. Located next to an older palace structure that later became identified with the zenana, Rao Bhoj's Palace was soon abutted and crowded by new structures added to the site by his heirs (see page 2 and figure 2.3).[10] As the structure of the fort grew, it came to dominate every corner of the town (figure 1.9).

Exhaustive study by Professor Attilio Petruccioli and his colleagues and students at the School of Architecture of the Polytechnic University of Bari, Italy, has defined several major building campaigns within the walls of Bundi Fort. Of special importance is their identification of the palace structure (of uncertain date) that preceded Rao Bhoj's Palace, a significant addition to the limited corpus of early Rajput palatine architecture. These two phases were followed by construction of the Hathipol or Elephant Gate (figures 1.10 and

1.11) and the Ratan Daulat (figure 1.12), which together transformed the visual impact and the public role of all palace spaces; built by Rao Ratan Singh, these additions provided a new monumental entrance and a far grander audience hall. With their construction, however, the function of the Palace of Rao Bhoj, with its more modest audience hall, needed to be reconsidered, and this may have helped to determine the final programme for that building's decoration. The further addition after 1631 of the Chhatar Mahal, an imposing monolithic structure built by Rao Chhatarsal in the southeast corner of the complex (see figure 1.1, where it appears as the closest portion of the distant fort), and a

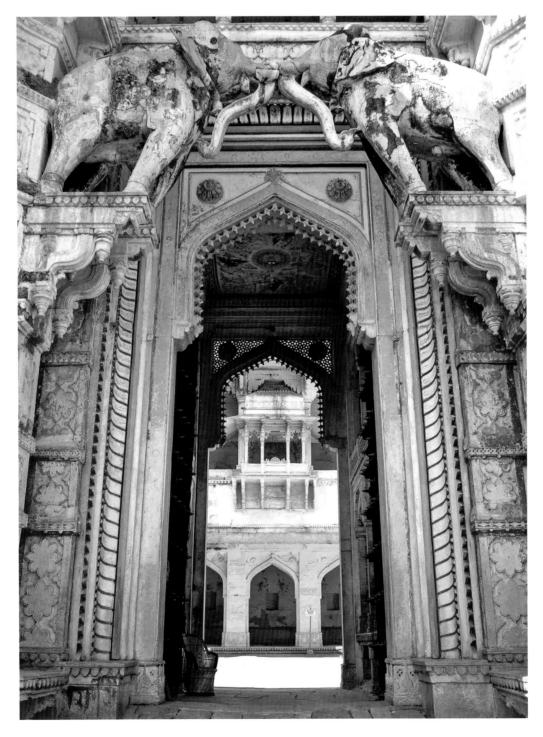

1.11 The Hathipol, Bundi Fort. Photograph: Milo C. Beach. The Ratan Daulat and the projecting throne of the raos is on a level above the entrance courtyard.

1.12 Ratan Daulat, Bundi Fort. Photograph: Milo C. Beach.

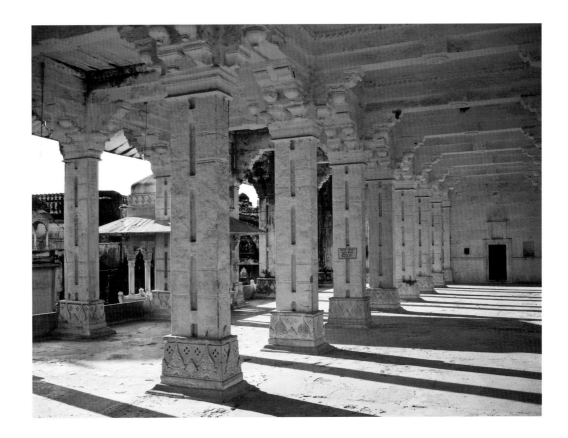

palace and various extensions associated with Aniruddha Singh (figure 1.13), complete the major structures seen today within Bundi Fort. Rao Bhao Singh, son of Chhatarsal, did not build within the fort walls, instead developing a new palace site, named Moti Mahal, just outside the walls on the south (figures 1.14 and 1.15).

The year 1631 was important for other reasons too. Following his personal bravery in various successful imperial campaigns, Madho Singh—a younger brother of Chhatarsal— was awarded by Shah Jahan with substantial territories in southern Bundi, these to be held as the independent state of Kota. This drastically (and purposefully) reduced Bundi's power and resources, and set up a family enmity that directed the future history of the Hadas. It must also have produced tension in Bundi's relationship with the Mughals—however calm that might have appeared on the surface. This may be one reason why Chhatarsal felt it necessary to reassert his importance by building such an imposing new palace, and by inaugurating at Bundi impressive traditions of historical documentation, literary activity, royal portraiture, and the lavish illustration of such themes as Baramasa and Ragamala or texts like the *Rasikapriya* and *Bhagavata Purana* (of which the most important copy is now in the Kota Museum).

Evidence of the high regard in which the Bundi raos were nonetheless viewed by the Mughals is further shown by two uninscribed portraits identified provisionally as Chhatarsal in the Late Shah Jahan Album, an imperial volume that includes portraits of many of the greatest men of the time—an unquestionable mark of imperial esteem (figures 1.16 and 1.17, see also figure 5.10).[11] Chhatarsal was further honoured by his several appearances at formal imperial audiences: soon after his father's death; in the ninth year when "the rao had the good fortune to kiss the emperor's threshold";[12] in the 21st year,

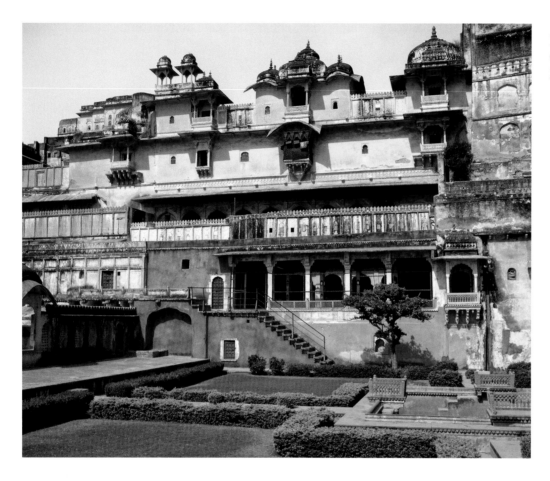

1.13 Aniruddha Mahal and Chitrashala, Bundi Fort. Photograph: Milo C. Beach.

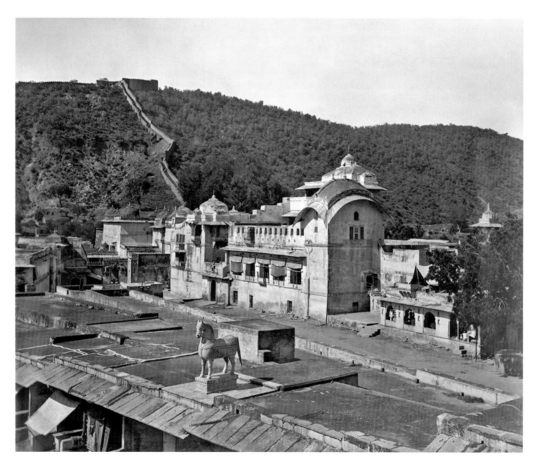

1.14 Moti Mahal, Bundi. Photograph by Gunpatrao Abajee Kale, c. 1900. © British Library Board – Photo 17/1 (9).

1.15 View of Moti Mahal, looking south from the Palace of Rao Bhoj, Bundi Fort. Photograph: Milo C. Beach.

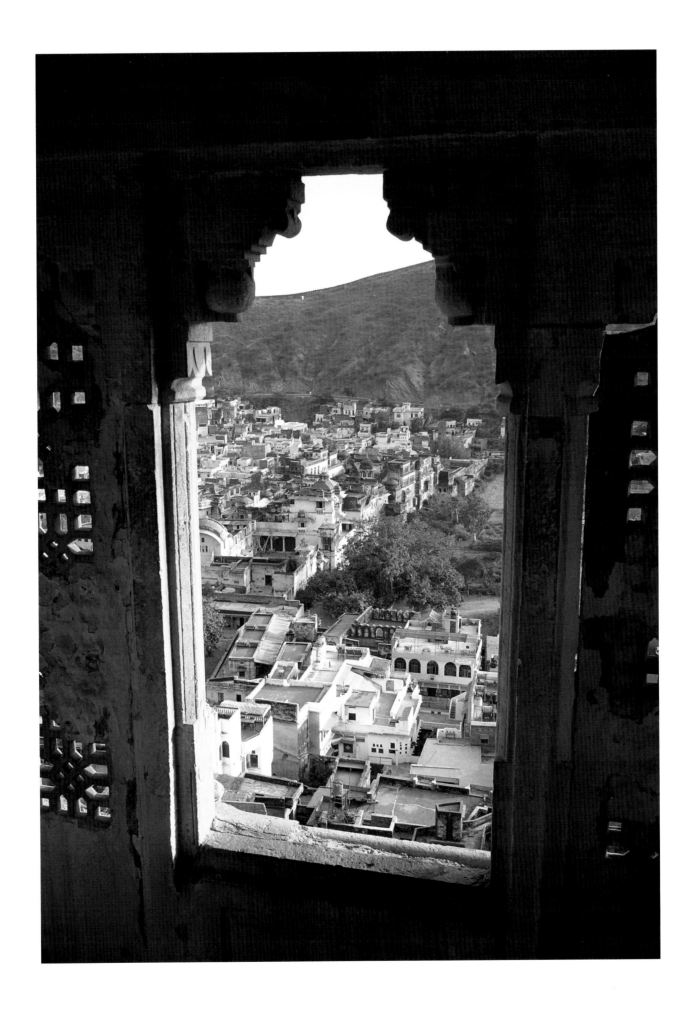

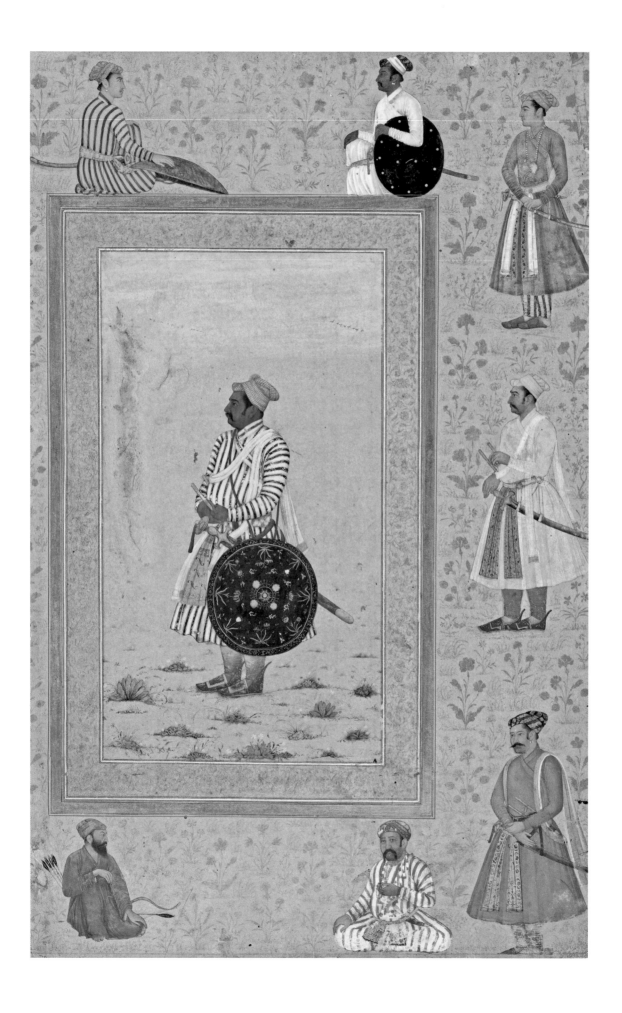

1.17 Detail of figure 1.16.

when he was given home leave; and in the 22nd year, when he was promoted. He served in Balkh, Badakhshan and Kabul, as well as Bidar and Bijapur in the Deccan, and died defending Shah Jahan's favoured son Dara Shikoh against his brother Aurangzeb at the battle of Samugarh in 1658. Despite the continuing ties to the Mughal power structure, however, Chhatarsal's prime allegiance to the local traditions of Rajasthan was never in question. Even in the well-known scene of an unidentified Bundi rao receiving a sword from a Mughal prince (figure 1.18), which is probably intended to depict Chhatarsal, the standing Rajput is shown in his non-individualized, iconic role as the ruler of Bundi—this taking precedence over the exploration of any distinctive physical appearance and character that defines the Mughal artist's intentions so sensitively accomplished in the Late Shah Jahan Album portrait (compare figures 1.17 and 1.19).

Virtually every study of painting in Rajasthan mentions Bundi, often alongside painting at Kota once that state developed its separate identity. Following the important early studies by W.G. Archer and Pramod Chandra, both published in 1959, Bundi has been given a prominence that has never diminished, although most studies have centred on the later 17th and 18th centuries. It is only recently that the extraordinary power and importance of painting at Bundi in the early 17th century has been recognized. This is the result of new and easier access to the wall-paintings of the Badal Mahal, first seriously published and studied by Joachim Bautze—whose interest centred on the important full series of Ragamala scenes.[13] The more recent study of court historical chronicles and poetic texts by Allison Busch and Cynthia Talbot, in particular; the new history of Rajasthan by Rima Hooja; recent essays by Lakshmi Dutt Vyas; the architectural studies of G.H.R. Tillotson; and the work of Professor Petruccioli and his colleagues (published here), are now providing a richness of interests that should serve as a model for future studies of cultural life in Rajasthan. (For writings about Bundi, see the Bibliography.) Of crucial importance for further exploration of the site are the extraordinary photographs taken by Hilde Lauwaert[14] and the illustrations generously provided for this publication by Shubha and Prahlad Bubbar. These visual images allow the close examination of structures and painted walls hitherto impossible for either the general public or the scholar, and they already challenge many long-held assumptions about the importance of Bundi.

The early palace buildings in Bundi Fort are only one aspect of architectural activity in Bundi. Palaces, gardens, hunting lodges and other structures are found throughout the territory, while important later wall-paintings, not discussed here, remain within the fort complex, most especially in the Chhatar Mahal and the Chitrashala (or Rang Mahal), a space visited by Rudyard Kipling in 1887 (see pages 4–5 and cover).[15] The Jain Adinath Temple in the town holds over-painted remains of 17th-century scenes, while other important wall-paintings are still visible in such havelis (mansions) as Rajpurohit ki Haveli;[16] on various chhatris (memorials), gateways, and stepwells; or in the palaces of such dependent territories as Karwar and Indergarh (both published by Joachim Bautze).[17] The dispersal and possible destruction of many of the individual paintings on paper that would have formed the royal collections has made a comprehensive study of painting at Bundi difficult, but the buildings and their decorations remain (albeit in severe need of careful conservation), and scholars have now discovered crucially significant but unstudied literary and historical texts which help to restore earlier periods to intense life. This new and unexplored material, when

1.16 Portrait of a Nobleman, probably Rao Chhatarsal, from the Late Shah Jahan Album, c. 1640. Opaque watercolour, gold and ink on paper; 38.42 x 27.62 cm (page), 21.59 x 12.38 cm (illustration). From the Nasli and Alice Heeramaneck Collection, Museum Associates Purchase (M.83.1.3), Los Angeles County Museum of Art.

1.18 The Ruler of Bundi Receiving a
Sword from a Mughal Prince, c. 1658–
60. National Museum, New Delhi, acc.
no. 50.14/23.
As noted by Allison Busch (see page
106), Chhatarsal was awarded a
jewelled sword in 1657 by Shah Jahan,
a ceremony attended by Chhatarsal's
young son Bharath Singh. This may
therefore be a Bundi artist's imaginative
depiction of that event.

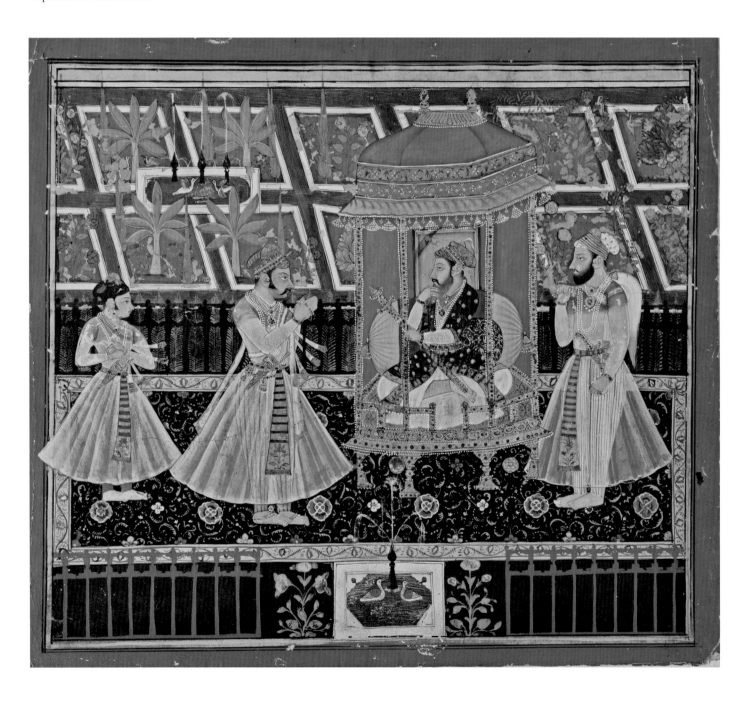

coupled with the now more generous access to Bundi Fort, will provide many rewards to those who continue to study this extraordinarily important site.

1.19 Detail of figure 1.18.

ACKNOWLEDGEMENTS

In assembling this volume, I am especially grateful to Keshav Bhati, for his knowledge, enthusiasm and essential help in gaining access to the fort, and for his kindness to several of the contributors. Nazir Muhammad, a long-time research assistant and driver, has been endlessly helpful and patient. Hilde Lauwaert has kindly allowed us to include both published and unpublished photographs from her extraordinary and thorough survey of Bundi wall-paintings, and we are grateful too to Shubha and Prahlad Bubbar for their immense generosity to this volume. The interest and support of Elizabeth Moynihan have been of crucial importance to the book's production. The entire editorial, design and production staff of Marg has overseen this book with precision, sensitivity and calm efficiency.

NOTES

1 These are two of the five stages of this siege illustrated in an imperial *Akbarnama* manuscript in the Victoria and Albert Museum, London, IS.2:72-1896 to 2:76-1896 (Sen 1984, pp. 121–27, pls. 52–55). The number of illustrations for this episode is evidence of the importance given to the Mughal victory at Ranthambhore.

2 *The Jahangirnama* 1999, p. 288.

3 Mahakavi Vishvanatha 1996, viii: 77.

4 For a report of this marriage, see: Abu'l Fazl 'Allami, *A'in-i-Akbari* 1965 (reprint), p. 510, no. 175.

5 For a discussion of Amar Singh's brief residence at Bundi and the effect on him of paintings he saw there, see Glynn 2011.

6 Tod 1957, vol. 2, p. 382.

7 Victoria and Albert Museum, London, acc. no. IS.2:103-1896.

8 An inscription in stone found in Taragarh, the 14th-century fort at the summit of the hill above the Bundi Garh, states that Bhoj built the palace in 1575, about the time of his brother's rebellion. The reliability of the inscription needs examination, however.

9 This name may have been given in honour of Phul Lataji, a concubine of Rao Bhoj (see also note 10 below).

10 Among the buildings outside the fort walls, the Phul Sagar Garden was laid out in 1602 by Phul Lataji (see note 9 above). It was later expanded to become the site of the Phul Sagar Palace, the most recent residence used by the maharaos.

11 For a recent study of the album, see Wright, Stronge and Thackston 2008, pp. 106–39. The proposed portraits of Chattarsal are discussed in Pal 1993, no. 78B; and Losty 2013, no. 1Q.

12 Khan 1911–14, vol. 2, p. 261.

13 See especially Bautze 1987a.

14 Beach and Lauwaert 2014.

15 Kipling 1919.

16 A further building in the town, Govardhan Singhji ki Haveli, was recently destroyed.

17 Bautze 1987a, pp. 165–90, and his "Mural Paintings of *Krishnalila* at Karwar", in *Arts of Mughal India: Studies in Honour of Robert Skelton*, ed. Rosemary Crill, Susan Stronge and Andrew Topsfield, London: Victoria and Albert Museum and Ahmedabad: Mapin Publishing, 2004, pp. 264–77.

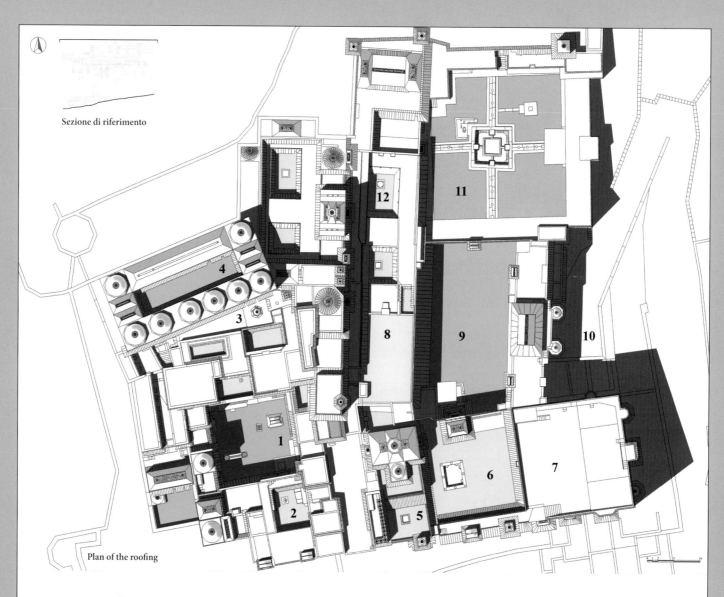

Sezione di riferimento

Plan of the roofing

Key:
1 Zenana's main courtyard
2 Early (16th-century) Rajput maharaja's apartment
3 Cenotaph platform
4 Conjectural 18th-century female apartments
5 Palace of Rao Bhoj
6 17th-century maharaja's apartment, main courtyard

7 Chhatar Mahal
8 Ratan Daulat (Diwan-i Amm)
9 Entrance chowk
10 Hathipol
11 Chaharbagh
12 Chitrashala (Rang Mahal)

BROWN: the basement chowks WARM GREY: the hanging chowks GREEN: the chaharbagh

Architectural Structures and Spaces in the Fort Palaces at Bundi

DOMENICO CATANIA, ATTILIO PETRUCCIOLI, CLAUDIO RUBINI

Bundi is the paradigm of a territorial settlement type found in the land of Rajasthan. The town lies on a hillside near a narrow gorge, where a gap in the chain of hills that run southwest to northeast for more than 100 kilometres opens to the plains watered by the river Chambal. In this place of transit and continuous occupation, a built landscape of inclusion took shape, where overlapping layers of history, each with its own identity, generated a palimpsest in harmony with the natural morphology.

All the elements that contribute to make a Rajput settlement have their representation at Bundi: the Taragarh Fort built on top of a hill, a site carefully chosen for control of the territory, and self-sufficient to face long periods of siege; the Garh palaces, seat of the court of the Bundi maharaos, perched lower on the hillside overlooking the city, providing a visible symbol of power, guidance and political, social and cultural order; the urban fabric with its aggregate structure of autonomous neighbourhood units that are yet integrated and interconnected by the long spine of the bazaar; the infrastructure of the water distribution network that guarantees access for the whole community, allowing the city to live and prosper. Each neighbourhood unit has its own well, generally a stepwell, which abuts a shrine or a temple that renews the daily relationship with the sacred. The artificial lake or kund, Nawal Sagar, the most spectacular example of hydraulic architecture of these regions with its long flight of steep steps that converge toward the depths, serves a wider section of the population, and is located outside the inner walls of the city.

The subject of this chapter, the residence of the Bundi maharaos, is a monumental complex that climbs the slope of the hill in a sequence of dense and complicated structures, piled one above the other along a labyrinthine path. There is an organization of movement, proceeding from the public spaces of the mardana or men's quarters to the most private ones of the women's zenana, that is common to other royal residences in Rajasthan and elsewhere in the country.

The whole complex is an exercise in harmonious balance that the rulers of Bundi achieved over the centuries, through the adaptation of the design to the invariant natural

2.1 Bundi Fort (Garh): plan as seen from above.

structure of the land and soil. The compositional logic that controls and achieves this harmony at Bundi is the combination of autonomous architectural elements: a series of courts, each one with its own orientation and its necklace of living fabric that defines its time. These nuclei are meticulously connected through a spontaneous mechanism of conformation similar to that of a crowded city, where the monumental buildings are absorbed by a dense residential construction fabric; in this sense, the Fort of Bundi can be seen as a microcosm that appropriates and implements the principles of an urban macrocosm.

The peculiarity of the Garh palaces, intimately consistent with the image of impregnability that the construction of a garh (or fortress) suggests and the topography imposes, is that the water supply basin is reduced to a deep closed well within the walls of the courtyard at the foot of the complex, unassailable and invisible from the city. Paintings in the palace's Chitrashala clearly show how the water was drawn up through an articulated system of hydraulic engineering, though they also depict porters loaded with goatskin bags, carrying up water drawn from wells in the plains. With the extension of the building beyond the limits of its original, compact core, and the urge to imitate the landscaped gardens of the

2.2 Plan showing the main spaces of the Bundi Fort complex. For the land use and the nomenclature refer to figure 2.1.

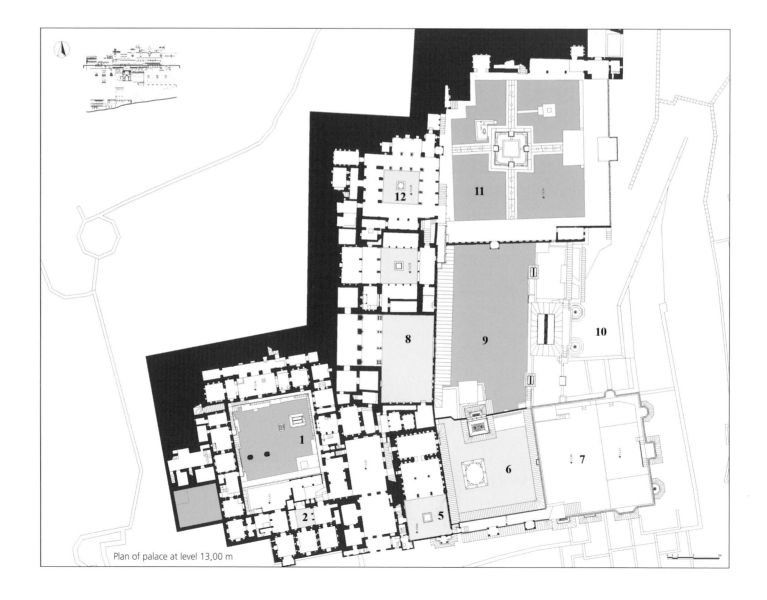

Plan of palace at level 13,00 m

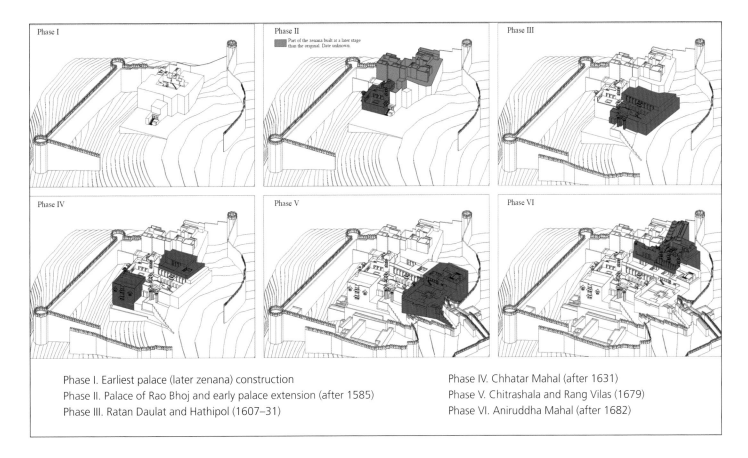

Phase I. Earliest palace (later zenana) construction
Phase II. Palace of Rao Bhoj and early palace extension (after 1585)
Phase III. Ratan Daulat and Hathipol (1607–31)

Phase IV. Chhatar Mahal (after 1631)
Phase V. Chitrashala and Rang Vilas (1679)
Phase VI. Aniruddha Mahal (after 1682)

2.3 Evolutionary phases of the Bundi Fort complex.

Mughal emperors, a roof garden was constructed with a tank at its centre, sanctified by the presence of Shiva's symbols, a linga and the bull Nandi (see chapter 7 by D. Fairchild Ruggles). With this, hydraulic architecture emerged from its underground shadowy world of wells and kunds into the open air.

The roof garden in the form of a chaharbagh is built on a high artificial terrace that serves as a parterre to the Chitrashala, the hall of paintings, which forms the first stage of the layers of apartments and private courtyards that develop behind it. The garden is built at a level over 4 metres higher than that of the private court or Diwan-i Khass and 10.5 metres above the Hathipol (Elephant Gate), the monumental entrance to the Garh. This green terrace is connected to the towers and channels that enable distribution of water throughout the palace. The supply system used in the Garh palaces is widespread all over Rajasthan: at Amber, for example, a sequence of three towers, each with a Persian wheel, raises the water from Maotha, the reservoir lake, to the Diwan-i Khass, from which it is distributed throughout the building, into the most private and protected areas. In Bundi Fort, the water reaches the innermost heart of the royal complex but never directly touches the public court of the Diwan-i Amm (Ratan Daulat) and the nakkarkhana (where the ceremonial drums were kept).

Our team's architectural survey of the Garh palaces, conducted from the chowk of the Hathipol upwards, followed the order of the functional layout.[1] However, examining the structures in this sequence, from public to progressively more secret spaces, from the monumental gate to the Diwan-i Amm, the Diwan-i Khass, and finally the infinite apartments of the zenana, does not allow one to fully grasp the process of design and composition—that is, the broader Rajput vision of this royal living space, and its historical-chronological construction.

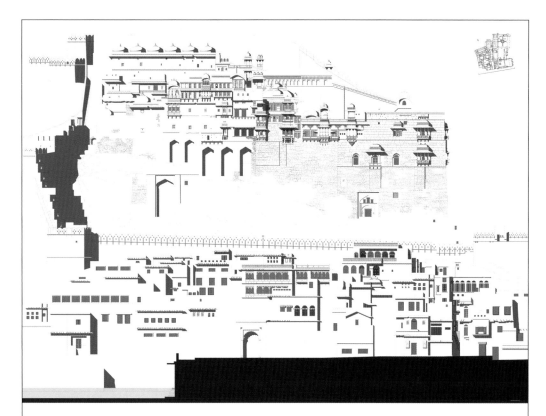

2.4 Bundi Garh, southern elevation.

From left to right, above: extensions of the zenana, the original 16th-century Rajput palace standing on five-arched base (later the zenana), minor encroachment probably dated end of the 19th century, Palace of Rao Bhoj rooftop, 17th-century maharaja's apartment main courtyard, Chhatar Mahal. Note the change in style from the solid base of the palace to the top that uses Mughal forms (curved bangaldar roofing, for instance). Below are shown the buildings just outside the southern wall of the fort.

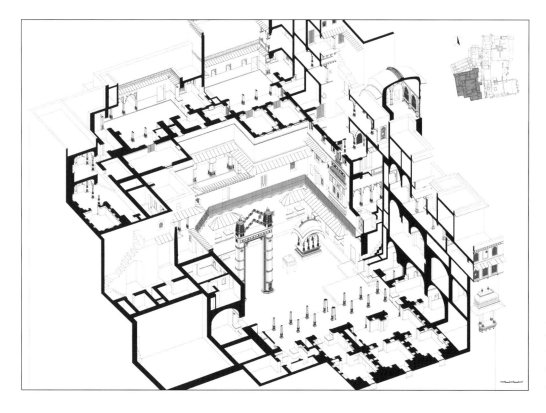

2.5 Exploded isometric view of the zenana showing the hierarchy of the nodal courtyard and the courtyards of the women's apartments.

2.6 Bundi Garh zenana (originally the palace): section looking east and plan at the level of the upper apartments.

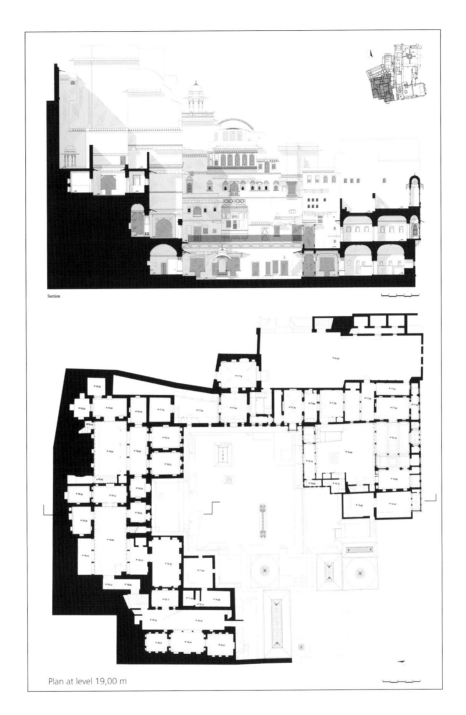

Section

Plan at level 19,00 m

The parts of the complex for which the patron and construction period are known are the Palace of Rao Bhoj (including the Badal Mahal) built by Rao Bhoj Singh (r. 1585–1607), the Ratan Daulat (Diwan-i Amm) and Hathipol built by Rao Ratan Singh (r. 1607–31) and the Chhatar Mahal built by Rao Chhatarsal (r. 1631–58) (figures 2.1–2.3). The first half of the 17th century has therefore to be understood as a fundamental period of transition in which to detect the evolution of the techniques of design and construction of the palace (figure 2.4). Later in the century were built the Chitrashala, Rang Vilas and Aniruddha Mahal.

The oldest part of the complex, the original 16th-century Rajput palace, coincides with the current block of the zenana, located in its westernmost area (figures 2.5 and 2.6).

The building is in very poor condition, consisting of a structure of massive whitewashed brick walls with small-size openings, surrounding a courtyard. This section likely once constituted the entire abode of the raja and his court, holding within it not only the private quarters for women and men, but in addition the spaces of political representation. It is possible to imagine a steep path from the plains below, ascending the hill to reach this original home of the Bundi court, isolated and impressive in its elevation above the five-arched substructure that provides the artificial ground on which it stands.

It should be noted that such a geometrically regular structure, as we see in the present zenana block that originally functioned as the palace, could only have been built in the absence of external constraints—that is, in the absence of pre-existing structures at the site. Other parts of the palace that date after the beginning of the 17th century, having been designed and built as additions, each with its specific function (Ratan Daulat or Diwan-i Amm, Diwan-i Khass, Chitrashala etc.), do not have such autonomy.

opposite
2.7 Scale drawing of the swing in the zenana.

2.8 Typological analysis. Left: modular grid of the zenana's layout; right: nodal spaces and anti-nodal position of the stairs.

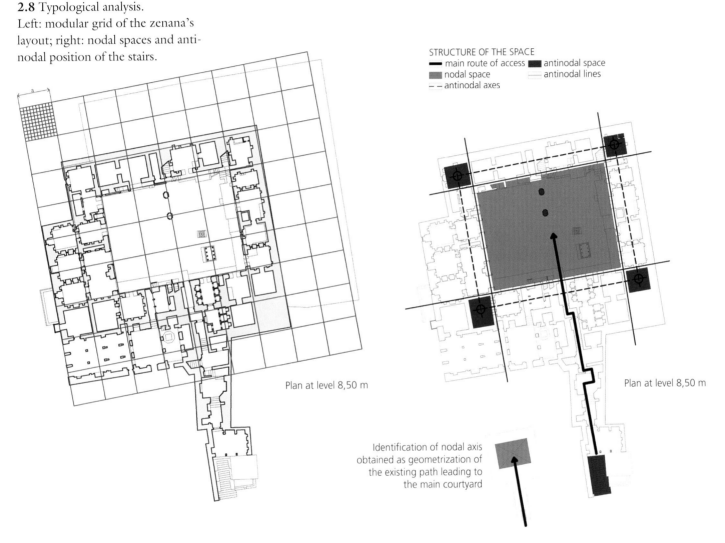

Plan at level 8,50 m

STRUCTURE OF THE SPACE
— main route of access ■ antinodal space
■ nodal space — antinodal lines
– – antinodal axes

Plan at level 8,50 m

Identification of nodal axis obtained as geometrization of the existing path leading to the main courtyard

Contemporary with the zenana courtyard is the monumental stairway that ascends to it, starting from the entrance chowk behind the Hathipol. This staircase, perpendicular to one side of the courtyard of the zenana, aligns with the axis of the courtyard, with the entrance at one end and at the other a large stone swing about 7 metres high, which supports the hypothesis about the use of these spaces as predominantly female (figure 2.7). The courtyard itself, from a geometrical point of view, therefore, arises as a nodal space of the zenana (figure 2.8). This interpretation is supported by the presence on the first floor of what must have once been the private apartments of the maharaja, which define a cross axis, orthogonal to that of the grand staircase. Translated into typological analysis, the courtyard represents a point of arrival for those climbing up from the chowk, and at the same time a transient node for those who wish to reach a further hierarchical level of distribution—the smaller courts, galleries, semi-open spaces and stairwells serving individual apartments of the zenana.

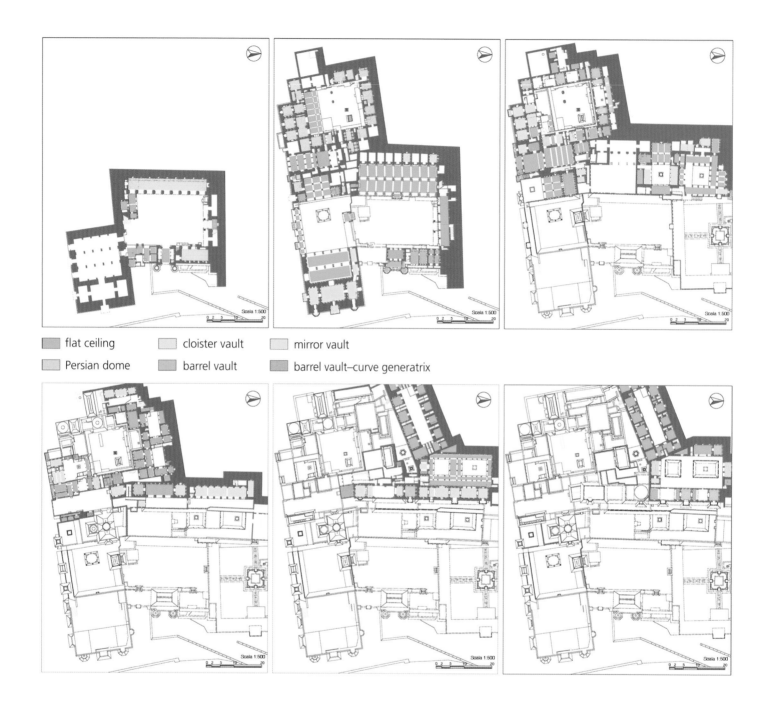

flat ceiling cloister vault mirror vault

Persian dome barrel vault barrel vault–curve generatrix

An immediate distinction that springs to mind, therefore, is that between serving and served spaces and paths. The serving spaces are a point of arrival for major routes, while secondary routes culminate in served spaces. These two levels of reading help us understand the site as a whole, in which the distribution, accessibility and uses of individual spaces contribute to the definition of a unitary space. Specifically, it can be seen that the open spaces act as connective support to the served areas—mainly the rooms along the four edges of the zenana, which overlook either the inner courtyard or the exterior through balconies or jharokas. Among these perimeter rooms the four corner ones are distinguished by their more specialized nature. Each is equipped with its own stairwell, making it directly accessible from the courtyard at the ground floor; in addition, their ceilings present special vaulted systems most likely of Persian influence (figure 2.9).

2.9 Nomenclature of the vaults of the Garh palaces at each level (upper to lower).

The measured architectural survey of the complex reveals its underlying design logic. This is based on the overlaying of self-contained sets of apartments, each comprising a private open courtyard overlooked by an arcade (tibari) and a variable number of closed spaces, independently accessible and acting as a frame around the courtyard. This is a world of smaller spaces that gravitate around the main courtyard, quite similar to the zenana of Man Singh's monumental Amber palace. Size and articulation of space are elements that by themselves make possible the recognition of those parts that originally were the private spaces of the sovereign, which occupy the southeast corner of the present zenana building and were extended to double the size through the construction of a further structure. They consist, again, of a central courtyard with tibari, and surrounding closed and vaulted spaces, all opening onto an external loggia facing the city. The walls on the southeast side of this building are today obliterated by the Badal Mahal, the porch of which occupies the south side of the great court of the zenana and is most likely, judging by the use of poly-lobate arches, a later extension amending the original symmetry of space.

A staircase, made around the northwest corner of the building, clearly designed as part of the original plan, connects the building of the zenana with a second building. This structure also consists of an aggregation of serial quadrangular cells around a long rectangular courtyard that, going by its space configuration, was destined to house the ladies of the palace, similar to the 18th-century Tiger Palace (Nahargarh) in Jaipur. Its chronology is open to dispute: on the one hand its function, the external solid elevation and its direct connection to the zenana suggest that it was contemporaneous with this early building; on the other hand the analogy with other princely mansions or havelis in Rajasthan and several typological features are suggestive of a later addition next to the zenana. These two buildings, moreover, preserve an open space between two of their converging perimeter walls, which contains a small system of terraces on which still stand two cenotaphs. Therefore the more certain hypothesis is that the northwest stairs would have led to a terraced lawn located at the highest altitude of the palace, used as a memorial garden for the dynasty.

Possibly the first extension made to the zenana was the Palace of Rao Bhoj. Reminiscent of the Vikramaditya Mahal of Gwalior in its configuration, it is a two-storey building. At ground level is a hypostyle square hall, the so-called Hathiyansal (with structural posts and beams forming 3 x 3 metre cells) flanked symmetrically by two pairs of ancillary rooms. The first floor has a small pillared hall opening onto a courtyard, enclosed by a high wall and with a water tank at its centre, communicating with a rectangular hall that has one jharoka each on the east and west sides. The second storey has a vaulted hall opening onto a small rectangular court. Looking out from the jharoka on the west side of the first storey, over the claustrophobic space of a steep staircase, one can see that the palace was born as an isolated building block. What was originally intended to be an open terrace to the south, was transformed into a pillared hall with its ancillary rooms at a later stage.

It is very likely that after this arrangement, works commenced during the 17th century changed the appearance of the whole structure starting from the Palace of Rao Bhoj, introducing functions derived from Bundi's direct vassalage to the Mughal court. These works, while conservative in their use of such space-based systems as the court with its complement of rooms, introduce a more complex language characterized by a progressive increase in open spaces.

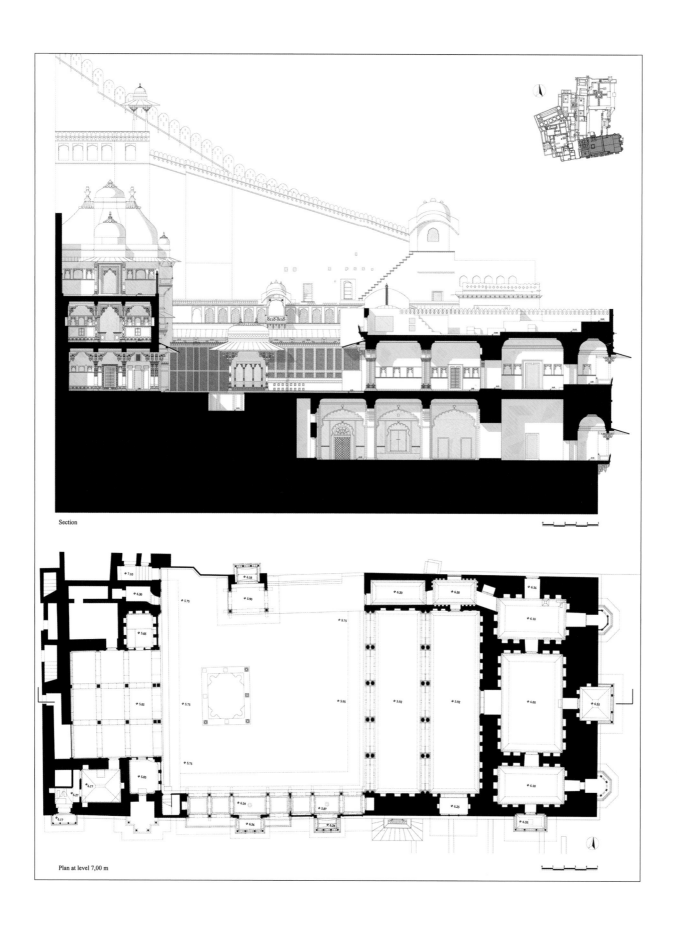

Section

Plan at level 7,00 m

2.10 Diwan-i Khass. Above: longitudinal section showing the Hathiyansal and the Chhatar Mahal; below: plan at the level of the hanging courtyard.

2.11 Ratan Daulat or Diwan-i Amm. Above: transversal section through the main jharoka and the nakkarkhana of the Hathipol; below: plan at the level of the jharoka.

Subsequent expansion saw the creation of buildings that can be identified today with the mardana, spaces dedicated to men. Arranged along the south side of the complex and bounded on the north by the monumental staircase leading to the zenana, these areas are organized around a hanging courtyard, placed at a lower level than the zenana. Above it, there are two hypostyle halls: the Hathiyansal to the west and the Chhatar Mahal to the east, each supported by a trabeated structure on pairs of columns (figure 2.10). It is possible that from the very first, these served as the Diwan-i Khass, or the private audience hall where the raja met with his ministers, while the Badal Mahal above was a place for the maharanis, as confirmed by the murals that can be seen in it. In fact, though both are now identifiable in a single building, the Chhatar Mahal was built in a later period as an extension of the courtyard to the east, thus leaving the water fountain, originally placed at the courtyard's centre, in an eccentric position.

Later, north of the mardana precincts, more structures were erected for the darbar, the public functions of the palace (figure 2.11). It is not a coincidence that here, along the east side of the large chowk, is the Hathipol, the present monumental entrance to the palace,

2.12 Exploded isometric drawing of the Chitrashala and the hanging chaharbagh.

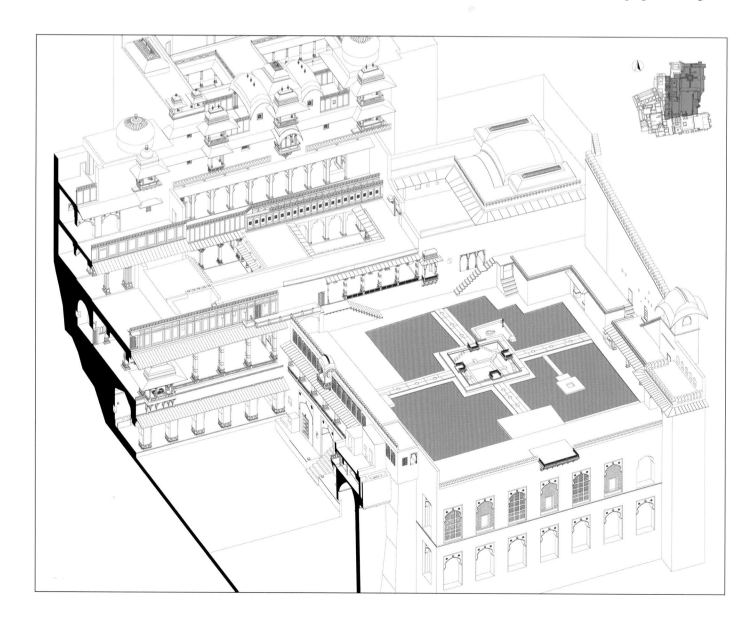

clamped between two sturdy octagonal towers, which terminate in chhatris or octagonal cupolas, from which protrude the trunks of elephants carved in stone. Opposite the portal are the stables for horses (nathan), filtered through a series of eight-pointed arches. Upstairs is the hall of Ratan Daulat, serving as the Diwan-i Amm or hall for public audience. In this hall was held also the ceremony of Tilak Raj, the installation of the new governor. Above the Diwan-i Amm is a large open courtyard, of the same period as the Chhatar Mahal. As for the chowk, it has the shape of a trapezium, whose sides follow three different orientations, while the nodes of the entrances and jharokas, added to give order and symmetry to the complex, are in reality off-axis with respect to the surrounding constructions. The different treatment of the inner facades, corresponding possibly to successive stages of intervention, and the lack of resolution where these buildings meet, reveal the original character of the chowk as an external space, subsequently closed with construction of the Hathipol.

The north side of the palace building is among the areas most recently realized (figure 2.12). This includes the Chitrashala, the painting gallery, also the place where the maharao received his guests and showed them the splendour of his court. The courtyard of the Chitrashala is surrounded by an uneven cloister: three sides consist of simple piers, lintels, and shelves of capitals, while the west side is made up of four large arches. Outside, the room faces east onto a roof garden contained between the outer wall of the building and that of the chowk entrance, designed as an asymmetrical chaharbagh. Probably the women of the palace were allowed access to this garden, since the Chitrashala is directly connected with the zenana above via a staircase. In further phases on superior terraces follow the last additions of the Rang Vilas in 1679 and the Aniruddha Mahal after 1682.

In conclusion, from the Garh palaces in Bundi it is possible to reconstruct the typologies and design principles of Rajput architecture in general, and aspects of residential architecture in particular, from the early 16th century to the 19th century. The zenana of the palace, identified as the original core, is a closed quadrilateral; a massive building of military aspect; centripetal or growing inward at the expense of its courtyard. The multifunctional quadrilateral accommodated in the 15th and 16th centuries both the private apartments and spaces for official duties. Similar design typologies are evident in the ruins of the 10th-century fort-palace of Ranthambhore and the Ratan Singh Palace in Chittorgarh (1528–31). After the fall of the latter fortress in 1568, the Rajputs progressively entered the Mughal orbit and adopted their customs and traditions, including first of all the segregation of the sexes. Rajput architecture changed at the same time, in favour of a centrifugal layout as a tent city with a provision for pavilions and volumes, open and well-lit, following the tastes of the imperial Mughal court.

NOTE

1 The measured architectural survey, and subsequent graphic representation and analytical interpretation of the palace, was conducted by a team of the Politecnico di Bari, Italy, in the academic year 2005–06, led by Attilio Petruccioli, with Paul Perfido; tutors: Domenico Catania, Luigi Guastamacchia, Claudio Rubini; and students: Vittoria Di Bari, Rossella Liso, Leonardo Maddalena, Domenica Marrone, Luca Spaccavento, Antonella Stallo.

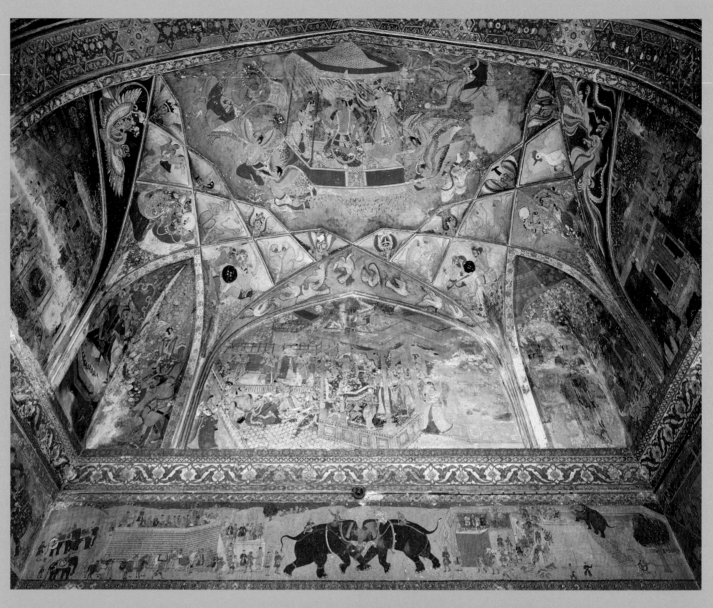
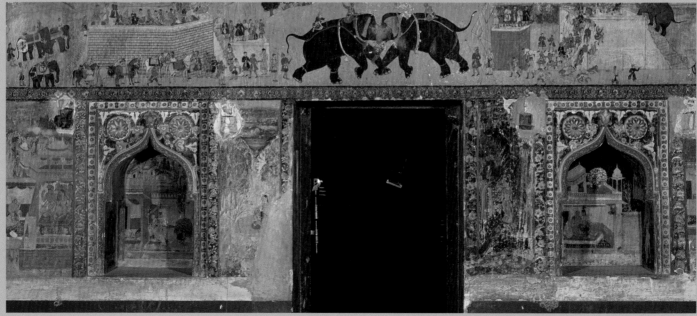

THE WALL-PAINTINGS
OF THE BADAL MAHAL

MILO CLEVELAND BEACH

The years around 1600 were times of extraordinary artistic and intellectual curiosity in north India, a period when interactions among different communities and distinct regions were encouraged, leading often to innovative and exciting results. It should be no major surprise, then, that exploration of the earliest paintings at Bundi, a Rajput territory in southeastern Rajasthan, leads us to a place both culturally and geographically distant: to lands controlled by the Mughal governor of Varanasi (Benares), located far to the northeast along the river Ganga. Events there resulted in one of the greatest painted spaces in India—the Badal Mahal in Bundi (figures 3.1–3.4).

A well-known Ragamala series painted at Chunar, a town near Varanasi, bears an inscription dated 1591.[1] The paintings that survive from that set (e.g., figure 3.5) are extraordinarily sophisticated, meaning that their style is innovative, mature in concept and self-confident in execution. Ragamalas would become the most popular series of themes to be illustrated in Rajasthan; and while the Chunar series, the earliest known dated Ragamala, is obviously the result of earlier stylistic experiments, nothing of those initial phases survives. There is no known Ragamala that might have provided compositional models for this set of paintings. The inscription on the Chunar set states that the painters were "the pupils of Mir Sayyid 'Ali . . . and Khwaja 'Abd al-Samad",[2] two great artists employed by the Mughal emperor Akbar (r. 1556–1605). They had both been brought from Iran by Humayun (r. 1530–40; 1555–56), Akbar's father, to initiate and oversee the establishment in India of a new imperial painting workshop. So the Chunar Ragamala painters were at least trained in Akbar's studios, even if they moved elsewhere in their later careers.[3]

While the veracity of the inscription was challenged when it was first discovered,[4] it is now widely accepted; and if the existence of earlier phases of activity cannot yet be supported by additional visual evidence, the information in the inscription can be expanded by historical texts. Most importantly, a local history, the *Vamshabhaskar* of Suryamalla Mishran, records that in 1591 political control of Varanasi—and by extension Chunar—was administered for the Mughals by Rao Bhoj Singh (r. 1585–1607), the Rajput ruler of Bundi.[5] This clue to the possible patron of the 1591 Ragamala (who is not identified in the inscription) is strengthened by extensive later use of the Chunar compositions in paintings solely made at Bundi and territories under its influence. Additional texts further document the family's

3.1A East wall (above), Badal Mahal, Palace of Rao Bhoj, Bundi, early 17th century. Photograph courtesy of Shubha and Prahlad Bubbar.
Above the frieze centring on a staged elephant combat, the dominant panel depicts an episode from the story of Madhavanala and Kamakandala. Overhead, Rama and Sita, accompanied by Hanuman, ride in a celestial chariot.

3.1B East wall (below), Badal Mahal, Palace of Rao Bhoj, Bundi, early 17th century. Photograph courtesy of Shubha and Prahlad Bubbar.
The complete Ragamala scenes placed on each side of the closed window, are (left to right) Gurjari Ragini, Kamoda Ragini, Kakubha Ragini and Vibhasa Ragini. Even in its present condition, the fineness of the execution, especially of the decorative details, and sense of humour of the artists (note the right third of the elephant combat) are evident.

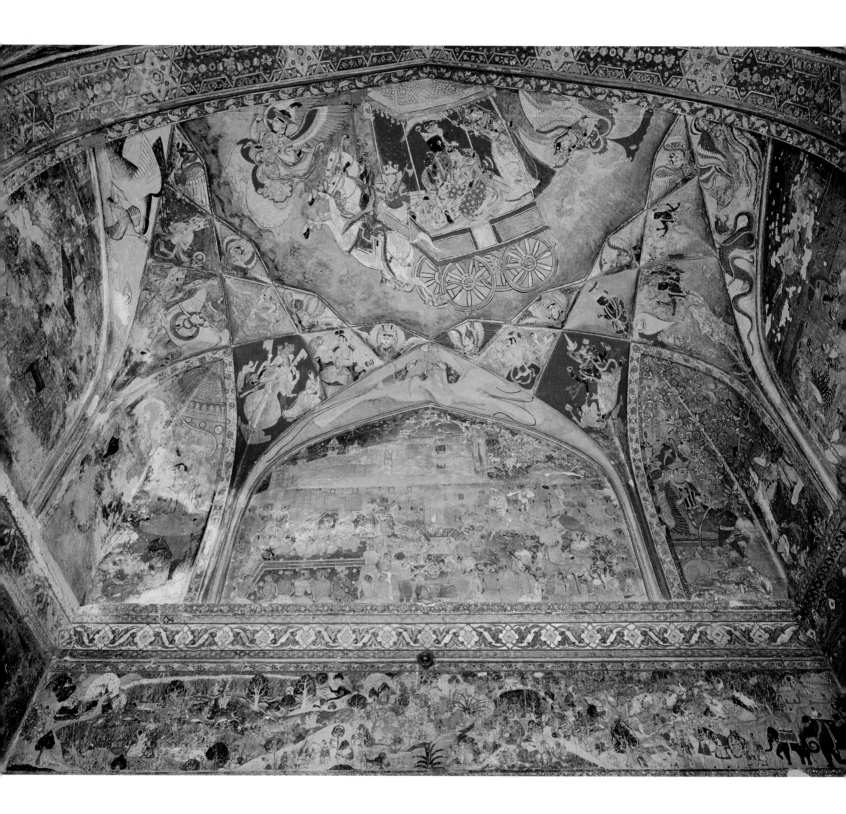

3.2A West wall (above), Badal Mahal, Palace of Rao Bhoj, Bundi, early 17th century. Photograph courtesy of Shubha and Prahlad Bubbar.
The detailed scene of hunting is set in a densely wooded mountain terrain. Above, flanked (as on the east wall) by depictions of foreigners, is a central panel portraying Rao Ratan Singh viewing the painting of an elephant. Above, Krishna and Rukmini ride in a celestial chariot.

3.2B West wall (below), Badal Mahal, Palace of Rao Bhoj, Bundi, early 17th century. Photograph courtesy of Shubha and Prahlad Bubbar.
The western exterior wall of the Badal Mahal is now buried against later structures. The original interior window seen here is flanked (left to right) by Hindola Raga, Malava Ragini, Khambhavati Ragini, Ramakari Ragini, Gunakari Ragini (on the side wall of the niche on the right), Gaudi Ragini and Malkausika Raga.

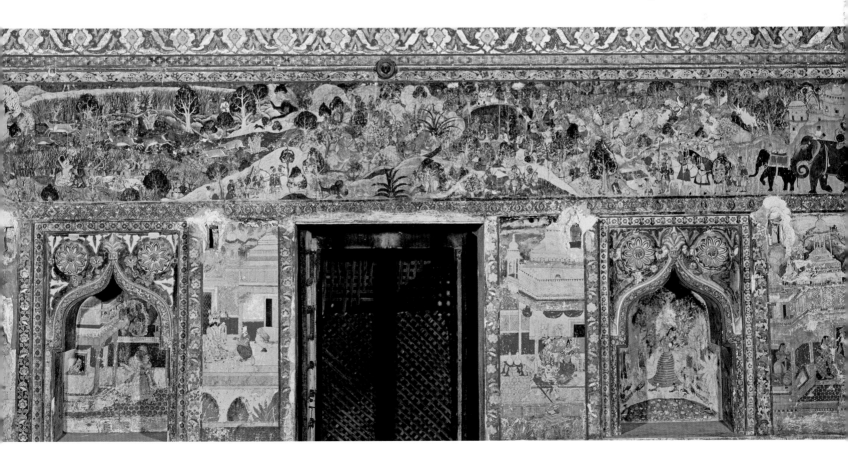

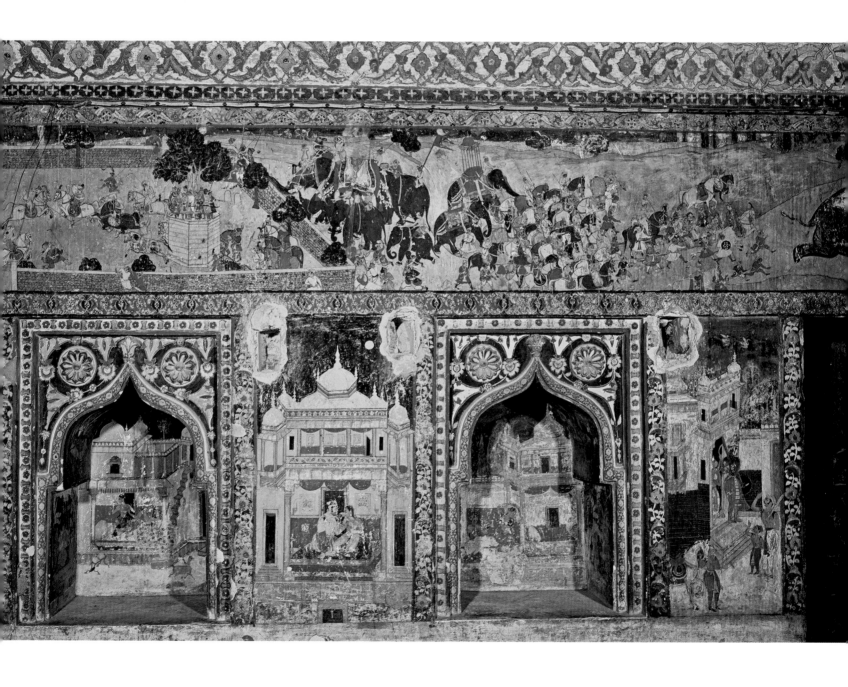

3.3 South wall (left), Badal Mahal, Palace of Rao Bhoj, Bundi, early 17th century. Photograph courtesy of Shubha and Prahlad Bubbar. Above to the left, courtiers watch a polo match from a tower while a procession forms to the right. Below (left to right): Desavairati Ragini, Dipak Raga, Vairati Ragini and Nata Ragini.

3.4 South wall (right), Badal Mahal, Palace of Rao Bhoj, Bundi, early 17th century. Photograph courtesy of Shubha and Prahlad Bubbar. Below the scenes of hunting tiger and rhinoceros, are (left to right): Todi Ragini, Gandhara Ragini, Vilaval Ragini, Desakh Ragini and Madhumadhavi Ragini.

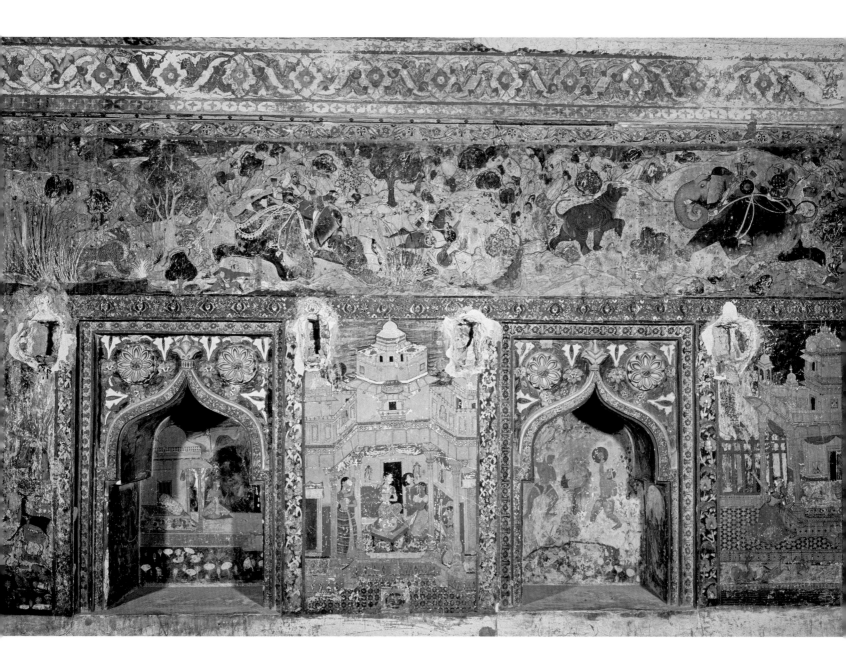

links to the Varanasi region, their activities while they were regional governors, and their relation to the Mughal court. These too are helpful.

Historical Context

Surjan Singh (r. 1554–85), the father and predecessor of Bhoj Singh, was overseeing the great Rajasthani fort of Ranthambhore on behalf of the Maharana of Mewar, the pre-eminent Rajput power in Rajasthan, when it was assailed in 1569 by the Mughal emperor Akbar, who had recently attacked the Mewari capital at Chittor too in his attempts to gain control over the entire region. In return for eventually handing over the keys to the fort (see figures 1.3 and 4.1), Surjan was assigned governorship of the recently conquered territories of Gadha-Katanga, near the Narmada river to the south. The acceptance of this position was a formal declaration of his alliance with Mughal political power, and in 1575 he was transferred to the more prestigious governorship of Varanasi, where he made Chunar his personal residence. The *Shatrushalya Charita* of Mahakavi Vishvanatha, a history written at the beginning of the reign of Chhatarsal (or Shatrusal), states explicitly: "That lord of armies [Surjan] himself resided permanently at Chunar, situated on the bank of the Ganga."[6]

Subsequently, referring to the lands of the governorship, the 19th-century British historian James Tod wrote:

> [Surjan Singh] beautified and ornamented the city, especially the quarter where he resided, and eighty-four edifices, for various public purposes, and twenty baths, were constructed under his auspices. He died there[7]

Suryamalla Mishran further noted that 200 householders from Bundi came with Surjan Singh and settled in the area.[8] Bundi was clearly a strong presence in that northern region.

Soon after Surjan Singh moved to this new posting, his eldest son Duda, who had been appointed to continue the family governorship of Ranthambhore, but now in subservience to the Mughals, left that post without permission and returned to Bundi. There the "vile wretch" (the words are those of Akbar's biographer, Abu'l-Fazl)[9] openly rebelled against Mughal overlordship, prompting Akbar to include Surjan and his younger son, Bhoj Singh among the troops sent to punish the rebellious prince. Duda fled, and Bhoj, who had been aiding his father at Chunar, became his representative in Bundi until Surjan Singh died in 1585.[10] Bhoj Singh then inherited the Varanasi governorship, although he actually spent much of his time on military expeditions, or in Lahore and Agra, living close to the emperor. His son, Ratan Singh, represented him in Chunar until that appointment ended in 1591,[11] when Akbar appointed Mir Sharif Khan to the post. The hot-headed Ratan at first refused to turn over his command without word from his father who was then in Lahore, although he did subsequently relinquish the assignment and return to Bundi that same year.[12]

After his accession as Rao of Bundi, Bhoj served with imperial campaigns that took him to Kabul, Gujarat, Orissa and the Deccan, among other places. It seems likely therefore that if the rulers of Bundi as governors of Varanasi and Chunar spent more time in the imperial capitals and on campaigns than they did in their assigned territories, they would have spent even less time in Bundi itself. The involvement of Ratan Singh and Bhoj Singh with what was happening at home must therefore have been sporadic and second-hand; and while the raos made their sons de facto rulers of Bundi while they were in active Mughal service,

these young princes too served in Mughal military campaigns. For example, important passages in both the *Akbarnama* and the *Shatrushalya Charita* refer to Bhoj's participation in the conquest of Gujarat when he was still a prince. Abu'l-Fazl wrote that on April 13, 1573, following the capture of the Gujarati city of Surat:

> the emperor set out for Agra A decree was issued for . . . Bhoj and many others to go via Idar to Dungarpur and that region and then to proceed to the capital. They were also to promise imperial favour to the Rana [the ruler of Mewar] and other landholders of the region and bring them to kiss the threshold, and anyone who refused to obey should be chastised by imperial forces.[13]

Vishvanatha, in turn, described the prince's return:

> Having reached the city of Agra with Akbar . . . [Bhoj resided] in a magnificent palace . . . endowed with beautifully painted, vast and charming galleries (with fresco paintings).[14]

The years which the raos spent in Lahore or Agra would certainly have kept them aware of changing imperial ideals in art and architecture, while their military assignments would have made them attentive to regional traditions—especially if, like Surjan Singh and Bhoj Singh, they already actively employed artists and architects.

All this suggests that Ratan Singh (r. 1607–31), the son whom Rao Bhoj left in charge of Chunar while he himself was serving elsewhere, may have been the man who actually oversaw the creation of the Chunar Ragamala—completed the year Ratan left Chunar to return to Bundi. And while the *Vamshabhaskar* of Suryamalla Mishran notes the construction in Bundi of a Badal Mahal ("Cloud Palace") by Rao Bhoj,[15] it was most likely Ratan Singh who oversaw the initial day-to-day work on site. It would seem then that, like the methods they developed to exercise political power, artistic patronage too was a shared family responsibility. This would be quite different from ideas that have developed about patronage at the Mughal court, where the emperor and other patrons are often thought to have so closely controlled the work of individual artists that the results were presented primarily as reflections of the patrons' individual personalities.[16]

Malkausika Raga (figure 3.5) is among the finest pages of the Chunar Ragamala. It is set within borders inspired by the cartouche and floral scroll patterns common to Islamic books and architectural decoration,

3.5 Malkausika Raga, from a Ragamala series, Chunar (Uttar Pradesh), dated 1591. Opaque watercolour and gold on paper. Private collection.
An alternative version of this raga on the west wall of the Badal Mahal is seen on the far right of figure 3.2B.

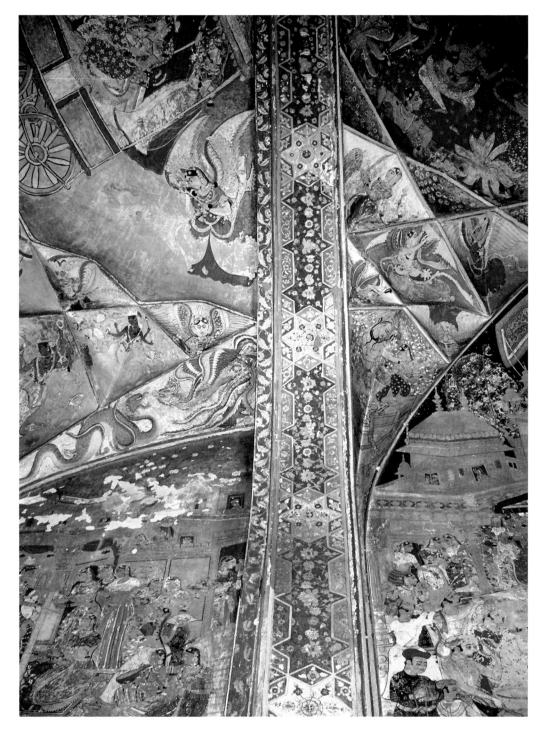

but found also in the architectural details of the Hathipol (Elephant Gate) and Ratan Daulat sections of Bundi Fort and the painted decorations of the Badal Mahal (figure 3.6). The Chunar Ragamala artist has well understood Mughal conventions for depicting spatial depth, and has been meticulous in describing the decorative surfaces of both the architecture and textiles, and in evoking a moody night sky. These are traits learned from Mughal practice, while the proportions of the figures—too large for the architectural space—and the rather squarish, generic facial types, drawn in profile, ally with Rajput sensibilities, which accepted Mughal interest in physical substance and personal individuality more

slowly. (For comparative works from elsewhere in north India, see chapter 6 by Edward Leland Rothfarb.) While firmly within the generic world of both imperial and sub-imperial Mughal painting stylistically,[17] this particular combination of elements gives a very distinctive character to the Chunar workshop. There are, however, other examples of the work of these artists: a large group of drawings in the Bharat Kala Bhavan, Varanasi, consisting of quick sketches based on varied Hindu themes;[18] and the earliest of a series of Bundi-related Ragamala drawings in the National Museum, Delhi.[19] If none of these explains the origins of the Chunar style, the references by both the Indian and English historians cited above certainly suggest a high level of architectural and artistic activity—including wall-paintings—at the courts of Surjan Singh and Bhoj Singh, and it must be in those lost works that the Chunar Ragamala style came to maturity.

The Programme of Paintings in the Badal Mahal

The Badal Mahal accredited to Rao Bhoj would certainly have been the building at Bundi now better known as the Palace of Rao Bhoj, although today only the top (third) level is locally known as Badal Mahal; and it is that level, consisting of a terrace and a large single room with one entrance, that contains the earliest wall-paintings made for Bundi rulers that have survived intact.[20] The room is elaborately painted, its programme of illustrations carefully planned to express the power of the ruler. The space is long, oriented east-west, and divided into three bays by decorative ribbing across the ceiling (figure 3.6). A single entrance is in the middle of the south side, and at eye-level a series of 13 shallow niches extends around the room. The niche opposite the entrance is larger, however (figure 3.7). Decorated with a scene of Krishna fluting, its placement marks both the beginning and the

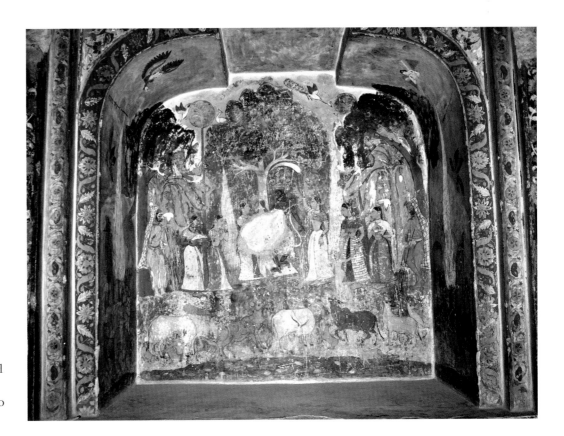

3.7 Krishna fluting, from the centre of the north wall, Badal Mahal, Palace of Rao Bhoj, c. 1630–40. Photograph: Milo C. Beach.

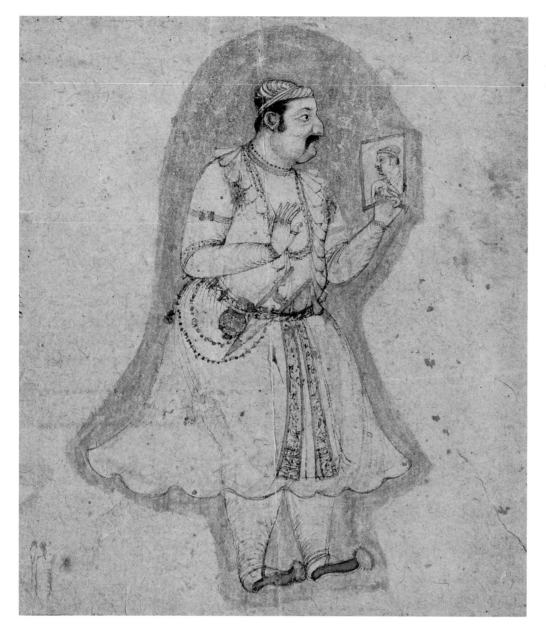

3.8 Rao Bhoj Singh of Bundi, Bikaner, c. 1600. Opaque watercolour on paper. Private collection.

end of a Ragamala of 36 scenes that circles the room counter-clockwise, filling the niches and extending onto the surrounding walls (e.g., figures 3.1B, 3.2B, 3.3 and 3.4).[21]

A band of illustrations also circles the room above the Ragamala paintings; this contains scenes of hunting and activities that celebrate elephants (figures 3.1–3.4). (The importance of elephants and hunting to the self-image of Bundi rulers is explored by Cynthia Talbot in chapter 4.) The vignette above the wider niche directly opposite the entrance shows the southern wall of Bundi Fort with the ruler seated in a turret, inspecting elephants being paraded on the grounds below. To the left are the harem quarters, where carefully guarded women view the scene through slatted blinds (figures 3.9 and 3.10).

This scene is the most lightly coloured area of the frieze, which becomes denser, more colourful, and more self-confident technically and stylistically as one moves to the left or right; this must have been the first area to be painted. A recently discovered portrait (painted at Bikaner) of Bhoj Singh (figure 3.8) suggests that he is the ruler shown here,

3.9 Detail of figure 3.10. Photograph courtesy of Hilde Lauwaert.

3.10 Rao Bhoj Singh inspecting elephants, from the north wall of the Badal Mahal, Palace of Rao Bhoj, Bundi, c. 1600. Photograph courtesy of Hilde Lauwaert.

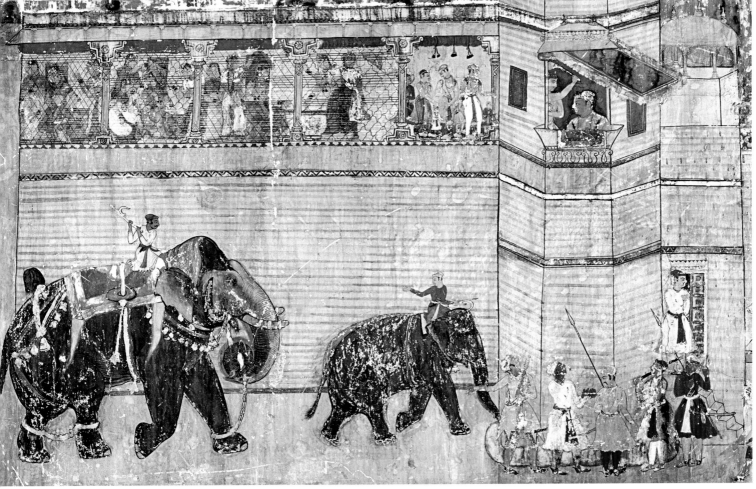

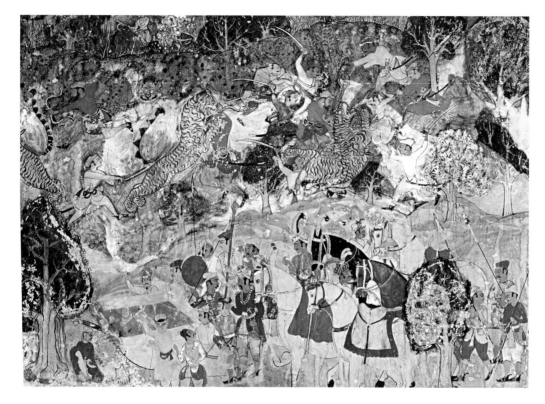

3.11 Hunting scene, from the west wall of the Badal Mahal, Palace of Rao Bhoj, Bundi, c. 1620. Photograph courtesy of Hilde Lauwaert.

for both men share a distinctively hooked nose not associated with his descendants (see the portraits in figure 1.2).[22] Equally important is the depiction of the harem quarters (figure 3.9). The men standing guard outside are very simplistically drawn, with squarish heads and triangular noses; in profile, personality and expressiveness, they are so close to the figures in the 1591 Malkausika Raga (figure 3.5) and associated early drawings, that they can be attributed to the same painters.[23] The form and simplicity of the architectural details are also closely similar, even if the technique of painting on walls does not yet allow the finish and detailing seen in works on paper. The beginning of the decoration of the Badal Mahal must therefore be roughly contemporary with the Chunar Ragamala, which suggests that one or more of the painters accompanied the prince Ratan Singh when he returned to Bundi in 1591. In this new location, their training in the Mughal workshops and the experiences gained subsequently by these artists at Chunar would have combined with the enthusiasms, aspirations and the new interests gained by the Bundi family in their varied travels. The model and potential of such mobility must certainly be kept in mind when examining painting traditions elsewhere within Rajasthan, although nowhere else is so rich a result known at so early a date.

Horizontal bands of wall-painting comparable in format to this band of sporting scenes were common at the Mughal court and were sometimes depicted when buildings were portrayed in Akbar-period manuscripts;[24] such practice would have served as a prestigious model. The Badal Mahal also draws—at least in this early frieze—on subject matter popular in the imperial context. The remains of painted elephant combats can still be seen on the walls of Akbar's capital at Fatehpur Sikri, while the hunting scenes at Bundi (e.g. figure 3.11) can also be compared directly with specific late 16th-century Mughal *Akbarnama* illustrations (e.g. figure 3.12), as has been pointed out by Joachim Bautze.[25]

3.12 Akbar slays a tigress (detail), composed (and with special portraits) by Basawan, painted by Tara the Elder, from the *Akbarnama*, c. 1586. Opaque watercolour, gold and ink on paper. © Victoria and Albert Museum, London, IS.2:17-1896.

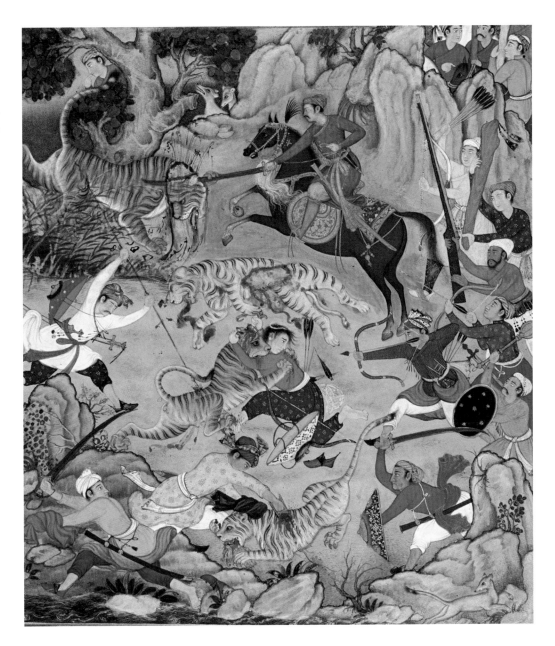

There are nonetheless distinct differences. Mughal illustrations of the period rejoice in minute detail (note the saddle-cloths in figure 3.12), the evocation of physical bulk through modelling in light and shade, a greater differentiation of facial types, refined colours and greater elegance of execution and design. On the other hand, for all the excitement of the Mughal tiger hunt, it lacks the movement and brouhaha of the Bundi scene, where the roughness of colouring and execution builds visual dynamism—the ferocity of the tigers is a good example. The extensive wall surfaces in the Badal Mahal would certainly have required additional painters, and with details such as the two men in the left foreground of figure 3.11, seen frontally and from the rear as they hail each other, one senses that these artists are experimenting, trying out new and exciting possibilities, rather than repeating and refining—as Akbar's well-trained artists are more apt to do at this point—familiar and accepted formulas. Many of the human figures in this frieze still have quickly sketched formulaic bodies, mannerisms and facial expressions, like those of the mahouts

and elephant-keepers in the scene of Rao Bhoj inspecting elephants (figure 3.10), but the layering of space, the overlapping of figures and the density of the composition in figure 3.11, for example, are among factors that argue for its date to be somewhat later than the scene with Rao Bhoj. Longer experience has allowed the painters to develop greater compositional and figural complexity.

However differently contemporary Mughal paintings and this band showing elephants and scenes of hunting have been executed in terms of technical ability, the raos were successfully transporting to their home territory traditions and interests that they had

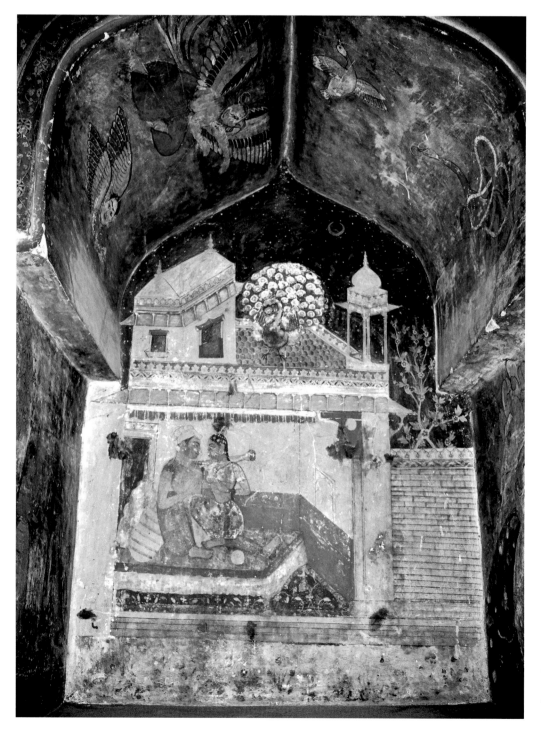

3.13 Vibhasa Ragini, from the north wall of the Badal Mahal, Palace of Rao Bhoj, Bundi, c. 1630–40. Photograph: Milo C. Beach.

developed as attendants at the Mughal court—thereby signalling their contact with imperial powers. With this link, they were also proclaiming their independence from their earlier alliance on Mewar.

The Chunar Ragamala was extremely influential on the Ragamala sequence placed below this band of elephants and sporting scenes. The 36 traditional illustrations of ragas and their associated raginis closely follow the compositions first revealed in the Chunar set, but rather than the self-contained compositions necessary for the set on paper, the artists have placed these scenes inventively in the back of the relatively deep niches and on the walls between, adding other scenes, depictions of gods, celestial beings, or birds and flowers that hover above the central illustration or animate the receding side walls of the niches (figure 3.13). The effect is of looking through proscenium arches onto three-dimensional stages—and this gives unprecedented energy and immediacy to the scenes. The painters' responsiveness to the architectural space also creates a fluidity of movement that extends around the room—beginning and ending at the broad niche opposite the entrance and directly below the scene of Rao Bhoj inspecting elephants. This establishes the niche (figure 3.7) as both the focal and symbolic centre of the room—and it was almost certainly here that the rao would sit.

Above the Ragamala and the bands showing the raos' prowess on earth, their mastery of elephants and the hunt, are scenes showing the camaraderie of the gods and the raos of

3.14 The marriage of Krishna and Rukmini, from the north wall of the Badal Mahal, Palace of Rao Bhoj, Bundi, c. 1620–30. Photograph: Milo C. Beach.

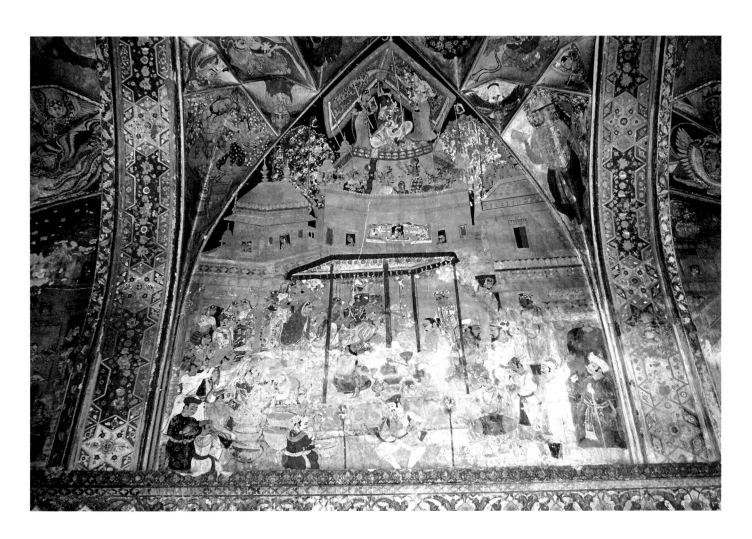

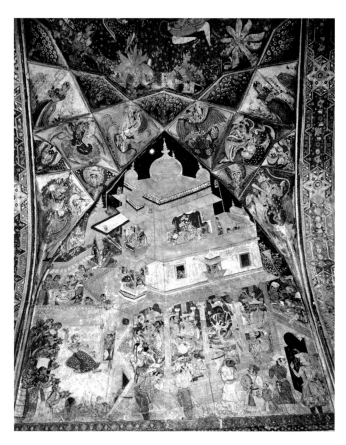

3.15 The birth of Krishna's son, from the south wall of the Badal Mahal, Palace of Rao Bhoj, Bundi, c. 1620–30. Photograph: Milo C. Beach.

3.16 Detail of figure 3.15. Photograph courtesy of Hilde Lauwaert.

opposite

3.17 Rao Ratan Singh viewing a painting, from the west wall of the Badal Mahal, Palace of Rao Bhoj, Bundi, c. 1620–30. Photograph courtesy of Hilde Lauwaert.

3.18 *Madhavanala-Kamakandala*, from the east wall of the Badal Mahal, Palace of Rao Bhoj, Bundi, c. 1620–30. Photograph courtesy of Hilde Lauwaert.

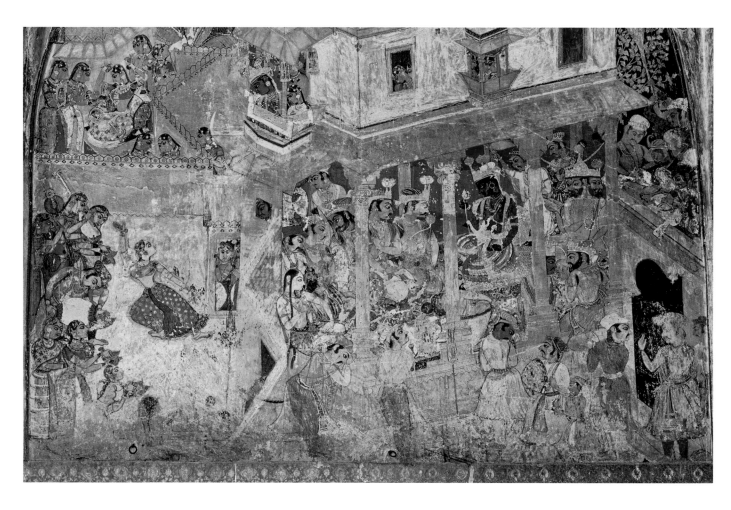

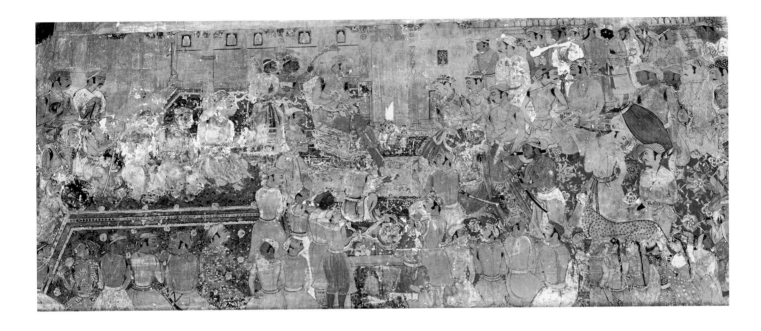

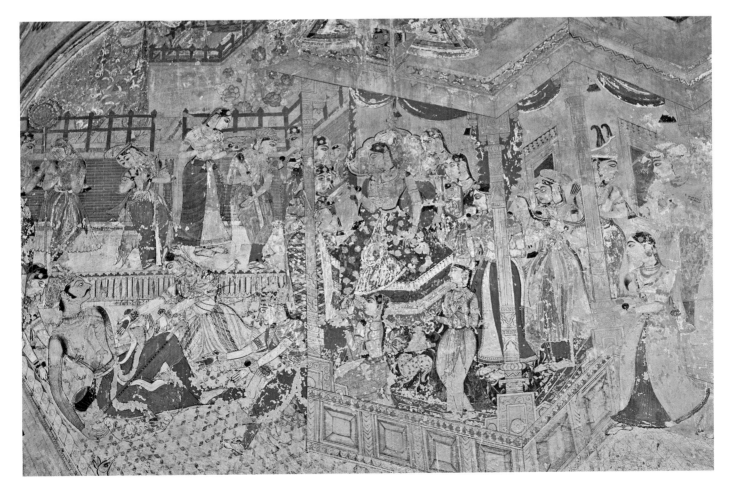

Bundi. In a tall arched panel in the centre of the north wall is a depiction of the marriage of Krishna and Rukmini with courtiers (including ladies) in attendance (figure 3.14). The panel opposite, above the door on the south wall, has been identified as the birth of Krishna's son,[26] and here two figures suggesting members of the Bundi royal family—they bear the characteristic sharp features of the young Chhatarsal (r. 1631–58)—are seated before the god, as Brahma and Shiva look on (figures 3.15 and 3.16). Each of these central panels is flanked by depictions of court ladies at leisure, with a badly damaged scene at the east end of the north wall showing the rao, surrounded by women, looking into a mirror held by a consort.

On the west wall, a rao, convincingly identified by Joachim Bautze as Ratan Singh,[27] is seated in darbar admiring the painting of an elephant presented by a painter kneeling at his feet (figure 3.17). This event takes place in the open court outside the Hathiyansal, the audience hall of the Palace of Rao Bhoj—the small black elephant capitals on top of the columns (see figure 1.7) that define that space are clearly visible—and such recognizable references to actual architecture, like the subject of a ruler examining a painting, also had Mughal precedents.[28] Facing this scene, on the east wall, is an episode from a favourite literary tale, the story of Madhavanala and Kamakandala (figure 3.18). Madhavanala, a master of music and other arts, is usually depicted as a Hindu holy man, but is here shown instead as a Rajput prince with a tanpura.[29] Within the Rajput world at this time, these are both extraordinary images, and they dominate the space of this room. Nothing could better reinforce the attentiveness of the raos of Bundi to visual, literary and musical arts, as well as to architecture—interests here presented inhabiting a realm placed literally above the worldly activities seen in the frieze below.

The niches that traverse the four corners of the room at this level are filled with large images of "foreigners", men in fanciful European costume (figure 3.20), and Joachim Bautze has drawn attention to a now familiar passage in the travel account of Peter Mundy to suggest that these figures were inspired by European tapestries.[30] The account includes instructions to Mundy from the Council at Surat:

> At Burhanpur they are to endeavour to recover from "Rajah Raw Ruttun" [Rao Ratan Singh] the amount due for some tapestry recently sold to him by Willoughby It is uncertain whether the Raja is at Burhanpur or still in the Deccan, "unto which parts hee is lately gone with the Kings (or be it Assuff Cauns [Asaf Khan's]) laskar [lashkar, army]"[31]

While these words affirm the availability of European wall-hangings in the marketplace, they are even more interesting for confirming the direct contact of Ratan Singh with Europeans. A taste for wall decorations with large-scale figures may well have developed from Ratan Singh's familiarity with tapestries, but the men shown here—imaginative impressions of European travellers—established a visual theme often repeated at Bundi and elsewhere (e.g., figure 3.19). This, however, is not the only evidence of contact with Europe.

It is tempting to find some symbolic meaning in the depiction of Krishna looking in a mirror, placed at the top of the marriage scene; in the ladies just below, who also hold mirrors; or in the depiction of a raja who—like Krishna—looks in a mirror held by the ladies of the harem at the east end of the same wall. Sir Thomas Roe, the first ambassador sent from England to the Mughal court, describes an evening darbar in 1616, when he

3.19 Standing European with a falcon, Bundi region, c. 1700. Opaque watercolour on paper. © Bharat Kala Bhavan, Varanasi, Acc. no. 559.

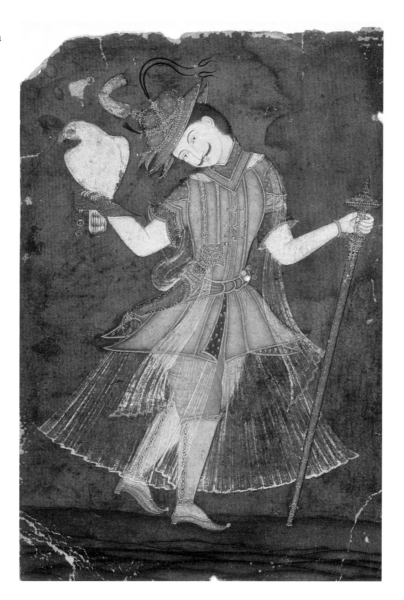

met the Persian Ambassador "with the first muster of his Presentes". He notes that these included "Italian pictures wrought in the stuff . . . which, as I suppose, was the hanginges called Arras [tapestries]", as well as "Great Glasses inlayed in frames" [certainly mirrors].[32] If tapestries were accessible to Ratan Singh through English intermediaries, as Mundy noted, mirrors too might have been available. It is recorded, for example, that the *Lyon*, the ship which brought Roe to India, had among the goods in its hold "thirty dozen" mirrors.[33] Glass mirrors were just becoming popularly available in Europe, so they must have seemed suitably novel luxury objects for the Indian trade. The depiction of mirrors within the Badal Mahal wall-paintings, therefore, might simply be a light-hearted reflection of what became a current fashion in India too, included here as evidence that Bundi was thoroughly up-to-date.

Above all these scenes on the walls of the room, the central bay of the ceiling depicts a rasamandala or rasalila, an image of the circular dance in which Krishna sports with the gopis, village milkmaids devoted to the god (figure 3.21), and the subject of Edward Leland Rothfarb's chapter in this volume.[34] At the east end, Rama and Sita are depicted

68 Milo Cleveland Beach

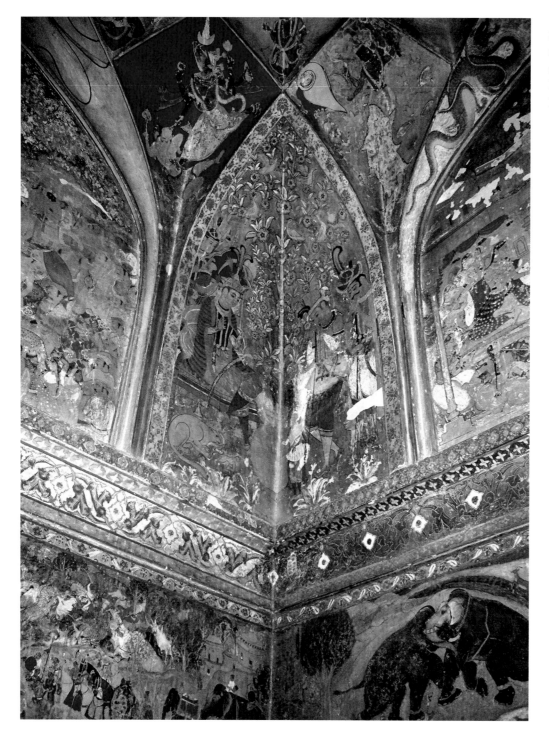

3.20 Figures of foreigners, from the northwest corner of the Badal Mahal, Palace of Rao Bhoj, Bundi, c. 1620–30. Photograph: Milo C. Beach.

in a celestial chariot, accompanied by Hanuman (figure 3.1A, top), while at the west end Krishna and Rukmini are shown travelling in their marriage chariot, guided by Ganesh (figures 3.2A, top and 3.22)—again a theme repeated later in paintings on paper (figure 3.23). The facets of the squinch nets that fill the transitional areas between the side-walls and the ceiling seem to project their decoration physically into the space; these images including avatars of Vishnu, figures important to both the lives of Krishna and Rama, and various celestial beings. It is this brilliantly evocative ceiling representation of the skies above that justifies the name of this room: Badal Mahal.

3.21 Ceiling, Badal Mahal, Palace of Rao Bhoj, Bundi, c. 1620–30. Photograph courtesy of Hilde Lauwaert.

The disposition of these bands of decoration has been carefully worked out. Above the plain red surface that acts visually as wainscoting, the Ragamala is what one encounters most directly—it is at eye-level. A second complete Ragamala is found in the Chhatar Mahal, across an open courtyard from the Palace of Rao Bhoj.[35] It is possible that the faint remains of paintings in the Hathiyansal, the ground-level audience hall of this palace, represent an additional series.[36]

Giles Tillotson recently published a passage from the *Pratap Prakash*, a chronicle written by the court poet of Maharaja Pratap Singh of Jaipur (r. 1778–1803), which describes a darbar at which, after official business, the maharaja "turns his attention to learned men and artists . . . the bards eulogise the royal family, and musicians perform the entire sequence of *raga*s and *ragini*s." Later, after refreshments, the ruler orders a dance performance, at which dancers again enact the complete cycle of ragas and raginis.[37] While later in date and at a different court, such ceremonial presentations of the Ragamala on public occasions—and the painted Ragamalas at Bundi fall into this category—need further exploration. No other series of illustrations is presented in this way or given this prominence.

Whether in music, dance, poetry, or visual imagery, the complete cycle of Ragamala is a symbolic catalogue of all possible emotional states, expressed as situations arising from human (or sometimes divine) encounters, organized and coloured by physical relationships, seasons of the year, times of day, and other factors. When associated with direct encounters with the maharao, it would seem to proclaim his sympathetic, all-knowing nature.

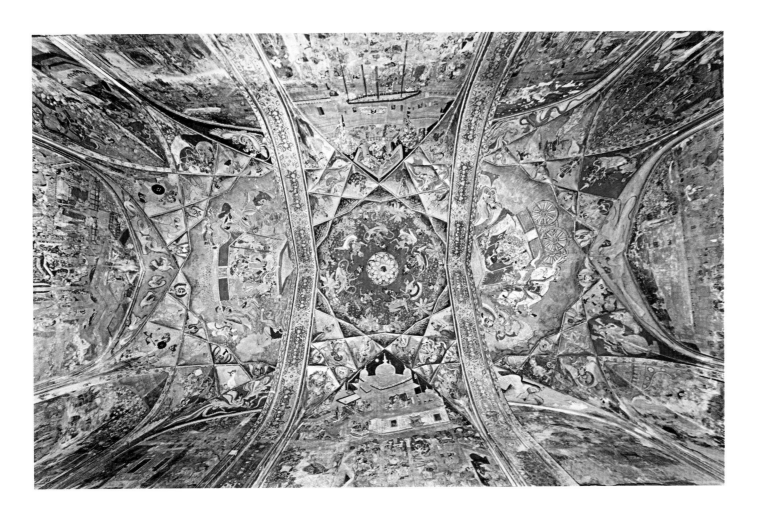

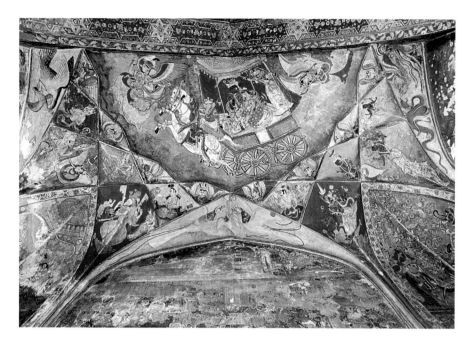

3.22 Krishna and Rukmini in a celestial chariot. Detail of figure 3.21. Photograph courtesy of Hilde Lauwaert.

3.23 Krishna with Rukmini as groom and bride in a celestial chariot driven by Ganesh, Bundi, c. 1680. Opaque watercolour on paper. Gift of Edwin Binney 3rd, Los Angeles County Museum of Art, M.74.13.

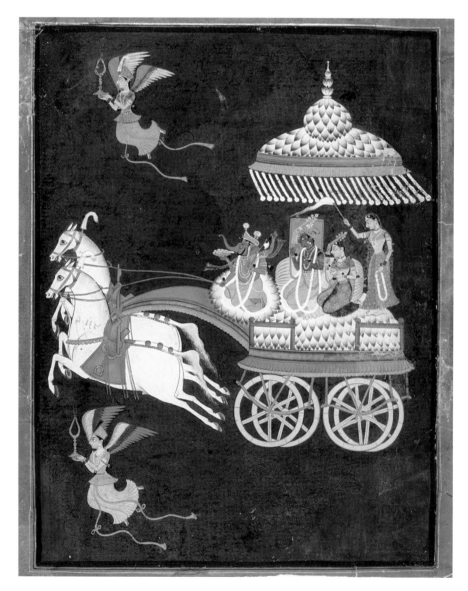

opposite
3.24 Rao Chhatarsal, Bundi, c. 1635. Opaque watercolour on paper; 21 x 14.2 cm. Harvard Art Museums/Arthur M. Sackler Museum, Gift in gratitude to John Coolidge, Gift of Leslie Cheek Jr., Anonymous Fund in memory of Henry Berg, Louise Haskell Daly, Alpheus Hyatt, Richard Norton Memorial Funds and through the generosity of Albert H. Gordon and Emily Rauh Pulitzer; formerly in the collection of Stuart Cary Welch Jr., 1995.91. Photograph: Imaging Department © President and Fellows of Harvard College.

Above the Ragamala, are depictions of the ruler in the very earthly pursuits of hunting and of taming elephants. Higher still, the ruler and his court are shown celebrating the arts and interacting familiarly with the gods, and given this ascension of hierarchies, it is inevitable that the ceiling shows the gods in their own territory—the heavens. It is an unprecedented programme, carefully worked out and far more elaborate than anything we know elsewhere in either the Rajput or Mughal worlds. It is unknown whether this scheme was intended from the beginning, for there are indications that the execution extended over several decades.

Style and Dating of the Paintings

We have proposed above that the earliest panel among the wall-paintings is the scene of Rao Bhoj inspecting elephants (figure 3.10). Placed directly opposite the entrance and above the niche showing Krishna fluting, at which the Ragamala series both begins and ends, this space is the central organizing point for the room. It is appropriate that Bhoj Singh is shown here, for court historians have written that the palace was built at his direction.

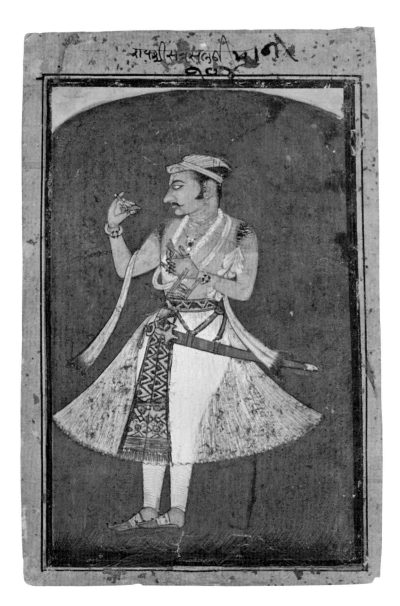

Since the generalized human figures in the harem quarters to the left are also directly comparable to those in the 1591 Ragamala, painted at Chunar during Bhoj Singh's governorship there, we have proposed that this scene may have been painted soon after Ratan Singh's return to Bundi, also in 1591. The faces of the men in the elephant combat and related scenes to the left and right on this wall present variants and elaborations of the simple facial and bodily definitions seen among the elephants' attendants in this earliest scene; the majority are still defined in general terms: by quick linear brushstrokes that emphasize shape and gesture, but give the forms little substance.[38] The compositions of the frieze on this east wall and the north wall (figures 3.1B and 3.10) are also quite basic, the architectural elements flat, and the spacing uncluttered. Moreover, the scenes are composed as loosely related vignettes. In figure 3.10 for example, the building appears as an insubstantial backdrop, a composition of flat shapes arranged within vertical lines to left and right that has little spatial continuity with the landscape to its sides.

On the west and south walls, this band depicts scenes of hunting, and probably represents the jungly grounds of southern Bundi (figures 3.2B and 3.4). Lions (present as symbols of royalty rather than for their factual presence), tiger, deer and boar are hunted from elephant- or horseback, and on foot. On both these walls the space is more densely layered, with action taking place in fore-, middle- and backgrounds.

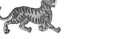

3.25 Rao Chhatarsal on horseback with three attendants, Bundi, c. 1631. Ink and opaque watercolour on paper; 18.8 x 18.8 cm. Harvard Art Museums/Arthur M. Sackler Museum, The Stuart Cary Welch Collection, Gift of Edith I. Welch in memory of Stuart Cary Welch, 2009.202.27. Photograph: Imaging Department © President and Fellows of Harvard College.

Running elephants possess a weight and energy not seen in the north and east wall friezes, and there is also a new command of portraiture. Two of the archers seen hunting chital and blackbuck at the left end of the frieze on the west wall (figure 3.2B), for example, are so specific in their physiognomies and in the fineness of their dress and jewellery that they must represent Rao Ratan Singh and his grandson and successor Chhatarsal (figure 4.5, right and centre). The depiction of the prince at the centre is especially (and innovatively) vivid; sharp-featured and alert, he seems to be a younger version of the subject in figures 3.24 and 3.25. (While painters continued to work from generalized figural types, the sharp features of the young Chhatarsal are quite distinct from the flatter profile and bulbous nose regularly associated with his grandfather—see the portraits in figure 1.2.) In the background, another man hunts boar, a figure identified by Bautze with Madho Singh, a younger son of Ratan Singh and the founder of Kota as an independent state.[39] The whole scene would then represent a family outing in the hunting field. The greater sophistication of these hunting scenes on the south and west walls is further indicated by the dense continuity of the composition on both surfaces, which even extends across the southwest corner. The painters seem more assured and relaxed in these scenes, and

increasingly comfortable with the spatial possibilities of the extended spaces available for wall-painting. Since Gopinath Singh, who was the father of Chhatarsal but died before he could accede to the throne, was born in 1589,[40] one might speculate that if the young prince—who looks here in his mid-teens—was born 20 years later, this section of the frieze might have been executed about 1625. But this is pure conjecture.

Above the depictions of hunting and the sports of elephants on the north and south walls are larger-scale panels that rise when possible into the curve of the ceiling. Of these, the panel on the south wall of the central bay of the room is an astonishing tour de force in both conception and execution and far more detailed and sophisticated formally than any scenes in the frieze below. The panel, identified as "The Birth of Krishna's Son", is among the most spatially inventive and experimental images in Indian painting (figures 3.15 and 3.16). The three-dimensionality of the building is palpable, its drama heightened by the view from above. Every area of the space is important to the scene's expressiveness. Figures are visible both inside and outside the building; in the foreground and in distant courtyards and gardens—where ladies care for a child; and on the two levels above the pillared space within which Krishna is attended by nobles bearing the pointed features of Chhatarsal. The figures twist and turn in space, move through doorways, look out from windows and peer over balconies. This is all far less haphazard in its effect than the scene just below; it is both calculated and complicated. (And its difference from the simple schematic presentation of the architecture in figure 3.10 is further evidence that the Badal Mahal wall-paintings were painted over an extended period.) Above, in the squinch nets that provide the transition to the rasmandala on the ceiling of the central bay, gods and angelic figures hover, literally filling the skies overhead.

In the illustrations found at this level, painters are no longer simply transferring to walls compositions that might be found in works on paper; in fact, nothing of comparable inventiveness has survived on paper. They are thinking in a new way, one that responds to the space in which the scenes are placed. At the same time, we find a growing ability of painters to give to wall-paintings the kind of precision of detail that had been mastered in such works on paper as the Chunar Ragamala. The scene of Rao Ratan Singh looking at a painting (figure 3.17), while severely damaged, still shows that the execution was precise and highly refined, with great attention paid to such details as the face of the ruler and the patterns of the carpets; moreover, the pigments were finer and gold was used extensively. The evolution of these interests is visible in the stages of the frieze below and the development of such important details as the faces and costumes of Ratan Singh and Chhatarsal (figure 4.5).

The Ragamala scenes, on a smaller scale, repeat the sense of a totally animated space, but the human figures here are defined with a more

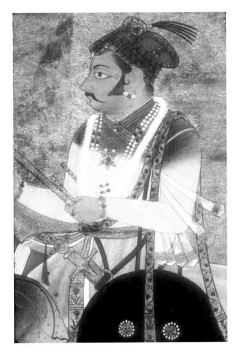

3.26 Rao Chhatarsal. Detail of figure 5.9.

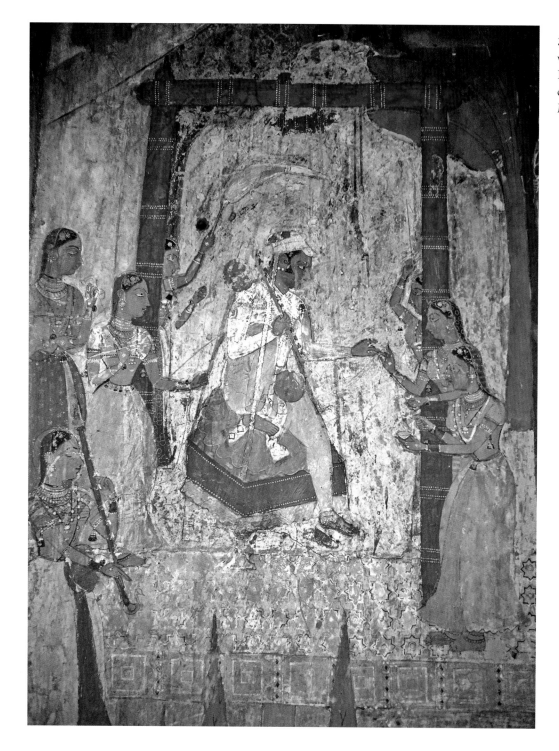

3.27 Hindola Raga, from the west wall of the Badal Mahal, Palace of Rao Bhoj, Bundi, c. 1630 or later. Photograph: Milo C. Beach.

controlled, less experimental formula. The graceful, rounded forms that now characterize women, free of the proportional awkwardness seen still in "Rao Bhoj Inspecting Elephants" (figure 3.10) or "The Birth of Krishna's Son" (figures 3.15), have immediate counterparts in works from such courts as Udaipur or Amber, all of which are closely related to the "sub-imperial" workshops at Agra—where the Bundi raos spent a considerable amount of time.[41] Moreover, they are painted with a consistency that indicates a well-established, familiar formula. Hindola Raga (figure 3.27) is the most stylistically advanced of the Ragamala scenes, and the face of its male figure is a recognizable countenance that first

appears in depictions of the mature Chhatarsal (e.g., figure 3.26), and then continued for his successors Bhao Singh (r. 1658–82) and Aniruddha Singh (r. 1682–95) (figure 1.2).[42] This disinterest in individuality of appearance marks a stage distinct from those earlier portraits that stress the distinctive physical characteristics of Ratan Singh, Bhoj Singh or the young Chhatarsal. The Mughal interest in individuality of appearance was of less concern to Bundi painters, and Bundi portraits (like the practice of patronage) increasingly stress commonality and continuity. So similar are the depictions of the older Chhatarsal and Bhao Singh, for example, that one scholar has differentiated their portraits solely by Bhao Singh's penchant for wearing flowers in his turban—a detail more important for Bundi painters than probing into character or distinctive physiognomy.[43] Hindola Raga, however, when viewed alongside the earlier scene that seemingly shows the youthful Chhatarsal hunting with his grandfather (figure 4.5), suggests that work on the Badal Mahal, and possibly the final plans for the decoration, extended well into his reign.[44]

Badal Mahal and the Development of the Bundi Style

When the Palace of Rao Bhoj was built, and despite literary references to "mansions shining with gold" and "multitudes of fortresses",[45] there may have been little else of importance on the hillside, beyond exterior walls, an earlier palace building that was later given for the exclusive use of the zenana (as discussed for the first time here in chapter 2 by Domenico Catania, Attilio Petruccioli and Claudio Rubini), and a small building placed at a distance, identified now with Prince Duda and possibly his residence when he was in charge of Bundi (figure 1.5). The Palace of Rao Bhoj, now deeply embedded within later construction, may at first have been relatively isolated. It is a stepped building, consisting of an audience hall on the ground level; a terrace, columned hall and closed interior space on the second level; and an open terrace outside the enclosed Badal Mahal chamber above (figure 1.6). Rather than a palace, this is really a small, independent apartment, with little space for supporting functions, and we do not know how it was used. The ground level was certainly ceremonial, and the character of the Badal Mahal overall suggests that it was (or became) a private audience hall—but this is not yet well understood. It may have been the first stage in the creation of more accessible public spaces at Bundi to allow the kinds of ceremonies in which the raos participated at the imperial court.

It is impossible to know how many painters were involved in the decoration of the Badal Mahal. Bundi was a small town, and there was no known earlier local tradition of painting for royal patronage. The stylistic intentions that motivated the initial Badal Mahal painters would therefore have been locally unfamiliar. Furthermore, it is probable that few artists other than those who accompanied Ratan Singh on his return from Chunar were initially available to work at any one time. Moreover, stylistic considerations suggest that execution of the paintings must have extended over several decades, from the reign of Rao Bhoj into that of Rao Chhatarsal (and perhaps beyond). It is therefore possible that the final decorative scheme was the result of expanding aspirations, rather than planned from the beginning. While Rao Bhoj and the harem attendants in figure 3.10 are close in style to the Chunar Ragamala figures of 1591, other men in this frieze are drawn with greater abandon, suggesting that they are the work of additional artists brought into the project, men who cared less for (or were less capable of) the careful precision of the Chunar

Ragamala pages.[46] It is also clear that the models initially provided by Mughal-trained painters became less and less appropriate for painters responding to a different view of the world.

Given the close ties of the Bundi rulers with the Mughal court, and their contact with traditions of architecture and art in which they—as literary men and patrons themselves—would have inevitably been interested, this must be seen as a mark of cultural strength and confidence. There is nothing in the Badal Mahal that shows more than a cursory interest in Mughal ideals. No Mughal is depicted, and there is no reference to any event occurring while the raos were in Mughal service. And this disinterest becomes stronger over time. It is the earliest phase of the Badal Mahal decoration—the band devoted to hunting and elephants—that was most influenced in both subject matter and format by established Mughal practice.[47] There is nothing in Mughal art comparable to the later stages of these Bundi wall-paintings, however. We have noted that references to contact with Europe exist, while other details (such as the decorative floral motifs in figure 3.20 that bear no relation to Mughal naturalism) are possibly derived from the Deccan. The European references, however, never included the interest in European subjects and techniques of modelling physical forms that became so basic to Mughal imagery and to Mughal ideals of realism. The deities and celestial figures on the squinch nets of the Badal Mahal—like the squinch net construction itself—may certainly have been suggested to Bundi by the putti (inspired by European prints circulated by the Jesuits) placed within such Jahangir-period decorative schemes as the palace at Lahore, which would have also been known to Ratan Singh and Chhatarsal.[48] But rather than being adopted to stress their links to the Mughal world, such details instead provided the means for this Rajput court to define its own heritage and beliefs in new ways. (For the relationship of the Bundi raos and the Mughals as expressed in literary and historical texts, see chapter 5 by Allison Busch.) In examining the Badal Mahal, therefore, we find evidence of fruitful contact with the Mughals and their traditions of architecture and art, but no hint of subservience. In fact, the room makes it clear that the power of the raos comes not through their Mughal alliances, but directly from the gods.

One of the most remarkable aspects of these paintings is that they provide a well-spring of models for later illustrations from the Bundi region. As noted, the Ragamala compositions here and in the Chunar set are copied very faithfully in sets from Bundi, Kota and such nearby states as Raghogarh, into the 19th century—examples have been published frequently.[49] The depiction of foreigners (in Bundi style) becomes a familiar motif, as we have seen (figures 3.19 and 3.20), as do the flying chariots with which Rama and Krishna travel through the skies of the Badal Mahal (figures 3.1A, 3.22 and 3.23), while the abundant elephant studies and hunting scenes formed the basis for painting at Kota.[50] Later paintings from territories related to Bundi are strongly rooted in the extraordinary works of the Badal Mahal painters.

Conclusion

The wall-paintings of the Badal Mahal follow a carefully conceived programme that demonstrates (in the ascending levels of the decoration) the power of the raos of Bundi over the natural world; their easy movement among the gods; and their proximity to the

empyrean. The scheme seems to have been initiated by Rao Bhoj, continuing under Rao Ratan Singh with a band of hunting scenes and celebrations of elephants. Under Ratan Singh and the young Chhatarsal the walls above this frieze were decorated with scenes in which the courts of Krishna and the raos alternated. Above this is the extraordinary ceiling, the realm of the gods, which literally hangs above and seems to observe the scenes below. The final addition to the room was a complete set of Ragamala, which quickly became a way to indicate the universal sensibilities of the rulers. This seems to have been completed by an older Chhatarsal.

Here again, contemporary histories provide further understanding of this decorative programme. In the *Shatrushalya Charita*, Chhatarsal, the son of Gopinath, is extensively lauded—the narrative was written at his command, after all. This account states that Gopinath "procreated Shatrushalya [Chhatarsal] like the husband of Laxmi [Vishnu/Krishna] begetting [his son] Pradyumna while sporting with Rukmini".[51] The passage thereby provides not only an explanation for the prominent scenes of Krishna's wedding and the birth of his son, it also indicates that the lives of the Bundi raos directly parallel the lives of the gods. It may also provide evidence that the final programme for the decorations of the room is a response to Chhatarsal's accession.

The Badal Mahal, one of the greatest achievements of Rajput art and architecture, powerfully embodies and celebrates the Rajput character. Its paintings convey to us that the raos of Bundi, powerful on earth and understanding of their subjects, moved among the gods, and that those invited into this space were similarly privileged. It is an astonishing, and beautifully executed, concept.

NOTES

1 The inscription (translated by Wheeler M. Thackston) reads: "The book Ragmala has been prepared on Wednesday at noon in the locality of Chunar. The work of the pupils of Mir Sayyid 'Ali Nadirulmulk Humayunshahi and Khwaja 'Abd al-Samad Shirin-Qalam the slaves Shaykh Husayn and Shaykh Ali and Shaykh Hatim son of Shaykh Phul Chishti. Written on the 29th of Rabi' II of the year 999 [February 24, 1591]. Written by the humble Daud son of Sayyid [illegible]" (Beach 2011, p. 292).

The complete inscription, in a translation by the late Simon Digby, was first published and discussed in Beach 1974, pp. 6–10.

2 See note 1.

3 A possible family relationship of the painters with Chunar is explored in Skelton 1981.

4 E.g., Archer 1959, p. 25.

5 Vyas 2002, p. 50. This is confirmed in Mahakavi Vishvanatha 1996, xi: 11.

6 Mahakavi Vishvanatha 1996, viii: 141.

7 Tod 1957, 2, p. 238.

8 Vyas 2002, p. 50.

9 Abu'l Fazl, *Akbarnama*, 3: 184.

10 Ibid., 3: 184 and 201–03.

11 Uncertainty about Bundi's continuing control of the Chunar area led to initial doubts about the truth of the Ragamala inscription, but Bhoj's continuation of his father's appointment there is confirmed by the recent study by Lakshmi Dutt Vyas of the *Vamshabhaskar* (see Vyas 2002, p. 50). The

Shatrushalya Charita also refers to "Rao Ratna staying at the beautiful place of Chunar, surrounding the upper summit of the table-land of the mountain" (Mahakavi Vishvanatha 1996, xi: 11).

12 Vyas 2002, pp. 50–51, which refers to an account in the *Vamshabhaskar* of Suryamalla Mishran.

13 Abu'l Fazl, *Akbarnama*, 3: 34.

14 Mahakavi Vishvanatha, 1996, x: 37 and 41.

15 The passage is cited in Bautze 1986, p. 88.

16 This was most memorably expressed by Stuart Cary Welch, who described the great Mughal *Hamzanama* manuscript as "a vision of the world through the eyes of a lion. And the lion, of course, was Akbar" (Welch 1963, p. 24).

17 See, e.g., Beach 1974, p. 8.

18 See Vatsyayan 1981; Beach 1974, fig. 9; or Vyas 2004–05.

19 The closest being reproduced in Beach 1974, fig. 10 and Beach 2011, fig. 4. There is no reason to think these drawings necessarily preceded the Chunar set. It is equally possible that they recorded its style for the use of later artists.

20 The badly worn remains of additional early wall-paintings in the public audience chamber (Hathiyansal) of the Palace of Rao Bhoj are discussed in Beach 2008.

21 A Ragamala of 36 scenes is divided into six sections, each including a raga, or musical mode personified as male, and five attendant raginis (female). The niche with Krishna fluting is flanked by Bhairava Raga and Sri Raga, the first and sixth ragas within that scheme.

22 This figure was previously identified as Ratan Singh by Joachim Bautze (1986, pp. 89–90 and fig. 6).

23 For further discussion, see Beach 2011.

24 E.g., Losty and Roy 2012, fig. 29.

25 Bautze 2000, p. 20.

26 See Bautze 1986, p. 172 and fig. 9.

27 Ibid., p. 90 and fig. 5.

28 The depiction of identifiable architecture was also an interest in the *Akbarnama* manuscripts; see Beach 1987.

29 For further discussion, see Beach 2008, p. 138. This narrative variant may be based on a specific unidentified text. For the Bundi raos' interest in literature, see chapter 5 by Allison Busch.

30 Bautze 1987a, p. 170.

31 Instruction from President Rastell and the Council at Surat to Peter Mundy in 1630, recorded in Mundy 1914, vol. 2, p. 24. The traveller Pietro della Valle had met Rastell in Surat in 1623, and described him as of "noble manners and accomplishments in everything . . . [and having a] handsome and gentle appearance" (della Valle 1989, p. 204). John Willoughby had travelled to India with Mundy, arriving in Surat in 1628, and both remained there until leaving for Burhanpur, Agra and other destinations in 1630. Ratan Singh must therefore have purchased the tapestries in Surat, and may have encountered this community, a small detail that helps to define the worlds within which he moved.

32 Foster 1967, p. 300.

33 Strachan 1989, p. 70.

34 A second, slightly later rasamandala ceiling can be found in a small room just north of the Badal Mahal (Beach 2008, fig. 30).

35 Joachim Bautze has attributed this series to the reign of Buddh Singh (1695–1729; d. 1739), and it is thoroughly discussed in Bautze 1987a.

36 Beach 2008, pp. 142–43 and figs. 32–34.

37 Tillotson 2006, pp. 58–59, quoted in Beach 2008, pp. 136–37.

38 The artist of figure 3.25 (identified here as a portrait of the young Chhatarsal) shows an indifference to physiognomic accuracy which matches that seen in the earliest wall paintings (e.g., figure 3.11); shoulders, for example, are drawn with rounded lines that ignore musculature, and torsos are impossibly inflated. Sometime during Chhatarsal's reign, that rao demanded greater accuracy and sophistication in figural descriptions (see figure 5.9).

39 Bautze 1986, pp. 95–97.

40 Bautze 2000, p. 16. According to L.D. Vyas (in private correspondence), Gopinath Singh died in 1614.

41 For the best discussion of this phase, see Chandra 1960.

42 For the most important inscribed portraits of Chhatarsal in this later phase of his depiction, see Desai 1985, no. 45; for Bhao Singh, see Bautze 1985; and for Aniruddha Singh, see Beach 1974, fig. 27.

43 Bautze 1985. However, inscribed portraits naming Chhatarsal in the Kanoria Collection and the Chhatrapati Shivaji Maharaj Vastu Sangrahalaya, Mumbai, also include flowers in the turban.

44 The women in Hindola Raga are so remarkably close to those in a painting by Mohan dated 1689 (Chandra 1959, pl. 2) that one needs to explore a possible later refurbishment of Badal Mahal paintings. A scientific study of the wall surfaces (currently underway by the Courtauld Institute) is needed to assess proposals which to date have been made by visual analysis alone.

45 Mahakavi Vishvanatha 1996, xi: 21, where the phrase is included in a description of Bundi under Ratan Singh.

46 There is an additional early Ragamala series that is far less exacting in its use of the Chunar compositions, suggesting that it was made by a different group of artists and apprentices. The physiognomy of the male figures is often close to early portraits of Rao Chhatarsal, perhaps indicating that it was done with his interests in mind. See Beach 1974, p. 18 and figs. 33–34.

47 Even the decorative bands that frame that frieze are comments on such identical floral scroll motifs as those found in the Begum Shahi Masjid (Mosque of Maryam al-Zamani) in Lahore, a building dated 1611; one of several models that would certainly have been known to the raos.

48 Thoroughly discussed in Koch 2001, pp. 12–37. The squinch nets at Bundi have abundant prototypes at Fatehpur Sikri, Agra, Lahore etc.

49 E.g., Beach 2008, figs. 27–29.

50 Bautze has discussed several later compositions from Kota that are adaptations of scenes from the Badal Mahal hunting frieze; e.g., Bautze 1986, figs. 12 and 14. That the sudden indifference of the Bundi raos to elephant studies and scenes of hunting on the model of the Badal Mahal frieze might be a result of the loss to Kota of the hunting grounds in southern Bundi is worth further exploration.

51 Mahakavi Vishvanatha 1996, xi: 24.

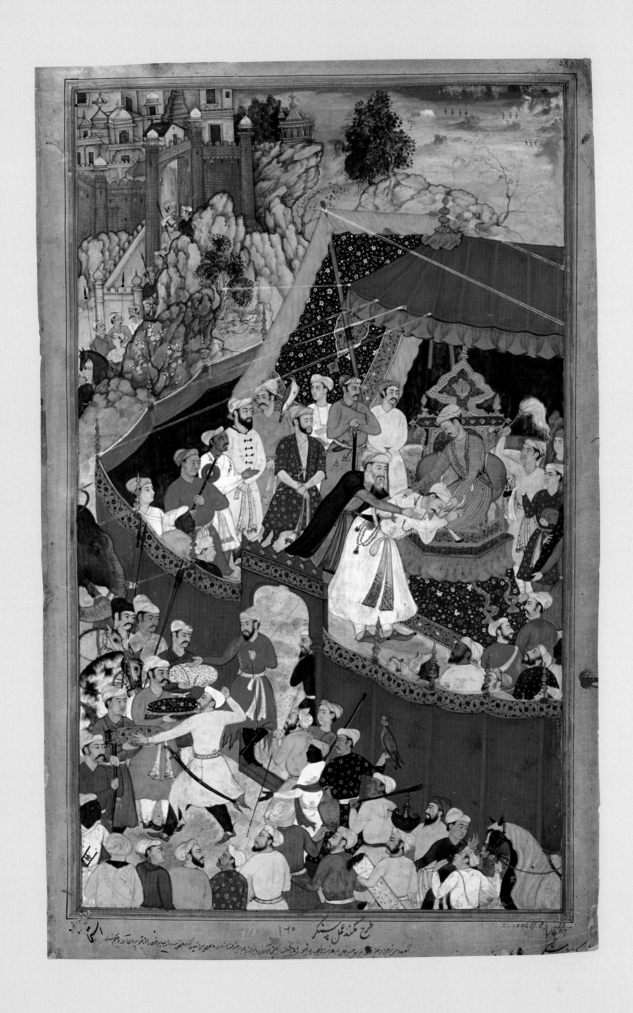

Elephants, Hunting and Mughal Service: The Martial Lordship of Rao Ratan

CYNTHIA TALBOT

The Hadas of Bundi were among the earliest Rajput lineages to become Mughal subordinates. This happened in 1569, after the Mughal army under Emperor Akbar's personal direction besieged Ranthambhore, then in the charge of the Hada chief Surjan (r. 1554–85). The campaign against this famous Rajasthani fort was celebrated by several illustrations in the *Akbarnama*, the official chronicle of the reign of Akbar (r. 1556–1605), including one showing Surjan bowing down in the formal ritual of surrendering the fort to the emperor (figure 4.1, see also figure 1.3). In addition, Surjan was required to join the Mughal imperial service: first as an officer in the Jabalpur area of central India, and later at Chunar near Benares. As a result of Akbar's trust in him, the Sanskrit poem *Shatrushalya Charita* tells us, Surjan experienced growing prosperity.[1] His status at the Mughal court rose steadily until he was one of the highest-ranking Hindu nobles by the time of his death in 1585. This was the beginning of a long and mutually beneficial relationship between the Hada warrior lineage and the Mughal empire. Not only Surjan, but several generations of his descendants, acquired greater wealth and prestige as a result of their participation in the imperial enterprise. On their end, the Mughal emperors gained the valuable military assistance of Hada warriors, who fought on their behalf as far afield as Bengal, the Deccan and Afghanistan.

As a result of their induction into Mughal service, the Hadas and other Rajput lineages were exposed to a more cosmopolitan culture, as is well known. Their greater affluence also enabled them to act more like traditional Indian kings than had previously been possible for these local warrior chiefs. Surjan Hada, for example, is said to have engaged in lavish gift-giving to brahmans in Benares, thereby establishing his kingly credentials in this renowned sacred site.[2] His son Rao Bhoj (r. 1585–1607) commissioned a Sanskrit work in the courtly Mahakavya (literally, "great poetry") genre, titled *Surjana Charita* ("Deeds of Surjan"), which commemorated the lengthy and illustrious accomplishments of the Hada dynasty. Like his father, Bhoj Singh participated in several Mughal military

4.1 Rao Surjan Singh Hada making submission to Akbar, from an *Akbarnama*, designed by Mukund and painted by Shankar, c. 1586–89. Opaque watercolour, gold and ink on paper. © Victoria and Albert Museum, London, IS.2:75-1896.

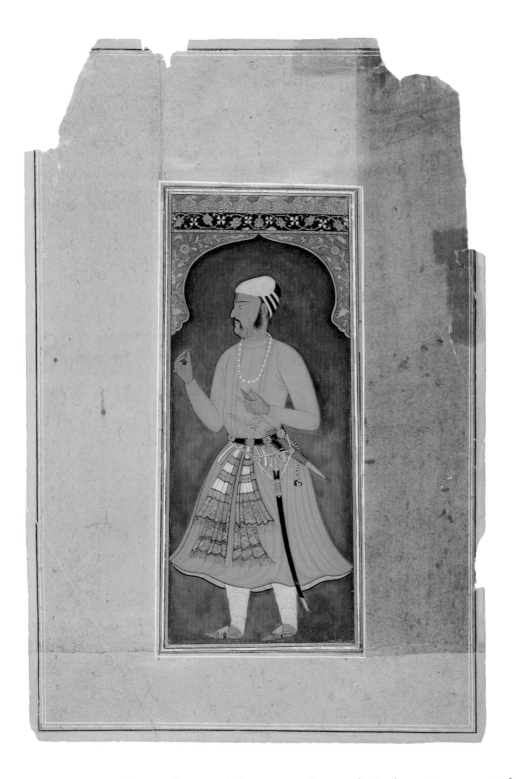

campaigns—in Gujarat, Orissa and the western Deccan; he is shown in a portrait from his lifetime wearing both the distinctively Indian dagger called katar and a curved talwar or sword (figure 4.2). It was during Bhoj's tenure as Hada leader that the famous Chunar Ragamala paintings were produced; one of the earliest surviving palaces in Bundi also dates back to his period (see chapter 3).[3] Bhoj's audience hall is known as Hathiyansal after the elephant sculptures that adorn the tops of its pillars (figure 1.7). Through their patronage of brahmans, courtly literature, palace buildings and new styles of painting, the early Hada rulers of the Mughal era displayed their newly acquired elite status and cultural tastes. (On their literary patronage, see chapter 5 by Allison Busch.)

The Ascendancy of Rao Ratan

Perhaps the most successful of the Bundi Hadas was Surjan's grandson Rao Ratan Singh (r. 1607–31), the main focus of this essay. He appears as a man in his prime in a contemporary portrait, wearing an almost transparent white shirt and holding a flower (figure 4.4).[4] Awarded the title Sarbuland Rai or "eminent lord" by Emperor Jahangir (r. 1605–27) upon presenting himself at the imperial court in 1608, Ratan Singh provided over two decades of military service to the Mughals. In 1614–15, he participated in the campaign that led to the submission of Maharana Amar Singh of Mewar, after decades of resistance by that kingdom. Rao Ratan also spent many years in the northern Deccan, first fighting against Malik Amber of the Nizam Shahi sultanate, and later defending the Mughal stronghold of Burhanpur against the rebellious Prince Khurram.[5] After Khurram ascended the throne as Emperor Shah Jahan in 1628, Rao Ratan Singh maintained his high rank of 5,000 zat/5,000 sawar (indicating a noble's personal ranking at court and the number of horsemen he was required to maintain), despite his role in putting down Khurram's earlier bid for power. The Rao's long sojourn in the Deccan is reflected in a later portrait in which Ratan Singh is portrayed on horseback in standard Mughal fashion, but with distinctly Deccani features such as the white scarf or shawl held over his head by one attendant and the dark skin and unusual dress of the other (figure 4.3).[6]

Two products of the Hada court from the early 17th century offer insights into the cultural milieu of Bundi's rulers and their court. Through examining these court-sponsored objects—one, a Sanskrit text on the Hadas titled *Shatrushalya Charita* ("Deeds of Shatrushalya"), and the other, a band of murals on the walls of Badal Mahal—we can

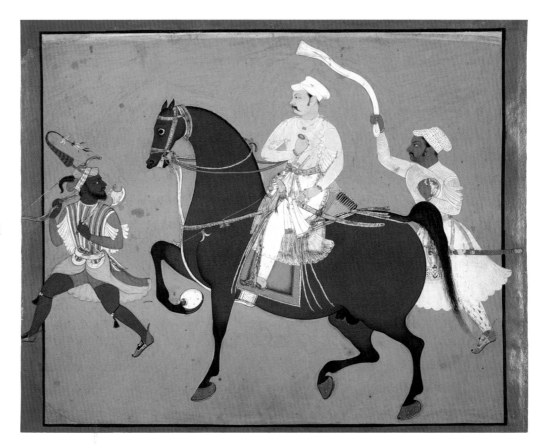

4.2 Rao Bhoj Singh, by Nur Muhammad, Bikaner, dated 1592. Opaque watercolour and gold on paper. Collection of Gursharan and Elvira Sidhu.

4.3 Equestrian portrait of Rao Ratan Singh of Bundi, Kota, c. 1680. Opaque watercolour and gold on paper; 29.2 × 36.5 cm (page). Philadelphia Museum of Art, 125th Anniversary Acquisition. Acc. no. 2004-149-62. Alvin O. Bellak Collection, 2004.

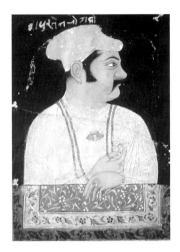

learn something about Hada conceptions of lordship, as well as the impact of Mughal culture on them. Both the murals and the Sanskrit Mahakavya are further signs of the elite status that the Hada lords had attained through their service for the Mughals, especially under Rao Ratan Singh. It is likely that the majority of the hunting and courtly scenes in the band of murals were painted during Ratan's time as Hada leader, probably in the 1620s.[7] Although much of the *Shatrushalya Charita* deals with the life of Rao Ratan's grandson Shatrushalya or Chhatarsal of Bundi (r. 1631–58), it was written around 1635, only a few years into Chhatarsal's tenure as Hada lord and not long after Rao Ratan's death.[8] The paintings and the literary text are similar in displaying a highly martial perspective on lordship, with a predilection for elephant imagery; the poem also reveals an ambivalent attitude toward the Mughal emperors whom Ratan Singh both defended and opposed in battle. In the remainder of this essay, I explore the theme of martial lordship as expressed primarily in the Badal Mahal murals and in the *Shatrushalya Charita*.

Warfare Represented in Words and Symbols

Unlike the earlier Sanskrit Mahakavya on Surjan Hada, the *Shatrushalya Charita* (*SC* henceforth) is full of references to battles fought by the Hadas on behalf of the Mughals. This is particularly notable in the verses about Rao Ratan Singh, whose relationship with Jahangir was one of friendship (*SC* xi: 49) and who marched out to the Deccan region against the Nizam Shah in order to provide assistance to the emperor, here called the lord of Delhi (*SC* xi: 64). Rao Ratan repeatedly sought to protect the Mughal overlord from his enemies (*SC* xi: 33), including Prince Khurram, who desired to kill his own father (*SC* xi: 75). The Hada lord is portrayed as one of Jahangir's staunchest supporters during Khurram's rebellion, which is covered at length, comprising half of the 172 verses in the canto on Rao Ratan. The only other details provided about Ratan Singh in this section of the poem, aside from his military activities in service of the empire, relate to his son Gopinath, who died young, and his grandson and successor Chhatarsal (Shatrushalya in Sanskrit).

While accounts of warfare pervade the *Shatrushalya Charita*'s coverage of Rao Ratan Singh, no battle scenes appear on the frieze in the Badal Mahal associated with this Hada lord. Considered to be the oldest illustrated portion of the room, the frieze forms a continuous band of murals that run along the walls, immediately below the recessed ceiling spaces. Instead of the armed combat between enemy warriors that is recorded in the Sanskrit poem, what dominates these murals are scenes of hunting and of elephants. Both hunting and elephants can be construed as standing in for the grim realities of war; both are also associated with kingly or lordly stature.

It may be that illustrations of battle were regarded as too gruesome to depict in this reception hall that would have hosted, among others, warriors who had only brief periods away from combat to enjoy visits to their homes. Or perhaps visual representations of warfare would have made it too evident that the Hada lords were fighting under the

4.4 Portrait of Rao Ratan Singh, Bundi, c. 1620. Opaque watercolour on paper. Collection of Rawal Devendra Singh of Nawalgarh, Jaipur.

4.5 Royal hunters shooting deer, antelope and boar from the west wall of the Badal Mahal, Palace of Rao Bhoj, Bundi Fort, c. 1625–30. Photograph: Milo C. Beach.

command of their Mughal overlords. Hunting and possessing war elephants, on the other hand, were activities that virile rulers engaged in, and thus cast Bhoj Singh and Ratan Singh as fully independent warrior kings—a role that the Hadas could successfully enact within their ancestral territory, if not elsewhere in the empire. Through the deployment of these two symbols of war—the elephant and the hunt—the military dimensions of Hada authority could be fully evoked in this palace space, despite the absence of battle scenes; so too could its royal character.

Hunting Imagery in Painting and Poetry

The archery skills and privileged status of the Hada lords are highlighted in one hunting scene from Badal Mahal, in which three archers lie in wait behind a tall hunting blind made of tree branches tied together with a rope-like vine (figure 4.5). The hunters, wearing loose lower garments with finely patterned tight-fitting shirts and necklaces, sit on carpets while shooting at chital and blackbuck that have been flushed out and driven toward them; in the far distance, some boar, who are not shown here, flee from dogs chasing them. Milo C. Beach has tentatively identified the archer on the right as Rao Ratan Singh and the one in the

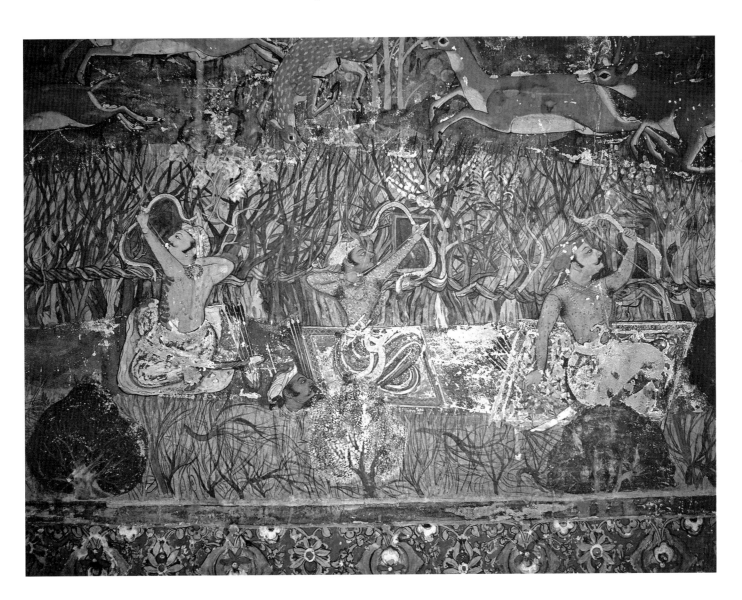

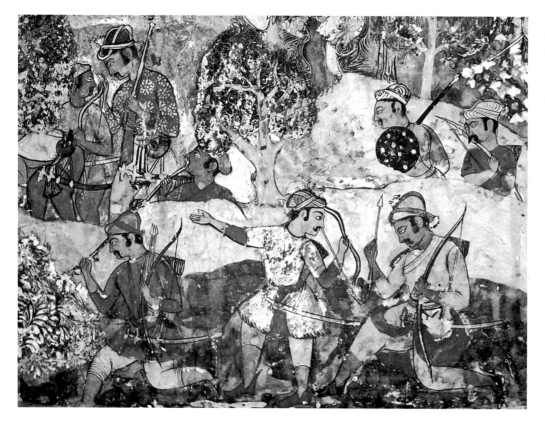

4.6 Hunters in the forest, from the west wall of the Badal Mahal, Palace of Rao Bhoj, Bundi Fort, c. 1625–30. Photograph: Milo C. Beach.

middle as his grandson Chhatarsal (see chapter 3). Only powerful and wealthy men like these Hada lords could command the animal and human resources involved in an organized hunt of this sort, in forests that would have been their personal reserves. Other hunts—in pursuit of lions, tigers and a rhinoceros—fill the remainder of Badal Mahal's west wall, reinforcing the impression that hunting was a means of honing martial skills for elite warriors.

Hunting and warfare could be conflated in poetry as well as in painting, as we witness in the *Shatrushalya Charita*. Hunting imagery is sometimes applied to warriors in battle, as when Rao Ratan is described as "fierce in the (sport of) hunting that is war" or "attacking with great force like a falcon pouncing (on prey) from on high" in the fighting around Burhanpur fort (*SC* xi: 157). Unlike the case at Badal Mahal, however, hunting episodes are rarely represented in this Sanskrit poem about the Hadas. An exception is a verse about Duda Singh (d. 1585), the elder brother of Rao Bhoj Singh. In a literary rendition of the picturesque landscape teeming with animal life that is illustrated in the murals, the poet situates Duda in the jungly terrain of Bundi (*SC* ix: 76):

> In a large forest with colourful birds, grunting boar, and darting deer,
> he (roamed) here and there.
> Quickly putting on clothes suitable for hunting and stringing his bow tight,
> (he killed) many wild animals.

Earlier in the poem, much is made of "brave" Duda's opposition to Mughal rule; thus, this verse may allude to the time Duda spent foraging in the countryside after being ousted from Bundi Fort in favour of his younger brother, Bhoj Singh. We can imagine Duda putting on a hunting outfit not unlike the short tunics and calf-length trousers or leggings worn by the three hunters in the foreground of another scene from Badal Mahal's west

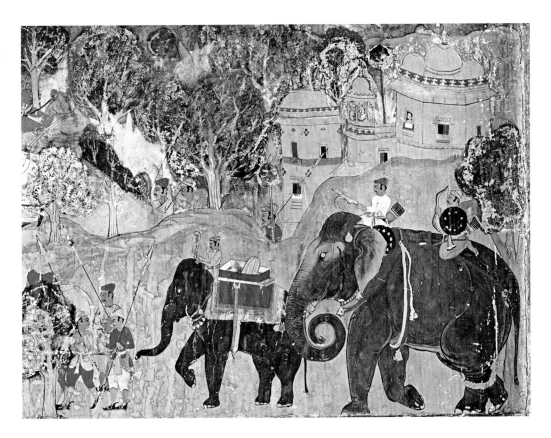

4.7 Two elephants with mahouts, from the west wall of the Badal Mahal, Palace of Rao Bhoj, Bundi Fort, c. 1620–25. Photograph courtesy of Hilde Lauwaert.

wall (figure 4.6). The man in the middle has a short recurved composite bow, originally designed for use on horseback, while the other two carry simpler bows with no curve, rather like the bows used by the indigenous Bhil people.

The Significance of Elephants

Far more notable than hunting, in both the Sanskrit poem and the Badal Mahal panels, are elephants. *SC* contains numerous references to elephants as part of an army in battle, as objects of gift, and as powerful creatures to whom the Hada lords and other mighty warriors can be compared. For example, Rao Ratan's son Gopinath is described as possessing the strength of ten thousand elephants (*SC* xi: 18), so that even as a child in play he could easily tear out the tusks of live elephants and place them instead on man-made elephants; that is, on elephant sculptures or toys (*SC* xi: 15). Elsewhere Gopinath's arms are said to have been "like sharp goads (ankusha) to the superb elephants that were the enemy warriors" (*SC* xi: 31).

Elephants also abound in Badal Mahal, with no fewer than 45 of them visible in the early 17th-century band of murals. Sometimes the elephants appear in or around the palace grounds, as in the case of the two animals in figure 4.7. On the back of the smaller of the two elephants is a box-like platform, which on this occasion is being used not as a person's seat but as a receptacle for some objects. At other times, the elephants are engaged in activities at some distance from the palace, as in the instance of an elephant on a hunt being attacked by a tiger (figure 4.8). On the elephant are two men, one aiming an arrow at the tiger while the other jabs a spear at the animal's head; another archer is running toward the tiger on foot. Elephants would have been safe mounts in encounters with lions and tigers, for they have

little to fear from such predators. This is especially true of the most admired war elephants, large males with tusks who were often in the heightened state of aggression known as musth.[9] Musth (from the Persian *mast*) is generally accompanied by the discharge of a thick fluid from the glands on the sides of the elephant's head, along with high levels of testosterone.

Thomas R. Trautmann emphasizes that warfare was the primary purpose for which Indian kings kept elephants, citing the words of the Mughal courtier and official historian, Abu'l Fazl, who wrote:

> This wonderful animal is in bulk and strength like a mountain; and in courage and ferocity like a lion. It adds materially to the pomp of a king and to the success of a conqueror; and is of the greatest use for the army.[10]

While Indian kings had used elephants in warfare since the ancient period, their pre-eminent role in battle had begun declining in the 12th century, due to the superior skills of horsemen from Central Asia and Afghanistan. Yet there "seems to have been a remarkable revival of the war-elephant during the sixteenth century",[11] even before the reign of Akbar, who was enamoured of elephants almost to the point of infatuation.[12] The number of elephants in the Mughal army escalated in Akbar's reign, and continued

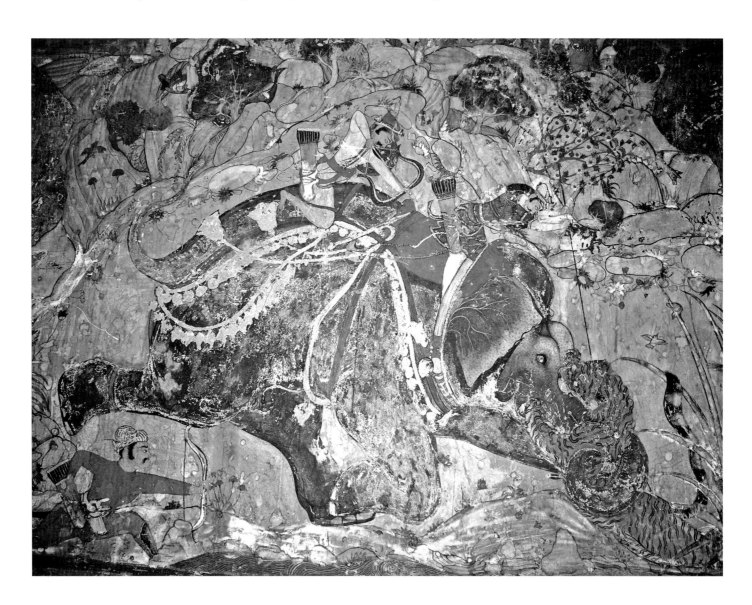

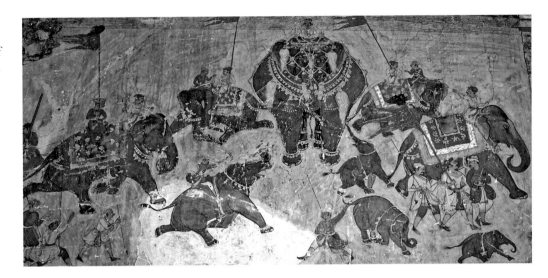

4.9 Elephants arriving for viewing, from the north wall of the Badal Mahal, Palace of Rao Bhoj, Bundi Fort, c. 1600–10. Photograph: Milo C. Beach.

to be high in the time of Jahangir, who also had a marked fondness for them. Due to the imperial fascination with elephants, who symbolized both war and royalty, the Mughal court sponsored numerous paintings of them, as did the Deccani sultanates; among Rajput courts, Bundi and later Kota were the most prominent in this respect.[13]

Because elephants were expensive and difficult to acquire, the gift of elephants was seen as the best of all presents offered at the Mughal court, above jewelled ornaments, weapons and even horses with gold-mounted trappings.[14] Rao Ratan was fortunate in twice being honoured in this fashion by Jahangir—he first received "the foremost among musth-aroused elephants" (*SC* xi: 49) after participating in the successful Mughal campaign against Mewar, and is also said to have been given hundreds of elephants and horses around 1623 (*SC* xi: 81), after years of serving the empire in the Deccan. The gifting of elephants was not a one-way process, for the Mughal emperors also expected their high-ranking nobles to supply them with choice specimens. Rao Ratan had done so when first introducing himself at court, during the third year of Jahangir's reign, as recorded in the emperor's memoirs.[15] On his initial appearance at the court of Shah Jahan, Rao Ratan's successor Chhatarsal was similarly generous and "presented an offering of 40 elephants bequeathed to him by his deceased ancestor".[16] These references in Indo-Persian chronicles to Hada gifts of elephants provide additional testimony that the Hadas kept a large stable of these animals.

The importance placed on maintaining a good supply of elephants is highlighted in the central scene from Badal Mahal's north wall, which faces the only entrance into the room. In it, a Hada ruler identified as Rao Bhoj Singh (r. 1585–1607) by Milo Beach looks down from a balcony at a large elephant that is being led out for his inspection (figure 3.10).[17] Also observing the proceedings from above are a number of women, barely visible behind screens (figure 3.9). To the left of the palace in the band of murals are an assortment of elephants being readied for the lord's viewing (figure 4.9). The variety in elephant sizes is apparent here, with some small elephants cavorting in the midst of larger animals wearing colourful saddle-cloths and ornamental trappings; the largest one faces the viewer in an unusual frontal position.

Elsewhere on the same wall of the Badal Mahal, a lordly looking man whom Joachim Bautze has suggested is Rao Ratan Singh sits on a fine horse and looks off to the right

4.8 Elephant being attacked by a tiger, from the south wall of the Badal Mahal, Palace of Rao Bhoj, Bundi Fort, c. 1625–30. Photograph: Milo C. Beach.

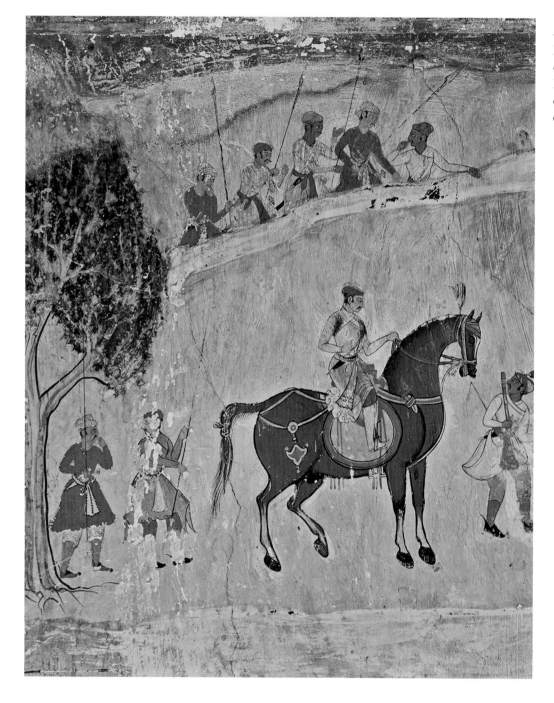

4.10 Rao Ratan Singh on horseback, from the north wall of the Badal Mahal, Palace of Rao Bhoj, Bundi Fort, c. 1620–30. Photograph courtesy of Hilde Lauwaert.

(figure 4.10).[18] He too is gazing at elephants (not illustrated here), but they are not merely being paraded before him as in the scene with Bhoj Singh on the balcony. Instead, Ratan Singh is assessing the warlike qualities of two elephants as they hone their skills by fighting each other. No less than four elephant fights are painted on Badal Mahal's walls, suggesting that they were both a frequent occurrence and a popular form of entertainment at the Bundi court. In a previously published section of this same wall,[19] courtiers crowd around a walled enclosure to watch a domesticated elephant grapple with a wild elephant whose back legs are bound, a well-known method for taming newly captured adult elephants. Conflicts between aggressive males could break out spontaneously too, as shown in a painting of two other elephants going head to head in combat (figure 4.11). This particular

4.11 An unplanned elephant fight, from the north wall of the Badal Mahal, Palace of Rao Bhoj, Bundi Fort, c. 1610–20. Photograph: Milo C. Beach.

fight was clearly unplanned, for the animals are unmounted and have no trappings, while alarmed men rush to separate them.

Ratan Singh was apparently an accomplished elephant-rider, a demanding skill which he no doubt practised with the elephants at Bundi as well as in the Deccan. Two literary works, an Indo-Persian text and the *Shatrushalya Charita*, remember a feat of bravery that he carried out on elephantback, while trying to prevent Khurram's general from taking possession of the inner fort at Burhanpur. The *Ma'athir-ul-umara*, a late 18th-century biographical compendium, describes the incident in these words:

> The Rao pushed forward the elephant Jagajot and fought in the marketplace, and behaved bravely. . . . It is stated that Rao Ratan at the time of the battle said "*Marshan?*" i.e., "I will die".[20]

The event is narrated at greater length in the *Shatrushalya Charita*, where the name of Rao Ratan's elephant is given differently, as Jnanabandhu rather than Jagajot. But both the Sanskrit and Persian texts are clearly referring to the same incident, which occurred in 1625.[21]

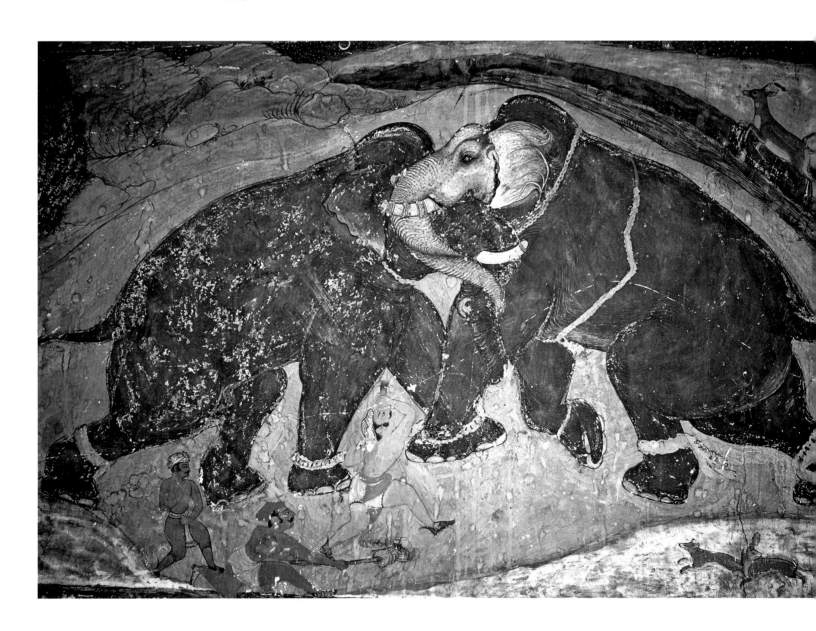

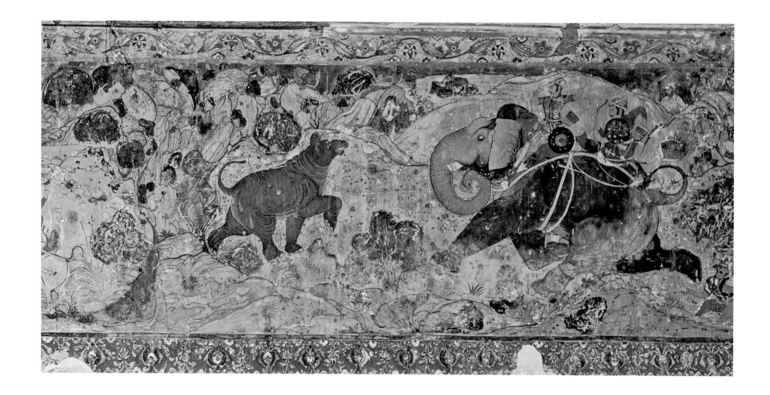

The *Shatrushalya Charita*'s account of this incident begins by stating that Prince Khurram's forces had broken through the mud rampart of Burhanpur, of which Rao Ratan had earlier been appointed as commander-in-chief (*SC* xi: 84), and entered the city's marketplace (*SC* xi: 153–54). Rao Ratan then mounted his war elephant Jnanabandhu and led the charge against the rebels. The poem continues the narrative in three verses (*SC* xi: 158–60):

> When this great enemy force (of Khurram's)—difficult to penetrate because of the hundreds of arrows and swords too that could end life, and spears that were capable of piercing vital organs—was ready to fight, (Rao Ratan's) elephant Jnanabandhu, the scent of whose oozing (musth) discharge terrified the adversary's elephants, was urged on by the mahout and destroyed the other army.
>
> That king among elephants (Jnanabandhu)—becoming blind with arrogance, scratching the banks of the river [or: pressing against the rear of the army] of enemy soldiers with his two tusks, extremely violent due to the terrible itching of his broad temples, forcibly plucking up the roots of the vine which was the good fortune of the multitude of wives of the foes [i.e., by killing their husbands] with the rod of punishment that was his trunk—shone, while amusing himself in battle as if playing in the forest.
>
> The extremely exhausted warriors of Khurram headed by Mahamad Taki [Muhammad Taqi], having seen that king among elephants—terrifying as Death with its dark body, as if stained with the infamy accruing from his initiation of the host of enemy wives into (the state of) widowhood—quickly went into the fort and closed the strong door of the gateway, in order to save their lives.

The poem thus attributes the defeat of the rebel army at Burhanpur to Rao Ratan's valour and the might of his great war elephant. The Rao's virility and bravery are reflected and

4.12 Elephant in attack mode, south wall of Badal Mahal, Palace of Rao Bhoj, Bundi Fort, c. 1625–30. Photograph courtesy of Shubha and Prahlad Bubbar.

magnified, as it were, by the awesome animal which he rode to victory; there is no greater mark of martial prowess than the ability to master such a superior elephant. It is described as being in the grip of musth—the word in Sanskrit is *mada*, literally "intoxicated, drunk with passion, maddened". This makes the elephant difficult to control, but also extremely aggressive toward the enemy. Perhaps the Rao's elephant on this occasion looked something like the energetic elephant on attack in figure 4.12, from Badal Mahal's south wall. It is a young male in full vigour, whose pale skin was considered a sign of beauty, charging boldly toward a rhinoceros.

A musth elephant figures in another striking verse from the *Shatrushalya Charita* about Rao Ratan Singh, once again presented as Jahangir's defender and rescuer. Here the poet compares the Mughal emperor to a mythical elephant (*SC* xi: 78):

> Then the exalted and great earthly ruler (Rao Ratan)—who possessed the radiance of Upendra on this earth, and whose splendid, extensive army was like a wheel in grinding down the enemy—desired to protect the lord of Indraprastha [Delhi], who was like the best among musth elephants caught in the mouth of the wicked crocodile that was Khurram.[22]

The verse alludes to the well-known story of the liberation of Gajendra, the mighty elephant, from the jaws of a crocodile. According to the *Bhagavata Purana*, Gajendra's foot was grabbed by a crocodile hiding in a lake, and he could not free himself though he struggled for a thousand years.[23] Exhausted and on the verge of death, Gajendra finally offered a prayer to Vishnu, who in response threw his discus-weapon down and killed the crocodile. The implication is that Rao Ratan wanted to act like the god Vishnu in rescuing the royal elephant who was Jahangir from the unjustified attack of the evil crocodile, his son Khurram.

Ambivalence toward the Imperial Power

By casting Rao Ratan in the role of saviour to the Mughal emperor, the poet Vishvanatha could reconcile the reality of Mughal sovereignty with the Hada desire to be represented as autonomous warrior kings. The existence of Bundi's imperial overlords might be ignored by the Badal Mahal painters, who drew attention to the royal attributes of the manly Hada leaders by showing them hunting and viewing war elephants in their Bundi homeland. In contrast, for a poet who wished to call attention to a Rajput lord's military successes, it was not possible to entirely write the Mughal emperor, and his other generals, out of the picture. Rather than describing him as obeying his monarch's orders, however, Rao Ratan Singh could be presented as acting of his own volition to "protect the sultan" (*suratranam tratum, SC* xi: 33 and 75), because he was an "associate" (*sahakritvan, SC* xi: 168) or "friend" (*suhridam, SC* xi: 88) of this "Delhi lord". This literary manoeuvre implied that the Hadas were equal to the Mughals in being full-fledged rulers, whose military aid was critical to the maintenance of Mughal power (on this point, see also chapter 5 by Allison Busch).

While the impulse to exaggerate the position of the Hadas is understandable, what is more surprising is the strong sense of ambivalence in the poem about Hada subordination to the Mughals. This is made manifest in the frequent denigration of Prince Khurram, even though he had become emperor by the time the poem was composed. Throughout

the canto on Rao Ratan, disparaging terms like rogue (*dhurta*), villain (*khala*) and wicked (*dushta*) are consistently applied to Khurram, who is accused of having temporarily turned Jahangir against the Hada lord (*SC* xi: 51–52), years before his treacherous attempt to usurp the throne from his own father. Even Jahangir, to whom Rao Ratan Singh is entirely loyal, is called a "drinker of alcohol" who was "under the control of a woman", referring to Empress Nur Jahan's alleged influence over her husband (*SC* xi: 98). At the end of the poem, Mahakavi Vishvanatha imagines Ratan Singh saving herds of cows from Khurram, "who propagated the evil practices of the Turks", an allusion to their eating of beef (*SC* xi: 171). In the end, Rao Ratan remembers his family's friendship (*sakhyam*) with the Mughals that had begun in the time of Surjan Hada, and so makes Khurram, once his enemy, the ruler of Delhi (*SC* xi: 169).

To conclude, their years of military service to the Mughal empire provided the Hadas with considerable economic security and enabled them to patronize poets, painters and architects in the manner of great kings. It also made them part of an imperial elite with shared conceptions of martial lordship, among which was a premium on the sport of hunting and an understanding of the war elephant as the epitome of royal valour. Even though they visibly benefited from participating in the enterprise of empire, analysis of the *Shatrushalya Charita* suggests that the Hadas felt some discontent about their subservience to the Mughals. They might have enjoyed thinking about themselves, when away from the imperial court in their own land of Bundi, as independent kings who were just as worthy as the Mughal rulers for whom they shed blood. Yet the Hada warriors spent much of their lives outside the ancestral territory, in the expansive and diverse world of the Mughal empire, where they were but one among a number of warrior lords. Only select aspects of the complex realities experienced by Rajput warriors in Mughal India can be uncovered in any single type of source material from their era. For a broader perspective into their fascinating society, we therefore need to examine both literature and painting—which offer different, if complementary, insights into the Rajput past—along with other historical artefacts and documents that survive.

ACKNOWLEDGEMENTS

I owe deep thanks to Milo C. Beach for kindly providing most of the illustrations to this essay. I am also grateful to Keshav Bhati for sharing his knowledge of Bundi Fort and to William Kramer for information on bows.

NOTES

1 Verse 8.81 in Mahakavi Vishvanatha 1996. In preparing my translations, I have also consulted another edition of the first half of the poem: *Chahvanavamsha Charita Mahakavyam*, ed. R. Tripathi, Varanasi: Sampurnanand Samskrit Visvavidyalay, 2007.

2 On Surjan, see Talbot 2012.

3 Beach 2011, pp. 293–95.

4 Bautze 1986, p. 89.

5 For political history, see Mathur 1986.

6 Terence McInerney, catalogue entry 66 in Darielle Mason, *Intimate Worlds: Indian Paintings from the Alvin O. Bellak Collection*, Philadelphia: Philadelphia Museum of Art, 2001, p. 160.

7 Bautze 2000, pp. 16–20.

8 Bholashankar Vyas, "Introduction", in Mahakavi Vishvanatha 1996, p. 5. Vishvanatha was a member of the vaidya or physician community from the Vidarbha country (M.M. Patkar and K.V.K. Sharma, eds., *Koshakalpataru of Vishvanatha*, Poona: Deccan College, 1957, p. 3). Chhatarsal's patronage of this poet from the northern Deccan is thus likely to be a consequence of the many years the Hada lords spent in that part of India.

9 Thomas R. Trautmann, *Elephants and Kings: An Environmental History*, Delhi & Chicago: Permanent Black & University of Chicago Press, 2015, pp. 27–28. I have relied heavily on Trautmann's excellent study; see especially his chapter "Elephants and Indian Kingship", pp. 50–182.

10 Abu'l Fazl, *A'in-i Akbari* 1989, Vol.1, pp. 123–24.

11 Jos Gommans, *Mughal Warfare: Indian Frontiers and High Roads to Empire, 1500–1700*, London and New York: Routledge, 2002, p. 124.

12 Asok Kumar Das, "The Elephant in Mughal Painting", in Som Prakash Verma, ed., *Flora and Fauna in Mughal Art*, Mumbai: Marg, 1999, p. 36.

13 See the many elephants in Andrew Topsfield, ed., *Visions of Mughal India: The Collection of Howard Hodgkin*, Oxford: Ashmolean Museum, 2012.

14 William Irvine, *The Army of the Indian Mughals: Its Organization and Administration*, London: Luzac & Co., 1903, pp. 29–30.

15 *Jahangirnama* 1999, p. 93.

16 *Shah Jahan Nama* 1990, p. 80.

17 Beach and Lauwaert 2014, p. 17.

18 Bautze 1986, p. 92 and fig. 3.

19 Beach and Lauwaert 2014, pp. 174–75.

20 *Ma'athir-ul-umara* (Vol. 2) 1952, p. 604.

21 For an account of Khurram's military activities between 1622 and 1624, while he was trying to seize power from his father, see Munis D. Faruqui, *The Princes of the Mughal Empire, 1504–1719*, Cambridge, UK: Cambridge University Press, 2012, pp. 208–17 and 219–20.

22 This verse has a double meaning in which Rao Ratan is compared to the god Vishnu on several levels: he is like Upendra, which is both the name of Indra's younger brother and of Vishnu's dwarf avatar; the words "extensive army" are equivalent to the name of Vishnu's commander-in-chief, Vishvaksena; and the wheel that grinds the enemy down can also be understood as Vishnu's discus-weapon, Sudarshana Chakra.

23 The story appears in Cantos 2 and 3 of the 8th book of the text; see *The Bhagavata Purana: An Illustrated Palm Leaf Manuscript Parts VIII–IX*, ed. P.K. Mishra, Delhi: Abhinav Publications, 1987, p. 15 and figs. 3–4.

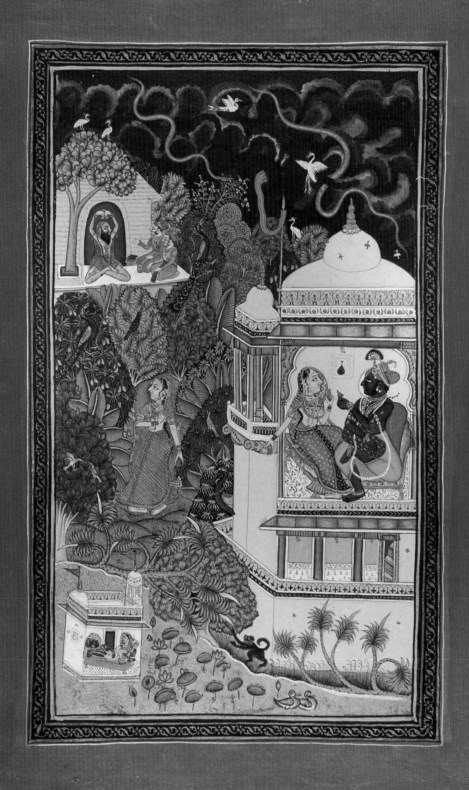

The Rulers of Bundi in Mughal-Period Literary Culture

ALLISON BUSCH

I t is the nature of courts to assert themselves aesthetically, and Bundi is no exception. Matiram Tripathi, one of the finest Brajbhasha (classical Hindi) poets of the 17th century, recognized the stature of the Bundi court precisely on account of its aesthetic achievements and praised the connoisseurs of the state, noting that "in singing, in poetry, and in the arts, the people are very knowledgeable".[1] Court arts invite connoisseurship but also patronage. Hindi poets of the Mughal period (1526–1858) often spoke of the worth of a court on the basis of whether "gunis" (those with talent) clustered there. Once again on the authority of Matiram, we know that Bundi was just such a place. The poet praises Rao Surjan Hada (r. 1554–85) as the founder of Bundi and its attendant cultural life.[2] It was also Rao Surjan who established formal ties with the Mughal empire and, perhaps not coincidentally, the first known Bundi literature is a Sanskrit biography of this celebrated king.

The Literature of Bundi

Rajput rulers participated in the Persian culture of their Mughal overlords but when it came to their own patronage preferences, they typically sponsored texts in Indic languages. At Bundi, as at other contemporary courts that entered Mughal service, the charita (idealized biography) genre had a special cachet. The Bundi court favoured Sanskrit for this genre, as evident from Chandrashekhara's *Surjana Charita* (Biography of Rao Surjan, 1590s) and Vishvanatha's *Shatrushalya Charita* (c. 1635).[3] These charitas combined biography, hagiography and history and are profitably considered Rajput analogues of the influential Persian chronicles, such as Abu'l Fazl's *Akbarnama*, that were produced at the Mughal court during the same period. The rulers of Bundi sponsored charitas to make claims about the magnificence of their dynasty.[4]

There is also ample evidence for the Bundi court's interest in significant works of literature that originated elsewhere. Some, such as the popular story cycle *Madhavanala-Kamakandala* (see figure 3.18) and the compositions of the Brajbhasha poet Keshavdas of Orchha, were expertly illustrated by Bundi painters. One such painting accompanies the following verse from Keshavdas's *Baramasa*, which features an ingenious woman who cannot bear the thought of her lover's imminent departure (figure 5.1):

5.1 "Don't leave me in the month of Asarh!", from a Baramasa series, Bundi, c. 1780. Opaque watercolour on paper; 36.6 x 25.1 cm. Museum Rietberg Zurich, Gift Collection Horst Metzger, © Photograph: Rainer Wolfsberger.

The high winds gust fiercely in all directions.

How can you leave your beloved at home?

Have you lost your mind?

Ascetics adopt a single posture for the whole month.

Even birds stay put.

This is no time for a man to leave home!

Shrinath[5] too takes to his bed with Shri right by his side.

It's unheard of for a person to set out in the month of Asarh.[6]

Indian poetry is filled with the laments of the iconic virahini, the woman who is separated from her lover, but here Keshavdas presents an original twist. The nayika or heroine gives a series of arguments as to why the month of Asarh is completely unsuitable for travel. When the next month arrives, she makes similar arguments against travelling at that time. In the end, all of the twelve months (baramasa) of the year prove to have impediments and thus the lover is never allowed to leave.

The Rajput and Mughal elites of early modern India relished such vernacular poems and many were prompted to appoint their own court poets. If we have a good sense of where Bundi literature starts, its development and full extent are still not well established. Indian courtly literature is a neglected subject and countless works available in Indian palaces and manuscript libraries remain unpublished. An anchor for any discussion of the Hindi literature commissioned by Bundi rulers is Matiram Tripathi's *Lalitlalam* (Finest Lover), a collection of 400 Brajbhasha poems that were written, as the poet puts it, "for the delight" of the Bundi king Rao Bhao Singh (r. 1658–82).[7] We also have a good sense of the place of Bundi in the literary imagination of other Rajput courts since several Hada kings feature in the poetry of Hindi writers working for other patrons. But the full extent of Bundi literary heritage remains to be discovered.

Narrations of Self and Other: Praise Poems as Literary Portraits

The complexity of a court's self-narration is one important issue to consider when approaching Bundi literature. How did a court poet like Matiram speak about his Bundi patrons? One central mode of narration was dynastic, as in this poem that proceeds chronologically through the lineage of Bundi rulers:

Surjan's son was Bhoj, protector of the gods on this earth.

Bhoj's son was King Ratan, renowned as King Bhoja himself in charity.

Ratan's son was [Gopi]Nath, lustrous as a precious gem (*ratna*).

[Gopi]Nath's son was Chhatarsal, a respected leader (*nāth*) of men.

Chhatarsal's son constantly spears the hearts of his enemies (*shatruna ura sālata*).

Matiram says, King Bhao Singh garners acclaim in the world day by day.[8]

Each line of this verse, which forms a "connected chain" (ekavali), reconstructs the Hada lineage generation by generation while also underscoring dynastic continuity by cleverly referencing how a royal son embodies the qualities of his father. Thus, Rao Chhatarsal was esteemed as a nath or leader, an epithet that invokes his father's name, Gopinath. And Bhao Singh, Matiram's patron, shows the martial qualities of his father Chhatarsal (a common modern spelling but originally written Shatrusal) because he constantly "spears" (salata) the hearts of his enemies (shatru). Like portraits (figure

5.2 Maharao Buddh Singh of Bundi and his forebears at worship, c. 1730–35. Opaque watercolour on paper; 29.4 x 20.7 cm. Museum Rietberg Zurich, Gift Collection Horst Metzger, © Photograph: Rainer Wolfsberger. Buddh Singh is seated at the top right, facing (from the top left): Rao Chhatarsal, Rao Bhao Singh, and Maharajkumar Kishen Singh and his son Rao Aniruddha Singh. On the right below Buddh Singh are Rawat Devi Singh of Begun (in green), Maharao Durjansal of Kota, and Malhar Rao Holkar, three men who helped Buddh Singh during a period of political turmoil.

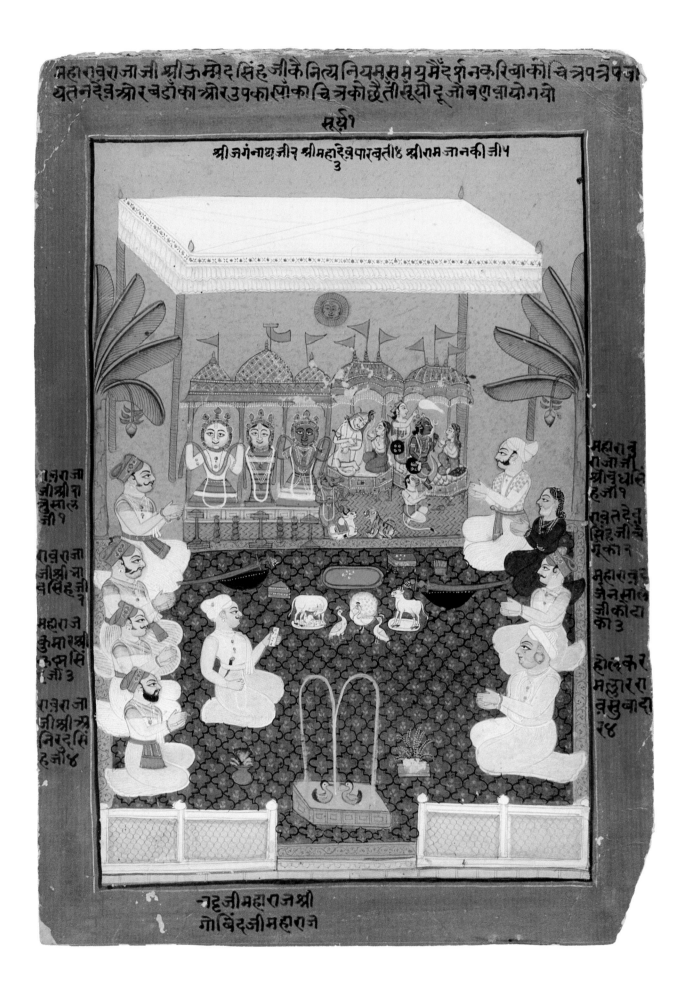

5.2), poems could serve as dynastic records that maintained the court's historical memory.

A longstanding Indian literary and inscriptional tradition was the prashasti or "praise" poem in honour of a ruler. These often showcase an interesting mix of generic and specific traits (the same can also be said of Indian portraits), since to be a king meant at once to achieve a certain paradigmatic form and to demonstrate individual worth. Since Bhao Singh was the patron of *Lalitlalam* it is only natural that he was also the focus of its panegyric intent. In several verses Matiram stresses the king's magnificent generosity (dana) or religious devotion (bhakti). Another prominent theme is sexual charisma, in keeping with longstanding norms of presenting Indian royalty as paragons of both the fecundity and the power upon which the prosperity of the kingdom depended. A person who is lalit is refined, and a lalit nayaka is the best type of lover according to Indian aesthetic theory. The likely import of Matiram's unusual Hindi title is to suggest that Bhao Singh was not just lalit but also the lalam ("forehead ornament") of all lovers, i.e., the very best.

Often Matiram's praise poems are politically inflected. Bhao Singh, like so many Rajput rulers of the day, was a mansabdar (ranked official) in the Mughal administration. He had an important post as a military commander in Aurangabad, and he took part in several of the Maratha campaigns in the Deccan alongside other leading mansabdars, notably

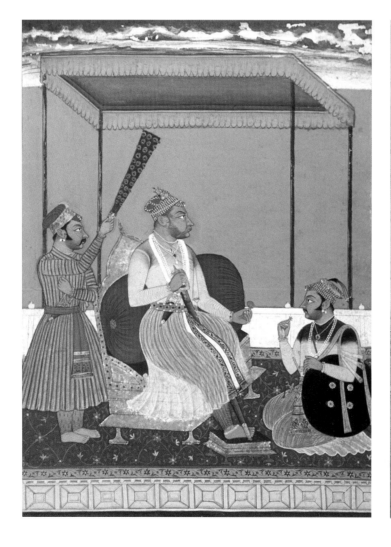

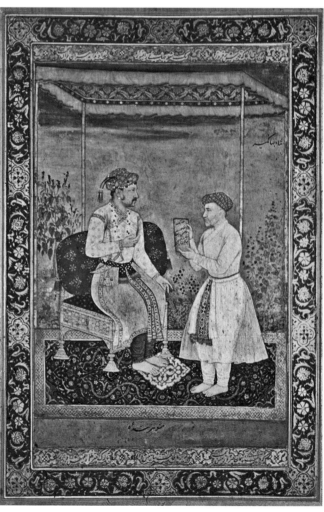

5.5 The town of Bundi and the Aravalli range. Photograph: Clark Worswick, 1968.

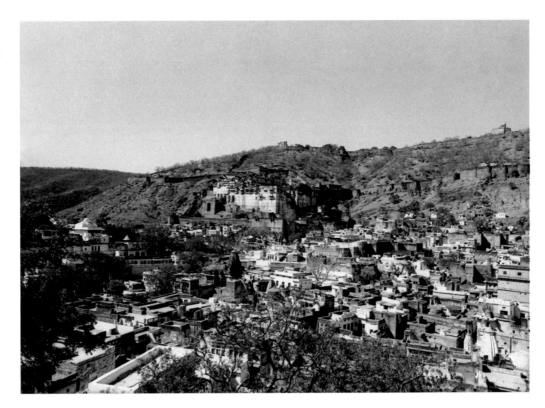

opposite
5.3 Portrait of Rao Chhatarsal of Bundi with his son Bhao Singh, Bundi, c. 1660–70. Opaque watercolour on paper. Formerly in the collection of Sangram Singh of Nawalgarh. Photograph: Milo C. Beach.

5.4 Jahangir and his vizier Itimad-ud-daula, from the Kevorkian Album, by Manohar, c. 1615. Ink, opaque watercolour and gold on paper; 39 x 25.9 cm. Metropolitan Museum of Art, 55.121.10.23.

Maharaja Jaswant Singh of Jodhpur and Maharaja Jai Singh of Amber.[9] Something of a balancing act was required for the simultaneous narration of the Bundi rulers as imperial servants to the Mughals—an ineluctable truth of the period for all Rajput rulers—and kings over their own domains.

What kind of cultural idioms were appropriate for the expression of Bundi political authority when the king himself was a subordinate to the Mughal emperor? In the case of portraiture, visual analogues between Rajput (figure 5.3) and Mughal (figure 5.4) styles indicate a shared vocabulary for kingly self-presentation. The Bundi painter responsible for figure 5.3 was manifestly aware of Mughal conventions and must have striven to present his patron in a manner that invoked imperial style, even if the final product remains squarely Rajput in its overall aesthetic. There are analogous cases for poetry. Matiram often stresses the Bundi court's authority in a style that draws on the language of Mughal governance while adding a local dimension. This might also be read as a subtle form of political insubordination. For instance, in these lines he embeds Persian titles in his Hindi poem to highlight Bundi power:

> Matiram says,
>
> The glory of King Bhao Singh, the rising sun of the Chauhan family,
>
> has expanded in every direction. How can the Mughal nobility (*umara*) even
>
> compare, when the emperor (*patshah*) of Aravalli parallels the [Mughal] *patshah*?[10]

This is not only a Mughal idiom, however. Invoking the Chauhans makes a specifically Rajput dynastic claim (the Bundi kings were descended from a Mewar-based branch of the Chauhan clan). Matiram also boldly asserts that Bhao Singh is "emperor of Aravalli", a reference to the mountain range that is a defining feature of Rajasthan topography, and the very landscape in which Rajput rulers expressed their kingly status architecturally through

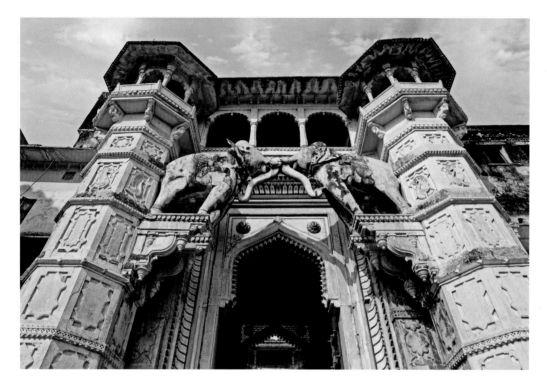

5.6 Hathipol, Bundi Fort. Photograph: Molly Emma Aitken.

the building of forts and palaces (e.g., figure 5.5). The claim that Bhao Singh is emperor of his own Aravalli region is a recurring motif in the *Lalitlalam* and its import seems clear. In an age when Rajput leaders were stationed as mansabdars all over India and challenged to prove their mettle, the rulers of Bundi demonstrably took pride in Mughal service and reaped its rewards but their own sense of political selfhood could not be denied.

As Bundi's court poet Matiram had an important political role to play and he used various strategies to execute that role. On some occasions he co-opted Mughal political idioms, infusing them with local salience; at other times he invoked classical tropes inherited from Sanskrit models of kingship. Any number of "literary portraits" of Bhao Singh readily attest to this point. For example:

A lion in warfare, worthy son of Chhatarsal,

you bestow spirited elephants, just like that.

Matiram says,

the heady fragrance of your fame spreads to the shores of the four oceans.

The world speaks of you as a Chauhan Sultan (*chahuvānī sulatānī*).

No king on earth comes close to being your equal.

Lord Bhao Singh, I see two things in you:

You are the rising sun of the Chauhan dynasty and the Sultan of Aravalli.[11]

Like the painted portraits for which Bhao Singh's reign is renowned (e.g., figure 5.7),[12] this verse makes an aesthetic and political argument about the king. He is a sultan of his region. He is wealthy and beneficent in his gifts of elephants—as earlier chapters have shown, elephants were associated with royalty, a typical gift to underlings, and a favourite decorative motif at Bundi; e.g., figure 5.6.[13] The poet also calls attention to his patron's widespread fame (kirti/yash), another classical kingly trait. A second literary portrait likens the Bundi ruler to Indra, the most regal of the Hindu deities:

5.7 Rao Bhao Singh of Bundi, by Tulchi, c. 1670. Opaque watercolour on paper. Collection of Rawal Devendra Singh of Nawalgarh. Photograph: Milo C. Beach.

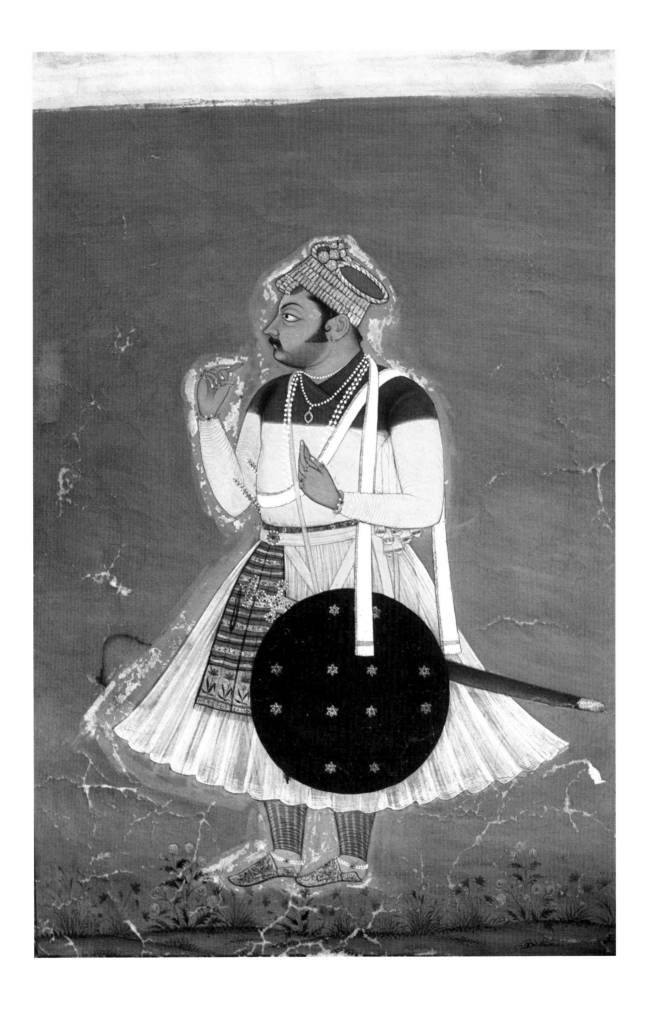

Wise men serve him, and he considers the gurus' words authoritative.

He is wrathful toward earthly enemies,

crushing the army formations of other kings.

A brimming sea of power finds force in his hands,

establishing his fame in the world.

You might think it is Indra of whom I speak

but it is His Majesty Bhao Singh.[14]

In this poem Matiram uses Hindi double entendres to reinforce his point. For instance, in line one the word for wise men, *vibudha*, also means "god" and the word for guru doubles as "Jupiter". The result is a powerful equivalence—powerful because it is reinforced at the level of language itself—between the Bundi king and the gods on high. The idea that earthly rulers were organically connected to the divine realm is also an important theme of Bundi painting.[15]

Matiram's *Lalitlalam* contains yet other clues about how the Bundi rulers saw themselves. A few verses evince something we might be inclined to see as communal partisanship, as when Bhao Singh is portrayed as "the shield of the Hindus" or "leader of the Hindus", but this spirit is by no means dominant in the work.[16] Matiram and his patron recognized that an important component of Mughal-period political ethics was to respect the lifeways of both Hindus and Muslims. Bhao Singh is accordingly praised with the epithet "leader of the two faiths".[17] This was also, incidentally, a title accorded to Jahangir by the poet Keshavdas, showing, once again, a rich consonance in cultural idioms across social and political milieus.[18]

Memories of Bundi Military Service

Being alert to instances of such consonance also proves useful when assessing the literary representations sponsored by the court. In presenting the early generations of Bundi rulers Matiram stresses their invaluable military service. Rao Ratan (figure 5.8) "attained great

5.8 Royal procession of
Rao Ratan Singh of Bundi,
c. 1615–20. Opaque
watercolour and ink on paper;
24.2 x 68.5 cm. Jagdish and
Kamla Mittal Museum of
Indian Art, Hyderabad.

5.9 Rao Chhatarsal riding an
elephant, c. 1655–60. Opaque
watercolour and gold on paper.
Kanoria Collection, Patna.
Photograph: Milo C. Beach.

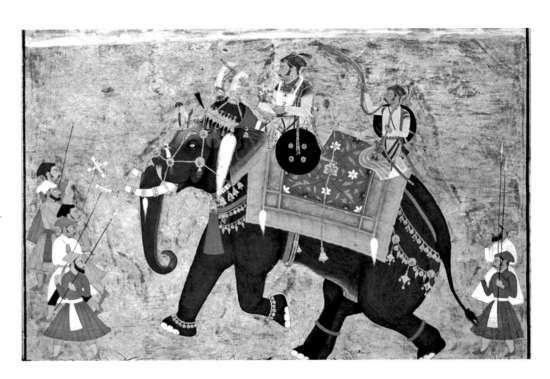

fame in the imperial wars", he notes, and was "a supreme ornament of the army."[19] This is
also an emphasis of the Sanskrit *Shatrushalya Charita*, mentioned above, and *Rao Ratan
Ri Veli*, a bardic composition in Rajasthani by the Jodhpur poet Kalyandas Mehadu.[20]
Contemporary Persian texts present a similar view. Jahangir, who benefited considerably
from Bundi military expertise, exclaims enthusiastically that Rao Ratan Singh Hada is "a
great servant of the court" and "a valiant Rajput chieftain". He was exalted first with the
title "Sarbulandi Rai" and later, after a stunning military success, "Ram Raj", the highest
title awarded in the Deccan. Rao Ratan also defended the emperor against an incursion
from his own son, Prince Khurram (the future Shah Jahan).[21]

When Shah Jahan fell ill in 1658 he too had to ward off the political rebellions of his
offspring and these events loom large in the literary records of Bundi and many other
Rajput courts. Matiram composed this prashasti poem to commemorate Chhatarsal, Rao
Bhao Singh's father (figures 5.3 and 5.9), for his heroic efforts to protect the emperor and
the heir-apparent Dara Shikoh:

The two armies clashed, prince against prince, and the whole world bore witness.

Martial songs blared, and all were primed for war, desiring a hero's fame.

Matiram says, [Gopi]nath's son did his duty, and the light of his fame brightened.

In shedding the blood of his enemies, Rao Chhatarsal was tried and true in battle.[22]

Ultimately Chhatarsal lost his life unsuccessfully defending Shah Jahan and Dara Shikoh
at the battle of Dholpur. Matiram's eulogy envisions his patron's father as having reached
"Kashi", or a place of liberation on the battlefield, his skull now adorning Shiva on Mount
Meru in heaven.[23]

Rao Chhatarsal's sacrifice was widely remembered beyond the Bundi court.
Maheshdas's *Binhairaso* ("Tale of Two", 1660s?), a Rajasthani narrative poem about the
Mughal war of succession of 1658, devotes considerable attention to the exploits of Rao
Chhatarsal and is a good example of why it is necessary to consider Rajput courts in

relation to one another and not simply in relation to the Mughals. Maheshdas, who was patronized by an entirely different Rajput clan, the Gaurs (and who thus would have had no special incentive to glorify the Hada dynasty), reports with great fanfare how Chhatarsal rushed to Agra to help the emperor after the imperial forces suffered a grave military setback at the battle of Ujjain (also known as Dharmat).[24] Out of all the people he could have summoned, it was the Bundi king whom Shah Jahan enlisted to try to remedy the situation (figure 5.10). Maheshdas reports on the Hada king's solemn acceptance of the emperor's charge:

> The Rao came to Agra and bowed at the feet of the emperor.
> He honoured him greatly, in all his majesty.
> With horses and elephants, a diamond-studded dagger, a gleaming jewelled sword,
> a shiny gold necklace and gems and emeralds that he had kept,
> the Mughal lord honoured him, and he readied himself, firm in his heart.
> He gave him a suit of clothing and betel.
> He placed the burden of Delhi on his shoulders.[25]

This notion that Rajputs carried "the burden of Delhi" is an important theme in Rajasthani literature. In Chhatarsal's case, and that of his 15-year-old son Bharath, who also bravely faced Aurangzeb's troops at the battle of Dholpur in 1658, the burden proved to be a heavy one. Maheshdas captures this succinctly: "they sacrificed their lives, performing manly duty".[26]

The consonance between the accounts of Matiram and Maheshdas is striking, even if they wrote in different Hindi dialects and resided at different courts. Both were deeply cognizant of Bundi military achievements and the kingdom's dynastic history.[27]

Notably, they also employ similar epithets for the Hada rulers. In Maheshdas's *Binhairaso* Chhatarsal is presented as "the lord of Hindus" but is also at the same time "esteemed among the two communities", suggesting his ability to protect his co-religionists while maintaining a non-partisan stance. And, although his Rajasthani poem is in part a celebration of imperial service, in which each Rajput must do his duty to the Mughal emperor, Maheshdas, too, points to the simultaneous capacity for regional political assertion when, as Matiram had done for Bhao Singh, he styles the Bundi ruler Chhatarsal "the emperor of Aravalli".[28]

Hindi writers continued to see Mughal service as a vibrant poetic subject into the next century, even as the empire began to weaken. We need only consider Krishna Bhatt's *Jajau Raso*, an unpublished Rajasthani poem about the Mughal succession war of 1707, so named because the battle took place at Jajau. As in 1658, the Mughal princes competed against each other in a deadly engagement. This time the antagonists were two of Aurangzeb's sons, Muazzam and Azam, and, once again, a Bundi king—in this case Buddh Singh (figure 5.11)—is shown in a key supporting role (on the side of Muazzam).

On this occasion the campaign is successful. "Buddh Singh achieved victory in a fraught engagement, cutting down his foes with his Deccani sword."[29] As often with Rajasthani war ballads, the poet creates wonderful sound effects that mimic the dashing of fierce warriors and the slashing of gleaming swords:

> *hakeṃ huṃkareṃ haṃkareṃ hāka pāreṃ,*
> *hakāreṃ hajāreṃ haneṃ hoḍa ḍāreṃ*

5.10 Portrait of a Hindu noble, presumably Rao Chhatarsal of Bundi, from the Late Shah Jahan Album, c. 1645–50. Opaque watercolour and gold on paper. Museum Rietberg Zurich, permanent loan Catharina Dorhn.

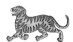

Such masterful onomatopoeic lines do not lend themselves to ready translation, but an approximate meaning is:

> Jostling and shouting, his troops pushed the enemy troops to the limit,
> slaying them by the thousands.[30]

Whatever perspective the Persian chronicles may present on Mughal events, it was always the prerogative of Hindi poets to showcase specifically Rajput valour. Rajput kings who generally merit only a few passing lines in a Persian account can attract an entire Hindi poem in their honour. Moreover, these poems frequently offer up their own slant.

The *Jajau Raso* puts Buddh Singh in the lead role at the battle of Jajau and his martial endeavours are given divine sanction in telling ways. As is often the case in early modern Indian poetry, the gods are seen as deeply connected to the threads of human action. In Krishna Bhatt's account Shiva and Parvati are shown in conversation up in heaven. Shiva gives his firm backing to the "greatly intelligent" Muazzam, who, crowned as the Mughal emperor Bahadur Shah (r. 1707–12), has "promised to protect the Hindus."[31] Once again, a commitment to Indian pluralism is presented as an important political ethic, and as grounds for a Muslim emperor gaining the approbation of Shiva. The goddess Kali, too, comes on the scene at the end of the work. She blesses Buddh Singh for his valiant efforts on behalf of the Mughal emperor.

Conclusion

Long after the Mughal heyday, the raos of Bundi continued to be celebrated in Hindi poetry. The Brajbhasha poet Padmakar, writing in Bundelkhand in central India in the 1790s, offered up this brief prashasti to them: "The Hadas are brave and excited to fight. Their worldly worth is in battle."[32] Bamkidas, an acclaimed poet from the Jodhpur court during the reign of Man Singh (r. 1804–43), memorialized Chhatarsal's honourable service to Shah Jahan and Dara Shikoh during the war of 1658. Like Matiram, who equated death on the battlefield with dying in Kashi, the highest form of liberation, Bamkidas found the language of pilgrimage a powerful metaphor for conveying the gravitas of a hero's death. He likened Chhatarsal's sword to a tirtha, or holy site, a place of crossing from earth into heaven.[33]

Generally the voices of Hindi writers have been little acknowledged when we look back at the Mughal period, with scholars giving overwhelming preference to imperial Persian sources. The investigation of Hindi literary expression in this essay has provided some additional views and, especially when combined with attention to the court's visual culture, offers clues about how the Bundi rulers saw themselves; how others saw Bundi; and how the Bundi court understood its role in Mughal political culture.

Hindi writers directed some of their efforts to the self-narration of the court. We see this in Matiram's attention to genealogy and statements that reveal the Bundi rulers' pride in their Chauhan lineage. Prashasti poetry, an established literary form whose primary purpose was the praise of kings, is an especially fertile genre for understanding the Bundi sense of self. Here it can be particularly helpful to trace relationships across the arts, since portraiture is a visual analogue to the prashasti style.

If noting genre crossovers can be illuminating, it is also useful to point to areas of discrepancy between painting and poetry. Narrativizing Mughal power is an important

theme of the Hindi literary records of this period, a subject that is largely absent from the world of painting. Of course, martial themes, a focus of this essay, are not the only poetry that was of interest to the court. Literature commissioned at Bundi covers a wide range of topics and includes devotional poems (especially about Krishna) as well as love lyrics that depict beautiful women and courtly diversions, including poetic compositions that elucidate the musical modes known as Ragamala. In these domains, which were more impervious to politics, there is much greater overlap between the visual and textual materials.

Mughal politics itself occasions differential treatment across the archive of Bundi literature. Sometimes the Mughal state is wished away by strategic omissions, as when

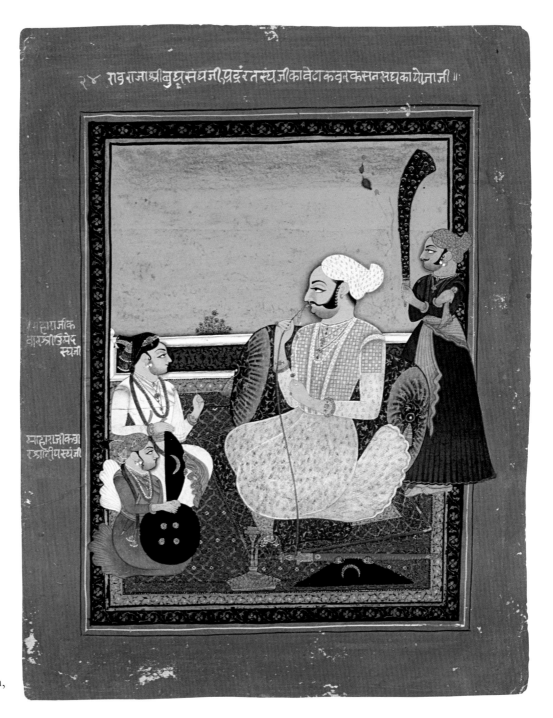

5.11 Rao Buddh Singh of Bundi with his sons Umaid Singh and Dip Singh, c. 1760. Opaque watercolour on paper. © Victoria and Albert Museum, London, IS.95-1955.

Chandrashekhara, an early Bundi court poet writing in Sanskrit, chose to focus on the Hada rulers, paying no heed to the dominant imperial power. At other moments, and this is largely true of the Brajbhasha and Rajasthani records, Mughal power sits front and centre. In modern popular understandings of Rajput-Mughal relationships Hindus are often thought to "resist" Muslims but the poetry tells another story, stressing cooperation and mutual benefit. The Hindi poets who wrote about Bundi show the court's pride in their military service and their willingness to fight to the death for the Mughal overlord. This is how Chhatarsal was widely remembered. And yet this is not to suggest an absence of political competition. In fact, Hindi poetry reveals the striking complexities of early modern political life. To claim of a Bundi king that he was "lord of the Hindus" or to praise the Mughal emperor for his protection of Hindus, as Matiram and Krishna Bhatt (respectively) did, points toward critical moments of negotiation about political and religious interests. And epithets like "padshah" or "sultan of the Aravallis" are arresting instances of how Islamicate terms were used to assert Bundi sovereignty. Narrations of self and other were, in other words, closely intertwined and drew on common cultural and political vocabularies.

ACKNOWLEDGEMENTS

The research for this essay was supported by a collaborative grant from the American Council of Learned Societies. I thank Molly Aitken and Keshav Bhati for their assistance in Bundi. I am grateful to the Maharaja Sawai Man Singh Sangrahalaya, Jaipur, particularly Chandramani Singh and Giles Tillotson, for permission to view the unpublished *Jajau Raso* in the Pothikhana (I also thank Aman Kumar for first pointing me toward the manuscript). Milo C. Beach has valuably contributed to my ongoing education about Bundi portraiture and I benefited from the astute comments of Molly Aitken and Cynthia Talbot on an earlier draft.

NOTES

1 "*Gīta kabitta kalāni ko, taham saba loga sujāna.*" *Lalitlalam* 1983, v. 7.

2 *Lalitlalam*, v. 22.

3 See Talbot 2012 and also chapter 4 in this volume.

4 Charitas are an important, if underutilized, resource for understanding early modern political culture. Contemporaneous examples of the charita genre can also be found in Brajbhasha and Rajasthani at neighbouring courts such as Amber and Orchha. Allison Busch, "The Classical Past in the Mughal Present: The Brajbhasha Rīti Tradition", in *Innovations and Turning Points: Toward a History of Kavya Literature*, ed. Yigal Bronner, David Shulman and Gary Tubb, New Delhi: Oxford University Press, 2014, pp. 648–90; see especially pp. 648–77. For further on Amber and Orchha, see chapter 6 by Edward Leland Rothfarb in this volume.

5 Shrinath ("Lord of Shri", i.e., Lakshmi) is an epithet of Vishnu and an apt choice in this context because it emphasizes the inseparability of the couple.

6 Keshavdas Mishra, *Kavipriya*, in *Keshavgranthavali* vol. 1, ed. Vishvanathprasad Mishra, Allahabad: Hindustani Academy, 1954, 10.27.

7 *Lalitlalam*, v. 38.

8 *Lalitlalam*, v. 260.

9 For a basic account of the political career of Rao Bhao Singh, see Gahlot 1960; Mathur 1986, pp. 143–54.

10 *Lalitlalam*, v. 58.

11 *Lalitlalam*, v. 165.

12 Bautze 1985, pp. 107–22.

13 For further on this point, see chapter 4.

14 *Lalitlalam*, v. 94.

15 See chapter 3.

16 *Lalitlalam*, vv. 34, 79. A similar expression is used in relation to Rao Bhoj in v. 25.

17 *Lalitlalam*, v. 140.

18 Keshavdas, *Jahāngīrjascandrikā*, ed. Kishorilal, Allahabad: Sahitya Bhavan, 1994, v. 31.

19 *Lalitlalam*, vv. 27–28.

20 On the *Shatrushalya Charita*'s portrayal of Rao Ratan, see chapter 4; Kalyandas Mehadu specifically references Rao Ratan's swami-dharma or commitment to the overlord. See his *"Rao Ratan rī velī"*, in *Aitihāsik Veli Saṅgrah*, ed. Narayansingh Bhati, Jodhpur: Rajasthani Shodh Sansthan, c. 1980, v. 99. I am grateful to Cynthia Talbot for the reference.

21 *Jahangirnama* 1999, pp. 288, 407, 433.

22 *Lalitlalam*, v. 195.

23 *Lalitlalam*, v. 33: "*nātha-tanai tihiṃ ṭhaura bhiryau, jisa jāni kai chatrina kauṃ rana kāsī/sīsa bhayo hara hāra sumerū, chatā bhayo āpu sumeru ko bāsī*" (The son of Gopinath entered the fray, knowing that for a kshatriya the battlefield is Kashi/His skull was added to Shiva's garland on Mount Meru, as Chhatarsal himself became a resident of Meru, i.e., heaven.)

24 "*Dilī madati dauṛiyā, pāṇṇa dharī būndī pattī*" (The Bundi king rushed to the aid of Delhi and remained steadfast). *Binhairaso*, 1966, 2:5.

25 *Binhairaso*, 2:6.

26 "*Prāna kaḷapi paurisa karai*". *Binhairaso*, 2:58.

27 Compare the treatments of Bundi genealogy in *Lalitlalam*, vv. 23–37 with *Binhairaso*, 2:7, 2:10.

28 These typical epithets of the Bundi kings are attested in *Binhairaso* 2:55 and 2:7.

29 Verse 18 in Krishna Bhatt, *Jajau Raso*, unpublished manuscript, Pothikhana, accession number #757, Maharaja Sawai Man Singh Sangrahalaya, Jaipur.

30 *Jajau Raso*, v. 18.

31 "*Bahādura sāhi mahāmativāna, karī pana rākhana koṃ hinduvāna*". *Jajau Raso*, v. 16.

32 Padmakar, *"Himmatbahadurvirudavali"*, in *Padmakargranthavali*, ed. Vishvanathprasad Mishra, Varanasi: Nagari Pracharini Sabha, 1959, v. 32.

33 There is a nice play on the word *dharā*, earth, and *dhārā*, sword blade. Bamkidas, *"Git Maharao Raja Satrasal Hada Hada Bundi Rau"*, in *Mahakavi Bamkidas Ashiya Granthavali*, vol. 1, ed. Saubhagyasingh Shekhavat, Jodhpur: Rajasthani Shodh Samsthan Chaupasani, 1985, p. 80.

PAINTED PALACES: EARLY 17TH-CENTURY RAJPUT ARCHITECTURAL DECORATION

EDWARD LELAND ROTHFARB

Krishna's circular dance, a painted tent, dragons, peacocks and celestial beings: such themes on the surfaces of early 17th-century Rajput palaces testify to the vibrant, varied world of architectural decoration. In the 16th century's last decade and the opening decades of the 17th century, new palaces were constructed in the Rajput kingdoms of Bundi, Orchha and Amber that were adorned with murals and painted reliefs, among other forms of decoration. Each of these palaces was built and decorated at the behest of a royal Rajput patron who enjoyed elite status at the Mughal imperial court of the emperor Akbar (r. 1556–1605) and/or that of his successor Jahangir (r. 1605–27). All of these palaces boast impressive programmes of wall-painting, which, to varying degrees, have suffered deterioration and, in certain cases, over-restoration. Despite their compromised physical state they remain key documents of early Rajput wall-painting.

It is our goal in this chapter to place the murals at Bundi in a contemporary context by examining the wider production of Rajput painting through the lens of architectural decoration. We will focus on four decorated palace ceilings of western and central India, each adorned with a circular theme set within an elaborately vaulted or domed chamber. The rasamandala, a Vaishnava theme depicting Krishna's circular moonlit dance with the gopis, graces two of these ceilings, the first painted at the Badal Mahal of the Palace of Rao Bhoj in the fort at Bundi (figure 6.12), while the second is a carved and painted relief in the Govind Mahal in Datia, in the former kingdom of Orchha (Madhya Pradesh). The third ceiling, a decorated dome interior with male dancers and avian imagery, is also at the Datia palace, while the pavilion-like palace at Bairat, in the erstwhile kingdom of Amber (eastern Rajasthan), is the site of the fourth. This last mural exhibits a divergent theme, a painted assembly of peris—winged celestial beings derived from Iran—bearing blossoms, vessels and musical instruments.

We will look at developments in the central Indian kingdom of Orchha under Raja Bir Singh Dev Bundela (r. 1605–27) and the Rajasthani kingdom of Amber under Raja Man

6.1 Rasamandala, from a dispersed *Bhagavata Purana* series, Palam (Delhi) area, c. 1525–40. Opaque watercolour on paper; 17.5 x 22.8 cm. Philadelphia Museum of Art (125th Anniversary Acquisition. Alvin O. Bellak Collection, 2004).

Singh Kachhwaha (r. 1589–1614) in a period roughly coeval with the reign of Bundi's Rao Ratan Singh (r. 1607–31), the ruler responsible for much of the exceptional decoration of the Badal Mahal. We focus on two aspects of architectural embellishment at these courts—style and iconography—in order to better gauge what these murals share and what distinguishes them from each other. We will also examine the relatively nascent Rajput engagement with Mughal visual culture at this time and how it affected the decoration of palaces in these three kingdoms. Through this investigation we explore the circulation of visual ideas in these three early 17th-century Rajput courts.

Visual Traditions

By the first decade of the 17th century the political, religious and artistic milieu of these courts was rich and increasingly complex. With the important exception of Mewar under the Sisodia dynasty, which would achieve a treaty with the Mughal empire in 1615, many Rajput kingdoms had already been in alliance with the Mughals for decades, a process that had been initiated in the mid-16th century by the previous generation of Rajput rulers.[1] Their courts' subsequent engagements with Mughal military, administrative and courtly culture had a varied impact on the arts of their kingdoms. We can assume that the majority of artists working for Rajput courts in this period had training in the indigenous Rajput and Hindustani visual traditions that had developed since at least the later 15th century at older Rajput courts such as Chittor and Gwalior as well as at urban mercantile centres of the Delhi and Malwa sultanates. These styles, known variously as "Early Rajput Painting" and the "Chaurapanchasika Style", emphasize bold, emotive, largely unblended colours, which are used in both an abstract and descriptive sense. They feature flattened, sometimes compartmentalized space, expressive line, stylization of form and a strong, graphic approach to composition.

The painted rasamandala scene in the dispersed *Bhagavata Purana* (also known as the Palam or Sa Mitharam-Sa Nana *Bhagavata Purana*) is an appropriate illustration for this style of painting for its thematic and distant stylistic connection to the two palace depictions of the same theme that we look at here (figure 6.1). We do not know the exact patron for this work produced somewhere in the region of Palam in Delhi, but it was clearly an elite and important production, with 10 artists producing as many as 300 or more folios illustrating the Tenth Book of the *Bhagavata Purana* sometime between 1520 and 1530.[2] The artists who created the ceiling decorations we are examining were likely trained in traditions that hearkened to the visual approaches employed in works like this *Bhagavata Purana*, one of the earliest extant depictions of the rasamandala on paper. The prevailing vision here is abstract, cosmic and iconic, with two bright red concentric roundels containing the sacred scene. The red background, a feature of much painting in this set, is an auspicious setting for the god, who is depicted fluting at the centre. The figures, with faces seen in profile and prominent almond-shaped eyes derived from earlier 15th-century Hindustani precedents, move jauntily, their torsos slightly inclined and narrowing at the waist. The red roundel is fixed like an icon within a stylized vision of the landscape of Vraj, the region north of Agra where Krishna spent his childhood and adolescence. The artist has set blossoming trees against a black background and framed it with a lush riverine setting below and the full moon in the nighttime sky above. The

goal of this style was to capture a timeless sacred or poetic moment rather than conveying a specific time, place or personage of this world. In this and other aspects, early Rajput painting constituted a highly divergent artistic vision from the Mughal styles that were to develop decades later in the reigns of Akbar and Jahangir.

The thrust of Mughal art, which drew on Persian, Hindustani and Western European traditions, was verisimilitude, naturalism (to a degree) and reportage—of events, actual or legendary; of places, real or invented; of objects and animals; of people via portraiture. Pictorial space featured depth and a sense of context; colour was subtle and often executed via expensive pigments. Book arts, including binding and illumination, were highly developed, as in the Persian and Central Asian courts that provided models for the Mughal atelier. By the last decades of the 16th century a number of indigenous artists who had originally been trained in Rajput styles were attached to imperial and aristocratic Mughal courts as well as urban ateliers at Agra and Lahore, where they received training in Mughal approaches to painting and design. Some of those artists went on to work for Rajput courts, as indicated in the inscription in the 1591 Chunar Ragamala created for the Bundi rulers Rao Bhoj Singh (r. 1585–1607) and possibly his son Rao Ratan Singh (r. 1607–31).[3]

Thus, in the late 16th and early 17th century, the courts of Bundi, Amber and Orchha had access to artists trained in local Rajput styles and, if they wished, could also engage artists with some exposure to Mughal styles. As a result, highly selective adaptations of Mughal styles begin to appear in painting patronized by Rajput rulers—among the earliest of such works, the aforementioned Chunar Ragamala—and are evident in aspects of architecture, painting and decoration in Bundi, Amber and Orchha by the early 17th century. The presence of such Mughal visual approaches at Rajput courts depended on a number of factors: the artist's/designer's direct or indirect training in Mughal styles, the degree of that court's intention to exhibit engagement with Mughal culture, and the audience for the artwork. What we see developing at these early 17th-century Rajput courts is an exciting and unprecedented visual blend of Rajput and Mughal approaches to art, a negotiation of style and subject matter that contributed to these courts' distinctive visual identities.

Datia

The rasamandala ceilings at the Govind Mahal in Datia and Bundi's Badal Mahal are among the earliest extant depictions of this theme in Rajput palace decoration. We look first at the two Datia compositions, both of which were created in the magisterial Govind Mahal, a squared, symmetric, multi-storeyed courtyard structure with a domed tower at its centre (figure 6.2). The Govind Mahal is the greatest expression of the single, symmetric courtyard Rajput palace form that developed in the Orchha kingdom and can be contrasted with the more widely encountered aggregate, asymmetric Rajput palatine form, a premier example of which is the sprawling hillside fort at Bundi, which was added to over the centuries (see figure 5.5).[4] The Datia palace, begun in 1620, is also one of the most richly decorated hunting palaces ever built—and then barely occupied—in India. At the Govind Mahal the Orchha court's artists and designers innovatively brought a style grounded in Rajput tradition to a new level of opulence that could only have been supported by a protean architectural patron like Raja Bir Singh Dev Bundela, a ruler of tremendous wealth and power, who built this palace towards the northern edge of his large kingdom.

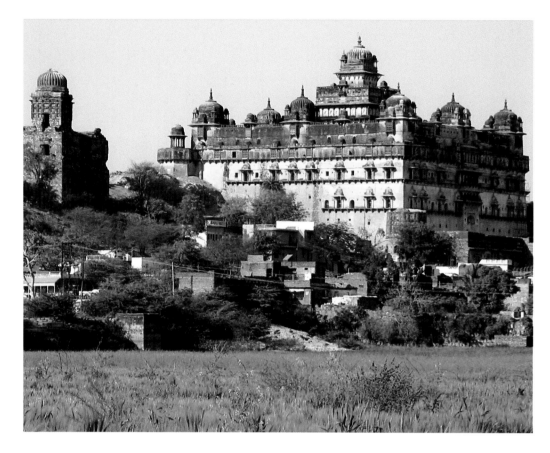

6.2 Govind Mahal, Datia, c. 1620, view from the southeast. Photograph: Edward Leland Rothfarb.

A carved and painted rasamandala scene is located in a tripartite chamber on one of the palace's lower ceremonial floors (figure 6.3). Due to relatively recent restoration work the mural is heavily painted in unblended pigments of carmine, ochre, white and black, a scheme that one presumes derives from its original colours, but not its original execution, given the palace's high craftsmanship. The circular composition is arrayed around a large carved flowering lotus representing the moon that bathed the ecstatic dancing Krishna and gopis in its light. The relief effectively conveys rhythmic, vigorous, somewhat percussive dance movements while possessing an almost iconic quality of stillness and composure. The figures stare outwards, full face. Their legs are poised in static postures. The relief is largely animated by the treatment of the attire rather than bodily gestures, save for the dancers' raised arms and joined hands. It is the use of carved, curved and flowing line animating the garments—from the gopi's rippling skirts and flaring odhnis (scarves) to the musicians' waving patkas (sashes) and the staccato texture of Krishna's short pleated skirt— that imparts the greater sense of movement to this composition. There is little engagement with naturalism here, yet in the elongation of the dancers' bodies and the flowing lines of their garments one senses a distant nod to current Mughal artistic taste at the court of Jahangir, who had placed Bir Singh Dev on the Orchha throne.

While the style used in the Orchha ruler's palaces drew largely on Rajput tradition, Mughal motifs abound, as they do at all of the sites under discussion. From the rasamandala to chini khana, meaning "China room", a motif of wall-niches containing vessels etc.; from ragamalas to peris, the assemblage of themes and motifs drawing upon Rajput and Mughal sources alerts us to a new, more complex canon of iconography in early 17th-

6.3 Rasamandala, ceiling relief in a tripartite chamber on one of the lower ceremonial floors in the Govind Mahal, Datia, c. 1620. Photograph: Edward Leland Rothfarb.

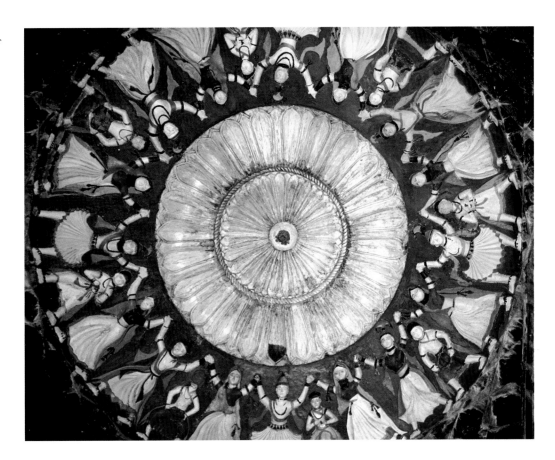

century Rajput architectural decoration. Bir Singh Dev's designers clearly had cognizance of imperial art, although they chose to interpret those motifs in the local rather than a "Mughalized" style, which is to say with a comparatively flatter, less contextualized sense of space, with more stylization, and with unblended, bold colour. Another ceiling at the Datia palace offers a further intriguing glimpse of both local and Mughal references and the richly reinvigorated traditional style in which they were rendered.

The domed chamber crowning the Govind Mahal's central tower was likely intended for Raja Bir Singh Dev's personal quarters and is the palace's most hierarchically charged space (figures 6.4–6.6). The dome interior is decorated with an ebullient, albeit much damaged, mural transmuting the sacred circular rasamandala theme into a courtly scene of the Dandiya Rasa or Stick Dance (the sticks representing swords of the Goddess Durga in her fight with the demon Mahisha), a western Indian dance form. The noble, all male dancers, flanked by musicians, are attired in Mughal court-style clothing of the Akbari era, although this scene was painted late in the reign of Emperor Jahangir. At Datia, however, we are in the provinces and at a Rajput court that might depict itself in a more conservative fashion than would have obtained in the Mughal capitals. Thus, we have Akbari-style turbans; fringes on the jamas (robes) buttoned to the left; fringed tabs beneath extended left arms in the style worn by Rajputs at the imperial Akbari court; and—quite out of fashion by the 1620s—six-pointed jamas on the dancers. All of the participants' heads are rendered in full profile with a single prominent eye, a style pointing to Rajput painting traditions continuing from the previous century (e.g., figure 6.1). The mural's many elements are stylized and expressive with little hint of naturalism. The male dancers' bodies move in an

exaggerated angular fashion, their shoulders diagonally skewed and their stick-wielding arms slicing through the air. Their attire appears to whirl with the dance, an effect much like the carved and painted figures in the rasamandala relief a few storeys below.

The dance, alive with its gesturing nobles and musicians, is but one component of the scene decorating the dome, for above floats a gorgeous faux painted textile, a heavenly tent inset with elaborately worked multicolour floral arabesques and hung with tiered bells surmounted by addorsed peacocks (figure 6.5). The bells—either the artist's marvellous invention or a glimpse of Rajput material culture that has been lost—extend downwards to just above the dome's drum and are flanked by large confronted peacocks, beaks open and crests erect, as well as more arabesque multicolour medallions. The floral imagery in the arabesques derives from designs pioneered at the Mughal court for decorative wall-painting, book illumination and carpet design. Such intricate decorative floral painting and, more generally, a highly developed sense of patterning, inlay and stucco work was a particular hallmark of architectural decoration under Jahangir and converges here with the Orchha court's own inclination to such invested decorative expression.

6.4 A courtly version of rasamandala with noblemen, dancers, peacocks and arabesques, ceiling painting in the domed chamber crowning the central tower, Govind Mahal, Datia, c. 1620. Photograph: Edward Leland Rothfarb.

opposite
6.5 and 6.6 Details of figure 6.4.

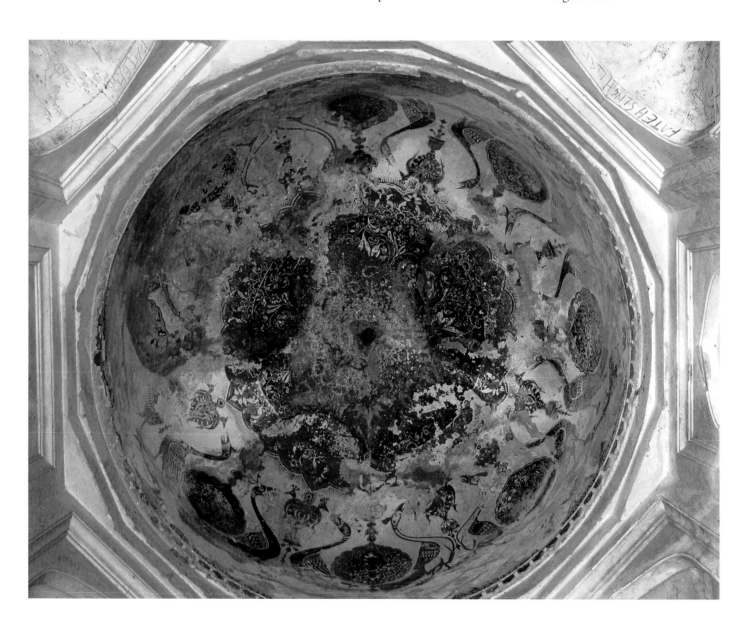

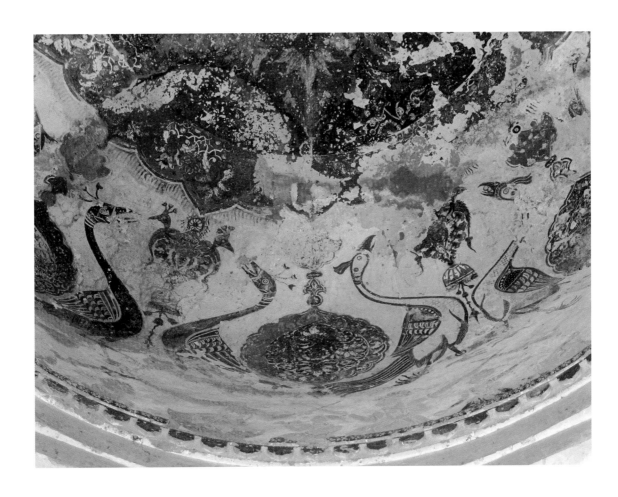

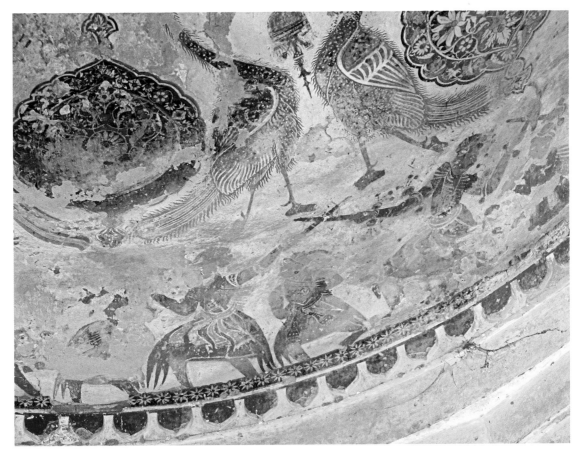

The effect of this mural is crisp and graphic, yet also refined, as if composed of inlay, a technique literally employed for other murals in this palace. Indeed, the use of pigmented chunam, a type of stucco, which is laid in multiple carved channels to compose an image, is uniquely encountered at this palace and seems to inform the construction of the style here, whether or not that technique was actually used in a particular work. Thus, the peacocks' feathers and the dancers' garments, like many of the images here, are composed of white stencil-like lines that enclose areas inlaid with single colours (see especially figure 6.6). Line is also used to differentiate shapes, to create designs and textures and, uniquely, to outline shapes with wave-like linear serrations or fringes. These fringes, employed for various shapes, animate and inanimate, suggest feathers in the case of avian imagery, and more broadly engage the object with surrounding negative space. This is yet another aspect of the mural painting technique that is unique to the Datia palace, where the style is vigorous, well-crafted and sophisticated.

Bairat

Comparing these two circular compositions at the Govind Mahal with one of the dome murals at the palace at Bairat, in the erstwhile kingdom of Amber, reveals a similar use of Mughal motifs, among others, but a more perfunctory, less skilfully crafted style grounded in Rajput tradition (figures 6.7 and 6.8). The Bairat murals, which had suffered great deterioration, were simply painted over rather than conserved, in a misguided effort at restoration; thus the artist's original "hand" is lost to us, save through earlier photo documentation.[5] The Bairat palace, which was built as a hunting pavilion, is considerably smaller than the massive Govind Mahal and its design draws directly on a Mughal

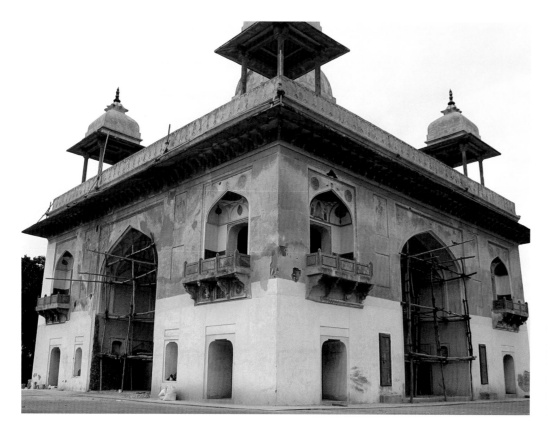

6.7 Water Palace, Bairat, period of Raja Man Singh Kachhwaha (early 17th century), exterior view under restoration. Photograph: Edward Leland Rothfarb.

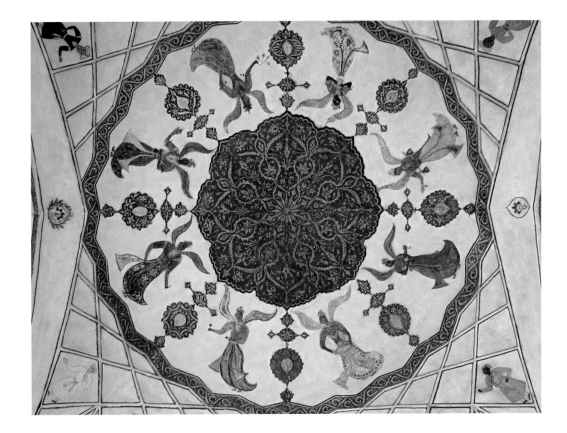

6.8 Mural of peris in the northeast hall, Water Palace, Bairat, early 17th century. Photograph: Edward Leland Rothfarb.

architectural prototype at nearby Narnaul, the Jal Mahal water pavilion built by Mughal courtier Shah Quli Khan around 1590. The Bairat pavilion, similarly set within a broad water tank platform, was either gifted to the Amber ruler Raja Man Singh Kachhwaha, a great architectural patron and one of the most important nobles at Akbar's court, or built by him around 1600.[6] It is important to note that Raja Man Singh, one of the greatest Rajput architectural patrons, built in a variety of styles to suit his dual roles as Rajput king and exalted Mughal official. At Rohtas in Bihar he employed a purely Mughal style linked to Akbar's Fatehpur Sikri for his imperial governor's palace, while at his dynastic seat in Amber he used a more traditional Rajput fortress palace style. Although the architecture of the Bairat palace is purely Mughal and based on the typical hasht behisht or nine-fold chamber plan, its decoration hews to Rajput tradition and was likely executed by local artists with limited cognizance of Mughal painting styles. Nevertheless, the iconography chosen here, like that of the Govind Mahal, freely mixes Rajput themes of martial prowess and Hindu narratives with motifs drawn from the court painting of the Mughal emperor Jahangir.

We focus here on the decoration of the northeast hall, one of the palace's four domed halls, with its circular composition of winged peris attired in long robes and peaked Jahangiri-style caps (figure 6.8). Each of the eight peris in this mural is flanked by small arabesque medallions while an immense round floral arabesque fills the dome's central area. Beneath, squinches transition downwards from the dome, some of them painted with generic figures of male courtiers in Mughal attire. The pavilion was probably painted in two phases, the latter phase marked not only by a certain elongation of figure and attire associated with the period of Jahangir but also by imagery uniquely associated with

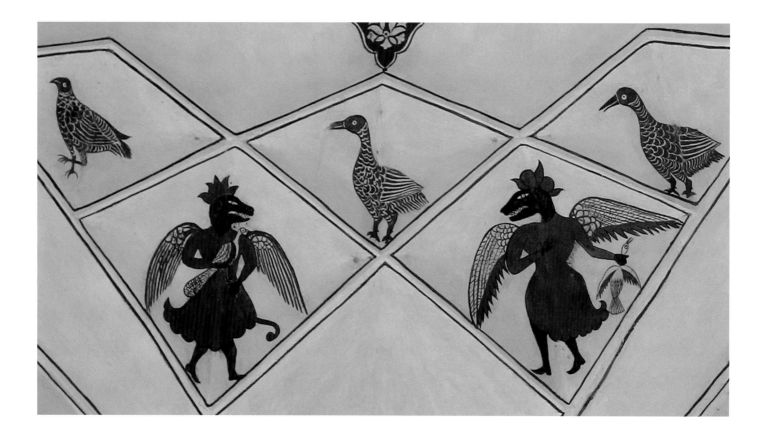

architectural decoration at the court of Jahangir. Scenes of angelic beings such as peris feature in Jahangiri painting on walls and paper and were adapted from both Persian and European sources. The iconography of angels and other winged beings like birds and the winged djinns (demons) holding birds, which appear on the northwest hall's squinches, alludes to the magical flying court of Suleiman, the biblical Solomon, who was the very model of a just ruler for Islamic kings (figure 6.9).[7] Such iconography at Bairat shows a provincial reflection of imperial imagery, yet the style on view here strongly diverges from the highly refined, naturalistic depictions of celestial beings associated with imperial patronage. Instead, the local designers translated Mughal source material with a loose sense of the original model—whatever that might have been—as in the elongated figural type and attire that they employed, but with an entirely divergent vision. At Bairat the winged figures are flattened, stylized and notational with flowing silhouettes, very loosely patterned attire, and traditional Rajput features such as faces in profile with prominent single eyes. There is little sense of the body animating the movement, save for the flow of the scarves and wings.

Compared to the sophisticated and carefully crafted style at the Govind Mahal, which is also firmly grounded in a traditional sensibility, the style and execution at Bairat is comparatively simpler and follows a different trajectory. Consider the floral arabesques at both palaces (figures 6.4–6.6, 6.8 and 6.10). The arabesque had been part of the standard decorative repertoire in Hindustan since the Sultanate period and was a motif transmitted to the Rajput milieu via the Mughals, who had reinvested it with the refinement of Iranian prototypes and the naturalism stemming from their inclination towards observation. At the Govind Mahal the arabesques are robust and rendered in multiple colours, an

6.9 Mural of djinns in the northwest hall, Water Palace, Bairat, early 17th century. Photograph: Edward Leland Rothfarb.

6.10 Arabesque mural in the Water Palace, Bairat, early 17th century. Photograph: Edward Leland Rothfarb.

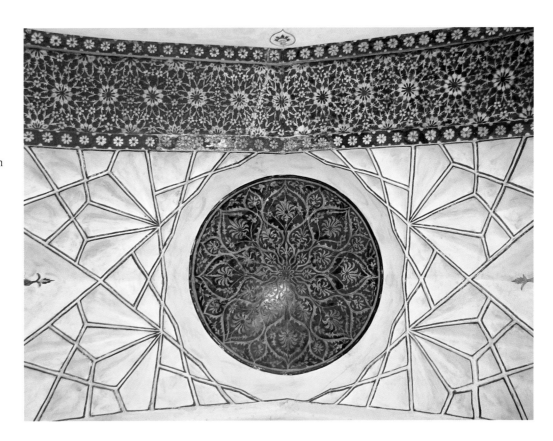

approach similar to Mughal prototypes, while at Bairat they are painted in carmine and white, a standard approach for both Rajput and Mughal patrons and a less expensive mural treatment. At Bairat the artists have not only depicted a more restricted range of blossoms than at Datia but they have rendered them with less invention and attention to detail. While the arabesques at the Govind Mahal contain an intriguing tension between the complex pattern's overall unity and the fine articulation of its constituent parts, the Bairat composition veers towards a flat, less articulated patterning.

It is instructive to compare the Bairat mural of peris with the painted frieze in the courtyard of Raja Man Singh's original palace at Amber, the so-called Zenana Mahal, a courtyard palace built in the last decade of the 16th century and, presumably, with decoration commenced around that time. By looking at the Amber palace we can gauge a further sense of decoration in Raja Man Singh's kingdom; in this case at his dynasty's seat (figure 6.11). At the Zenana Mahal the original friezes between the brackets upholding the courtyard balcony are painted with mounted horses, elephants, camels and human figures, some in architectural settings. The paintings, simple in design and rudimentarily rendered, likely derive from a vernacular style of wall-painting executed by local artists who were not exposed to the more sophisticated stylistic options, Rajput and Mughal, then available in Hindustan. As such, these paintings offer us a portrait of a completely localized, non-cosmopolitan Rajput style at the close of the 16th century. It is important to remember that Raja Man Singh was one of the most powerful men in Hindustan, and his designers would have had many options here, but this approach is what was chosen for the palace's original decoration. However, within a decade or two later, possibly when Raja Man Singh still ruled (he died in 1614), a new set of paintings appear in the Zenana

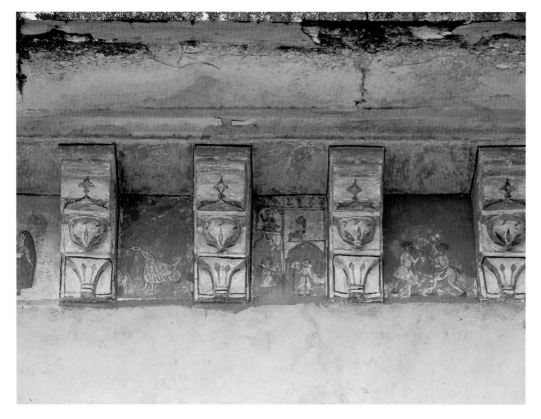

6.11 Bracket mural in southern court (Zenana Mahal), Amber Palace, late 16th–early 17th century. Photograph: Edward Leland Rothfarb.

Mahal. Most of these are in a fragmentary state at present, but they reveal more carefully composed and crafted scenes distantly reflecting the elongated figural elegance of Jahangiri painting. The Bairat murals (figures 6.8 and 6.9) fall somewhere between these two styles: while they lack the elegance of the later Zenana Mahal paintings at Amber, they are more assuredly crafted than the earlier courtyard frieze paintings at that palace; moreover, unlike the Amber frieze paintings they indicate cognizance of Mughal iconography, with their Solomonic imagery of peris, winged djinns and birds common at the court of Jahangir. We will see the same iconography of peris, as well as birds—fantastic and ordinary—and even dragons (which also appear on the entranceway at the Govind Mahal and once supposedly decorated Bairat's outer walls) at the Badal Mahal in Bundi, where they are rendered with comparatively greater expression, verve and richness than at the other two palaces.

Bundi

At Bundi, the local rulers Rao Bhoj Singh and his son Rao Ratan Singh, the former a Mughal governor posted far from his kingdom at Chunar, near Varanasi, would build and decorate a palace beginning in the mid-1580s in a traditional local Rajput architectural style. That structure, among the earliest portions of the sprawling hillside Bundi Fort complex, is now known as the Palace of Rao Bhoj. The Badal Mahal, the uppermost chamber of the Palace of Rao Bhoj and likely a ceremonial room judging by its size and elaborate treatment, was decorated during the reign of Rao Ratan Singh in the first three decades of the 17th century and perhaps afterwards as well (see chapter 3 by Milo Beach). That chamber's complex ceiling vaults draw on Mughal architectural precedents that had become widely used in Hindustani religious, funerary and palatine architecture. The room's

elaborate decoration, some of the most inventive, vibrant and accomplished wall-painting in all of Rajasthan, if not north India, can be seen as a dance towards, as well as away from, Mughal painterly prototypes from the reigns of Akbar and Jahangir.

We have noted that Krishna's circular dance is depicted at both the Bundi Badal Mahal (figure 6.12) and the Govind Mahal in Datia (figure 6.3), the former in paint and the latter via a carved and painted relief. The composition of both of these early 17th-century works diverges from the early–mid-16th-century *Bhagavata Purana* folio scheme in which Krishna flutes alone in the central roundel and the gopis dance in the outer circle (figure 6.1). At the Bundi and Datia palaces Krishna dances with the gopis while a similar architectural feature, a carved round lotus, occupies the central space. At Datia the musicians, all male, are placed in the same circular register as the dancers, while at Bundi the female musicians occupy the composition's edge amid banana trees and blossoms. The latter device is critical, for with it the Bundi artists have not only created a context, a setting that evokes the lush riverine landscape in which the miraculous dance took place, but they have also skilfully integrated the entire composition through this rhythmic border of flora. The Datia composition lacks a sense of setting and is comparatively terse, iconic and somewhat abstract in its narration. In this sense it falls closer to the inherent abstraction of the century earlier *Bhagavata Purana* rasamandala painting, at least to its central image of the god and dancers framed in flat red roundels.

At Bundi, on the other hand, the artists achieved a deft balancing act, seamlessly integrating sacred abstraction with a level of observation derived from Mughal example, albeit at a certain remove. The dancers are arrayed against a red background, the auspicious cosmic setting that recalls the earlier *Bhagavata Purana* painting on paper (compare figures 6.12 and 6.1). Nevertheless, the treatment of the dancers and landscape embodies quite a different approach hinting at observation rather than abstraction. It suggests a degree of exposure to Mughal styles of painting that the Bundi artists altered and adapted to local taste. Consider the gopis' encrusted jewels, their diaphanous, delicately waving scarves and the blossoming Persianate branches beneath them. As Milo Beach has noted, this rasamandala mural is already more removed from Mughal sources than the earlier and more carefully observed figures in the court and hunting mural occupying the Badal Mahal's second register on the wall below. Still, the artists here animated their figures with convincing gestural movement derived from the body rather than reliance on attire to suggest movement, as seen at the Govind Mahal and Bairat. Krishna and the gopis incline their heads towards each other, a pose suggesting emotional engagement. Their legs, bent at acute angles as they dance, foster a sense of graceful flow and whirling movement.

The Bundi artists also employed a highly nuanced use of colour, again, in the manner of Mughal painting, and were attentive to detail. While the artists at Datia were masters of strong, graphic composition, a physical approach to painting and rich decorative surfaces, the Bundi artists were masters of the painterly gesture, of weaving a setting and endowing it with exquisite yet vigorous detail, and of rendering the whole in lavish, expressive colours.

Synthesis of Rajput and Mughal Imagery

The artworks that we have considered at Datia, Bairat and Bundi are noteworthy not only for what they reveal about style in early 17th-century Rajput architectural decoration but

also for their unprecedented use of imagery rarely seen together at Rajput courts before this period. From peris and djinns to gorgeous arabesques, from noblemen dancers dressed in Mughal court attire to Krishna and the gopis, this is a new canon of iconography drawing on diverse sources, Rajput and Mughal, Hindustani and Persian, being displayed on Rajput elite structures. The components of this canon include Mughal imperial imagery associated with Jahangir's reign such as peris, djinns, and avian imagery; chini khana with vessels and blossoms; and figural scenes of royalty and courtiers, the latter a practice already well established in the reign of Jahangir's father, Akbar. Mughal and Sultanate literary court culture contributes illustrations of Persian literary narratives, notably key scenes

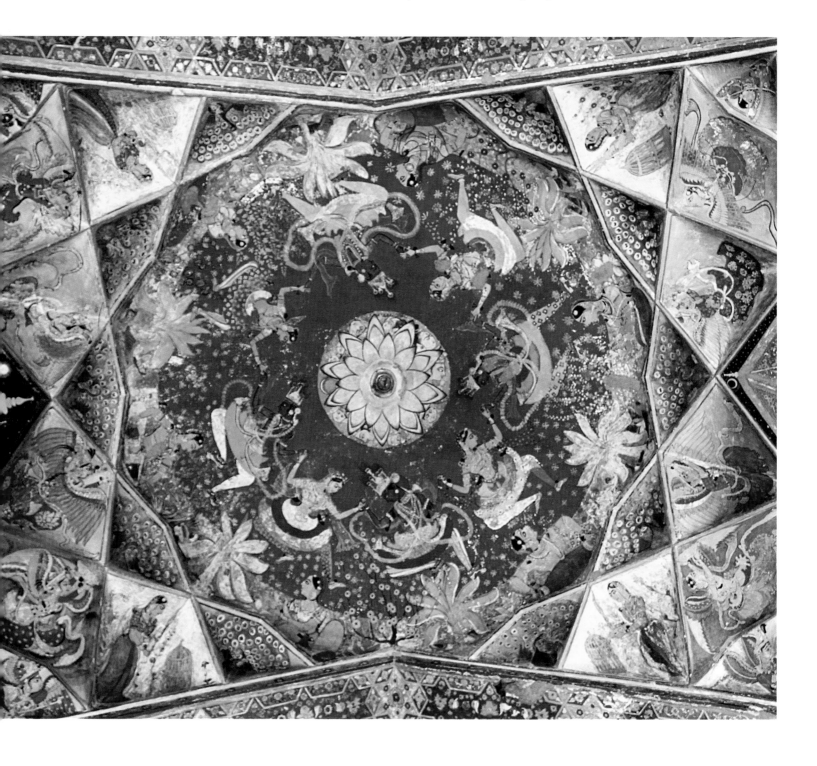

from *Layla and Majnun*, from the *Khamsa* of the Persian Nizami and the Hindustani Amir Khusrau Dihlavi. Then there are Rajput courtly themes of martial arts, including wrestling and swordplay, hunting and, very important, ragamalas. Finally this new canon of iconography quite naturally embraces religious subjects, notably Vaishnava devotional themes depicting the life of Krishna that had emerged with new popularity during the 16th century and, to a lesser degree, scenes from the life of Rama, which are on display at the Badal Mahal.

The exposition of this new canon entailed not only synthesizing motifs but also the simultaneous display of discrete imagery culled from disparate sources. Thus, we have a characteristic Mughal painterly convention such as lines of birds flying across the sky, set within depictions of the sacred groves of Krishna's adolescence; or the display of simurghs, fantastic creatures from Persian mythology, on the same wall as ragamala scenes. Such blending that took place in Rajput mural painting and works on paper is part of the broader stylistic synthesis within early 17th-century Rajput visual culture in which a hybrid style containing Mughal elements begins to appear. This type of painting, first placed under the rubric Popular Mughal, is more accurately thought of as a Mughalized style produced by various Rajput courts and urban ateliers, although assigning works to their exact sources remains problematic without firm documentary or stylistic evidence. Wall-painting at the very least leaves no question as to provenance and can illuminate stylistic issues for works on paper. The simultaneous presence of motifs culled from different sources and the stylistic synthesis on display in these early 17th-century Rajput structures affirms that this visual canon, although relatively new, had already become a unified, inclusive cultural expression, a hallmark of the new visual identity then being crafted at Rajput courts.

Why does this new canon of architectural decoration suddenly appear in this period in Rajput history? Two reasons come to mind. The first is that Rajput kingdoms already had exposure to Mughal courtly culture for a number of decades. As such, they had the time to adapt, to a greater or lesser degree and depending on that court's orientation, certain conventions into their own artistic expression that constituted the beginnings of a pan-Hindustani aristocratic style. The second reason is that there was a flurry of Rajput palatine construction commenced within a few decades before and after the turn of the 17th century. Older royal centres such as Chittor and Gwalior had ceased being centres of Rajput power, as Akbar conquered Gwalior in 1558 and Chittor in 1568. Newly enriched Rajput rulers, whose wealth had flourished through their association with the Mughal imperium and whose courts had expanded as their own power base grew, had a need for larger and more impressive administrative and residential centres. For these newer dynasties, the passage from being local rulers to being elite players in the cosmopolitan Mughal court fostered a more expansive sense of their own fort-palaces as centres for courtly ritual and the desire to project more powerful symbols of rule. The decoration of these new structures simultaneously broadcast rootedness in Rajput visual traditions as well as a new fluency with imperial Mughal culture for the elite Rajput patrons and noble audiences that inhabited their palaces.

Architectural decoration under Raja Man Singh of Amber, the patron of the Bairat and Amber palaces, exhibits the first examples of this new canon of Rajput architectural decoration appearing, as it were, fully formed. References to ragamala murals in Man

6.12 Rasamandala ceiling mural in the Badal Mahal, Palace of Rao Bhoj, Bundi Fort, early 17th century. Photograph: Edward Leland Rothfarb.

Singh's buildings come from two contemporary literary panegyrics to that ruler, both entitled *Man Charitra*. The first was composed by Amrita Rai in 1585 while the second, authored by Narottam Kavi, was completed shortly before the end of Man Singh's reign in 1614.[8] Kavi's text describes the types of subjects illustrated in Raja Man Singh's Amber palaces, which hew to a more Rajput orientation, including ragamala themes as well as scenes from Krishna's life, the romantic/erotic medieval Sanskrit poem *Amaru Sataka* and scenes of flora and fauna. Unfortunately few of these murals survive at the Amber palace, although extant—but seriously abraded—murals in other structures built by Raja Man Singh testify to an even greater repertoire of images decorating his buildings. This repertoire is consistent and includes Vaishnava scenes from both the *Bhagavata Purana* and *Ramayana*, mythic Indic beasts such as the gaja-simha, scenes from *Layla and Majnun*, Jahangiri motifs, Rajput martial, hunting and musical/poetic subjects, and aristocratic figures in Mughal court dress. Such murals can be seen in Raja Man Singh's domed funerary chhatri in Amber (c. 1620) as well as at the Bairat palace. They exhibit a similar blend of iconography on display at Raja Bir Singh Dev's palaces at Orchha and Datia and at Rao Ratan Singh's Badal Mahal in Bundi.

Conclusion

The decades surrounding the turn of the 17th century witnessed a surge of palace building at Orchha, Amber and Bundi, Rajput courts that had forged alliances with the Mughal imperium in the latter portion of the previous century. These alliances brought greater power and wealth to these kingdoms. They allowed them to consolidate and aggrandize their local kingship and to participate in the imperial system, with its growing military and administrative involvement in the subcontinent. All of these factors allowed these Rajput kingdoms to commence new royal residential and administrative courtly centres that conveyed an enhanced architectural message of power. The decoration of these palaces exhibits increasing exposure to Mughal courtly and visual culture through the adaptation of Mughal styles and/or Mughal imperial iconography drawn largely, but not exclusively, from the reign of Jahangir. At the same time, the murals and reliefs we have examined show the heightened development of local styles based in Rajput artistic traditions that had been developing since the latter part of the 15th century. Each of these courts negotiated its own architectural and decorative style according to its artistic and financial resources, the messages it wished to communicate and its ambitions for that particular palatine site. The result, by the early 17th century, is an intriguing and vibrant array of artistic sources and design choices in the Rajput milieu.

NOTES

1 Bharmal (r. 1548 –74), head of the Kachhwaha dynasty and ruler of the kingdom of Amber, entered into an alliance with the Mughal ruler Akbar in 1562 and married his daughter to the emperor. The Kachhwaha dynasty would rise to special prominence at the Mughal court, with Raja Man Singh, Bharmal's grandson, assuming high positions under Akbar. Rao Surjan (r. 1554–85) of the Hada dynasty of Bundi entered into a treaty with Akbar in 1569 after the fortress of Ranthambhore that was under his protection was besieged by Mughal forces. The Hadas would become loyal warriors and administrators for the Mughal dynasty and Surjan was given the governorship of the region of

Benares (Varanasi), including Chunar, which became his seat. The Bundela ruler Madhukar Shah (r. 1554–92) entered into a treaty with Akbar in 1578 after his kingdom had been invaded by the Mughal ruler. The alliance was not a strong one, however, and Akbar's son Murad would invade the Orchha kingdom once again by the latter part of Madhukar Shah's reign. Although Madhukar Shah's successor, Ram Shah, was loyal to the Mughals, it was only with the ascent of Bir Singh Dev, who usurped the Orchha throne with the help of Jahangir, that Orchha entered into a period of tremendous loyalty to the empire and favour from it. That would all collapse in the reign of Bir Singh Dev's successor, Jujhar Singh, whose rebellion against Shah Jahan would result in the Orchha ruler's death and the reduction of the kingdom by imperial decree.

2 For the most recent information on the dispersed *Bhagavata Purana* manuscript see Daniel Ehnbom, "The Masters of the Dispersed *Bhagavata Purana*", in Beach, Fischer and Goswamy, eds. 2011, pp. 77–88. For further information on the *Chaurapanchasika* group see: Pramod Chandra, *The Tuti-Nama of the Cleveland Museum of Art*, Graz: Akademisches Druck u. Verlaganstalt, 1976, pp. 37–42; Moti Chandra and Karl Khandalavala, *New Documents of Indian Painting: A Reappraisal*, Bombay: Prince of Wales Museum of Western India, 1969; Daniel Ehnbom, "An Analysis and Reconstruction of the Dispersed *Bhagavata Purana* from the *Caurapancasika* Group", PhD dissertation, University of Chicago, 1984; Darielle Mason, *Intimate Worlds: Indian Paintings from the Alvin O. Bellak Collection*, Philadelphia: Philadelphia Museum of Art, 2001, pp. 44–49; Andrew Topsfield, *Court Painting at Udaipur*, Zurich: Artibus Asiae, 2001, pp. 27–44.

3 See Beach 2011.

4 For information on the Orchha palatine style and the Govind Mahal see: Tillotson 1987, pp. 71–87; and, Edward Leland Rothfarb, *Orchha and Beyond: Design at the Court of Raja Bir Singh Dev Bundela*, Mumbai: Marg, 2012, pp. 92–147.

5 For documentation on the murals at Bairat, as well as at other sites in the early Amber kingdom, see Rosa Maria Cimino, *Wall Paintings of Rajasthan: Amber and Jaipur*, New Delhi: Aryan Books International, 2001, pp. 1–36.

6 For Raja Man Singh's architectural patronage see Catherine B. Asher, "The Architecture of Man Singh", in Barbara Stoler Miller, ed., *The Powers of Art: Patronage in Indian Culture*, Delhi: Oxford University Press, 1992.

7 For angelic imagery in Jahangiri painting see Ebba Koch, "Jahangir and the Angels: Recently Discovered Wall Paintings under European Influence in the Fort of Lahore", in Koch 2001, pp. 12–37.

8 G.N. Bahura, *Literary Heritage of the Rulers of Amber and Jaipur*, Jaipur: Maharaja Sawai Man Singh II Museum, 1976, pp. 33–34; idem., "*Amer Sthita Man Singh Mahal ke Bhittichitra*", *The Researcher (A Bulletin of Rajasthan's Archaeology and Museums)*, XII–XIII, 1972–73, pp. 63–70.

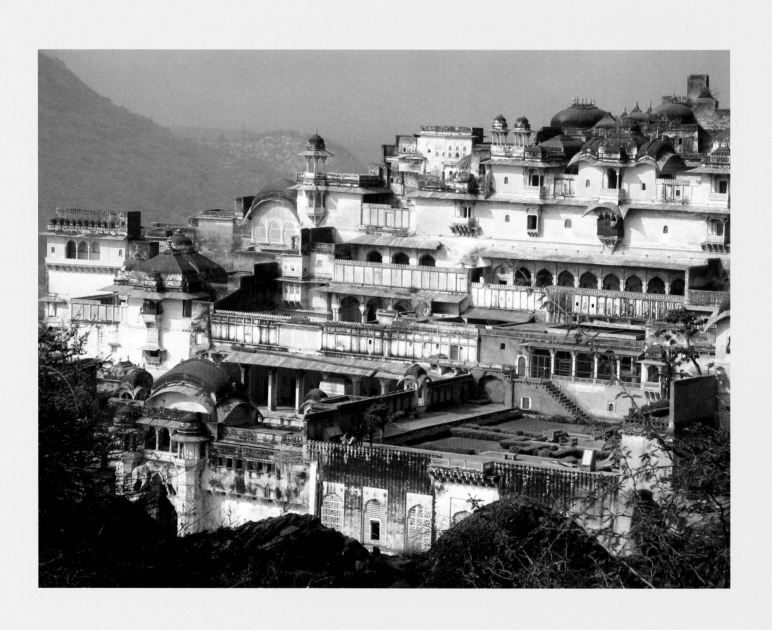

THE RANG VILAS GARDEN:
AN UNUSUAL RAJPUT
CHAHARBAGH AT BUNDI

D. FAIRCHILD RUGGLES

The Bundi Fort clings dramatically to the steep slope of a hill in the Aravalli range east of Mewar, its courtyards and halls—built by different patrons at different times—cut in terraces that afford views through framed balconies and windows onto the city of Bundi below. The palace complex is known principally for its remarkably well preserved and extensive programme of wall-paintings, but it also deserves recognition for its unusual garden. This is a classic chaharbagh, or four-part garden, an Islamic formal type that can be found across the Muslim world and especially in Mughal settings (figure 7.1). This begs the question: what is the purpose and significance of a traditional chaharbagh here in this Rajput setting?

The garden, placed in an open courtyard that measures about 30 x 33 metres, stands in front of the Rang Vilas (also called the Chitrashala), a hall set within the late 17th-century Aniruddha Mahal (figure 7.2). Bundi Garh (Fort) is not a single unified building but a tiered complex that was built in six stages, according to a recent study led by Attilio Petruccioli (see figure 2.3). On the basis of close archaeological observation, his group dated the Rang Vilas, its courtyard garden, and the Aniruddha Mahal to 1679 and later, this ensemble together forming the last major phase of palace construction within the garh walls.[1]

Although Bundi was the seat of the Hara Chauhan Rajput clan, it has never attracted the kind of admiration from outside visitors that was bestowed on other Rajput palaces, such as the Amber Fort or Mehrangarh in Jodhpur, and consequently there are few documentary descriptions or images of its interior. Although the architectural historian James Fergusson (1808–86) went to Bundi in the third quarter of the 19th century, he does not seem to have gained entrance to the interior of the fort, and so the palaces are scarcely mentioned in his *History of Indian and Eastern Architecture*.[2] One visitor who did gain access was Rudyard Kipling who in 1887 walked freely about, accompanied by a guide with the keys to unlock doors. They climbed from one hall to the next until eventually reaching "a heavily timbered garden with a tank for goldfish in the midst".[3] Impressed, Kipling inquired who had built it, to which his guide responded: "Who knows? It was made long ago." Kipling noted that the garden had a foot-high parapet along one side, beyond which there was a straight drop

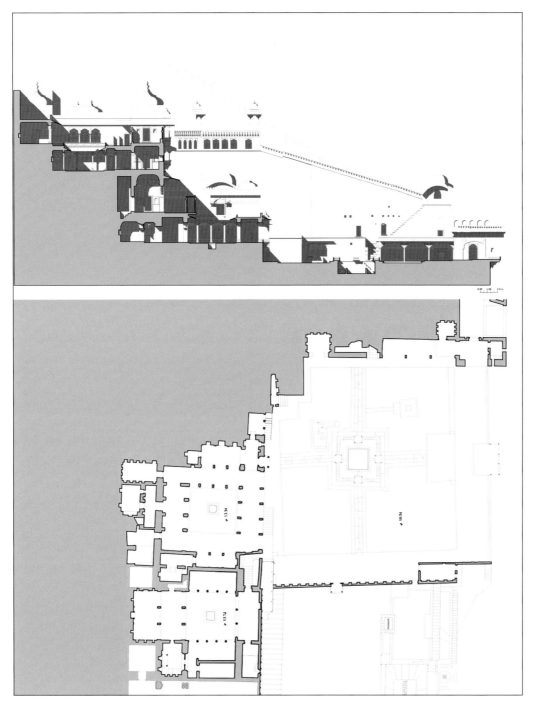

7.2 Axonometric view (and plan) of the Rang Vilas and Aniruddha palaces, Bundi Fort, c. 1679. Drawn by a research team of the Politecnico di Bari in the academic year 2005–06 led by Attilio Petruccioli, with Paul Perfido and tutors: Domenico Catania, Luigi Guastamacchia, Claudio Rubini; students: Vittoria Di Bari, Rossella Liso, Leonardo Maddalena, Domenica Marrone, Luca Spaccavento, Antonella Stallo.

of "scores" of feet to the stones below. He described the garden as "fair" and "full of the noise of birds and the talking of the wind in the branches", perhaps augmented in some way by echoes or special effects, since he referred to it as a "delusion".

By "heavy timbered" he surely meant that there were lots of trees growing there, which is how the garden appears in 19th-century photographs (figure 7.3). This may have been a sign of neglected overgrowth more than 200 years after the garden's construction, or it may have been a state of the garden that was closer in character to its original appearance than the trim lawn that fills the space today (figure 7.4). The garden has surely changed over the centuries. Although it does not seem to have been documented by early print views

7.4 The garden courtyard in front of the Rang Vilas, Bundi Fort, c. 1679. Photograph: D. Fairchild Ruggles.

7.3 Street view in Bundi with the fort and palaces. Photograph by E.C. Impey, 1860s. Private collection.
The garden and its then thick vegetation are visible above the walls at the top centre.

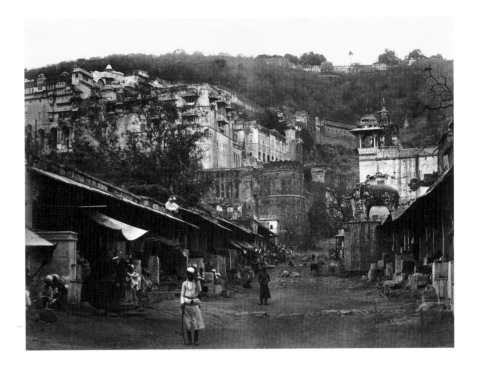

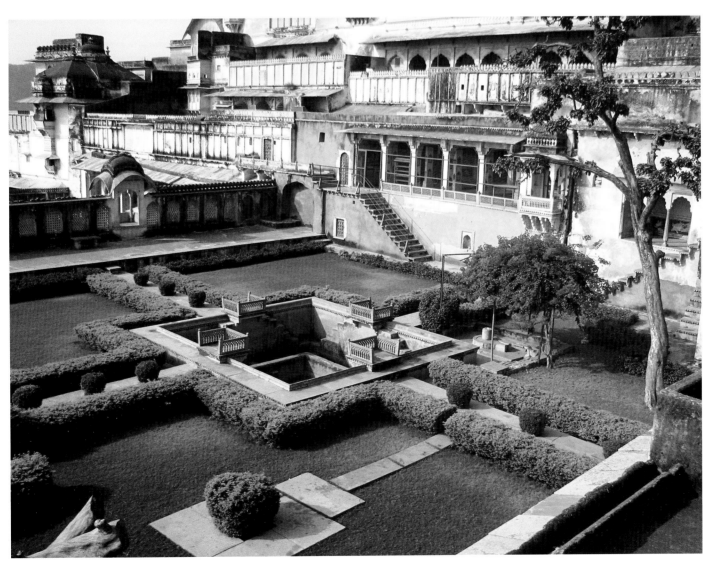

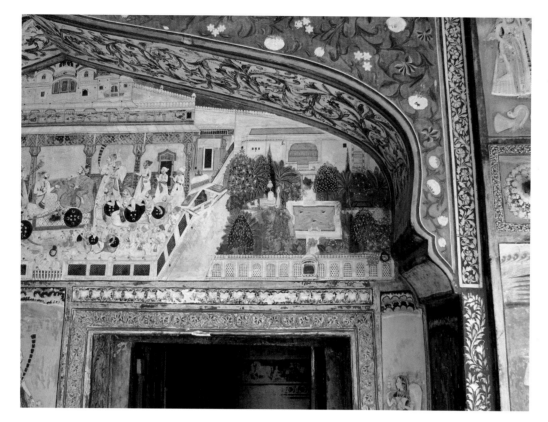

7.5 Rao Raja Umaid Singh in Darbar outside the Aniruddha Mahal, mural in the Rang Vilas, Bundi Fort, late 18th century with later recolouring. Photograph: D. Fairchild Ruggles.

and photographs, wall-paintings throughout the palace give a vivid sense of what some of Bundi's gardens may have looked like. The murals show princes, gods, courtly life, hunting, palace gardens and graceful pavilions set amidst thickly forested semi-natural landscapes; they reveal that the Bundi palace was connected to a larger landscape of pleasure gardens, and that these gardens that were enclosed within architectural contexts, like the Rang Vilas garden, adhered to tight geometrical organization.

One painting seems to show the Rang Vilas garden itself. The painting, above the doorway that leads into the bed-chamber in the Rang Vilas, has been identified by Milo Beach as representing Rao Raja Umaid Singh in darbar outside the Aniruddha Mahal and next to the Rang Vilas's garden (figure 7.5). He dates the mural to circa 1760—about 80 years later than the garden itself—with repainting of circa 1885.[4]

The right-hand portion of the scene shows a garden with a central, water-filled tank with three swimming ducks (figure 7.6). The tank is rimmed with stone from which chabutras (raised platforms with balustrades) project from the centre of each side. From these four projecting balconies, broad walkways lead to the edges of the garden, dividing it neatly into equal quadrants. The slightly sunken beds of the chaharbagh thus formed are filled with broad-leaved palms, slender tapering cypress, flowering trees, a grape vine trained on a wooden trellis with hanging clusters of fruit, and a rich variety of smaller flowering plants. Two of the walkways are punctured by a small sunken basin containing a broad-bladed plant. Some areas of plain green turf are barely visible under the plants and trees, but the overall effect is of an abundance of plants that fill the space.

However, the garden that one sees in Bundi today is planted very differently from the mural's depiction. When I visited the palace in 2012, the garden was under the stewardship

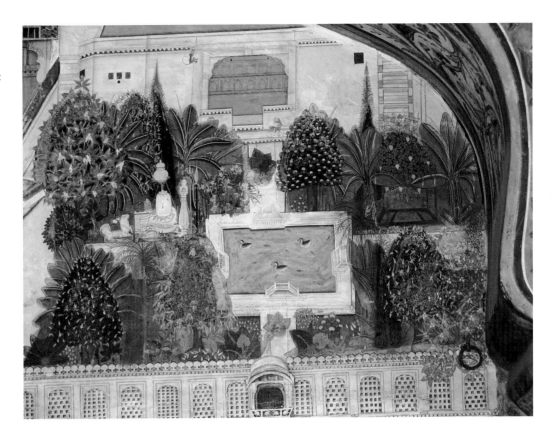

7.6 Detail of figure 7.5: the garden in front of the Rang Vilas, Bundi Fort. Photograph: D. Fairchild Ruggles.

of the Archaeological Survey of India. It was well tended and consisted mostly of turf with a few trees—the kind of serviceable but uninspired effect seen at many ASI sites. The garden fills a rectangular courtyard with a low parapet along the eastern edge that offers magnificent views to the distance, beyond the palace (figures 7.7 and 7.8). In his 1987 publication, Giles Tillotson identified this as a hanging garden, but the fairly broad terrace bordering this side makes it unlikely that plantings could have literally overflowed the perimeter.[5] Moreover, such hanging plantings would have blocked the jali (perforated screen) windows of the apartments below (visible in figure 7.3 right) and possibly impeded traffic on the ramp leading to the palace's grand entrance. A much higher, stone, screened barrier encloses the southern edge, though it offers a view through a distinctively curved bangla-roofed (so-called for its Bengali origins) aedicule to the Hathipol, the entrance courtyard 10 metres below. The Rang Vilas occupies the western edge, and along the north perimeter are service rooms with rooftop catchment that collects and directs rainwater into the garden. A hammam (bath house) occupies the northwest corner.

Four paved paths, running at a slightly sunken level, divide the garden into quadrants that today are planted with plain turf bordered by pruned shrubs. The pavements are interrupted at regular intervals by concavities in which are set smaller shrubs. The species is Golden Duranta, but it belongs to the ASI's replanting and is unlikely to have any link to the original plants.[6] A brilliant crimson bougainvillea grows on an iron trellis in the northeastern corner. In the centre is the goldfish tank that Kipling noted (figure 7.9). A balcony with a stone screen projects from each of the four sides, from which narrow flights of steps lead down into the deep tank, which has another, slightly shallower tank set in its floor. The stonework throughout is the characteristic pink sandstone of Bundi (quarried

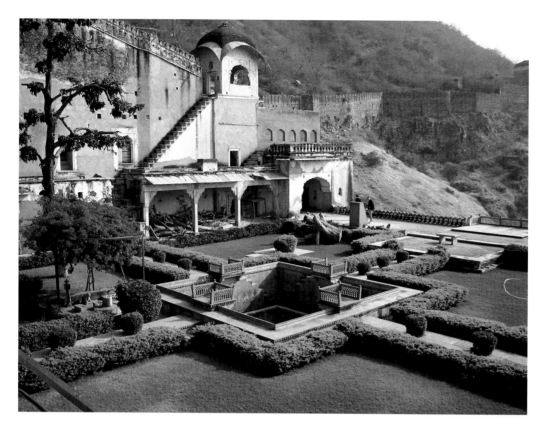

7.7 The garden courtyard in front of the Rang Vilas, looking toward the eastern perimeter, Bundi Fort, c. 1679. Photograph: D. Fairchild Ruggles.

7.8 Garden in front of the Rang Vilas, looking across the central tank, Bundi Fort, c. 1679. Photograph: D. Fairchild Ruggles.

7.9 Tank in the centre of the garden in front of the Rang Vilas, Bundi Fort, c. 1679. Photograph: D. Fairchild Ruggles.

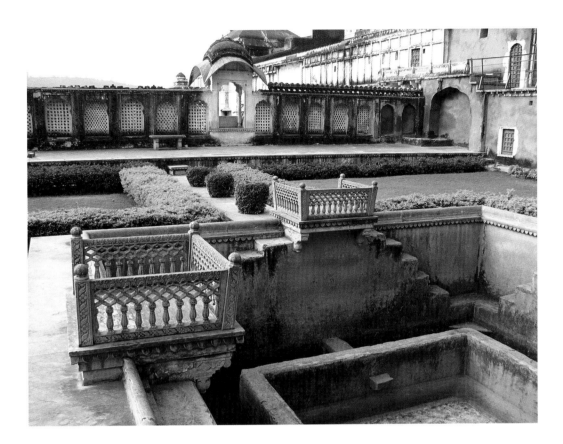

locally and throughout Rajasthan), with the edges ornamented by a modestly scalloped carved border. The symmetry of the quadrants is interrupted by a devotional shrine in the northwest corner (discussed below), and a platform that extends into the northeast corner. The stone paving of this platform has an aperture from which a shrub grows today. While the purpose of such a feature is unclear, it does echo the mural's picturing of a pavement with cavities containing broad-leaved plants.

How was the water obtained to sustain the garden? It was collected most immediately from the roofs and terraces of the surrounding buildings during the rainy season, which produced 615 mm of rain annually, and was stored in the central tank that had a depth of approximately 3–4 metres. (A small portion of one of these rooftop channels is visible in the lower right corner of figure 7.4.) This method of using the architecture itself to obtain water is a simple, and nearly invisible, catchment technique found throughout South Asia.[7] However, because that system had limited capacity (and only served the courtyard to which the runoff was directed), much greater quantities of water were collected in tanks in the Taragarh complex on the hill above. Placed there as a defensive post, with views to the valleys on both sides of the hill, the hilltop fort of Taragarh also had several large deep tanks for the collection and storage of water. The Rang Vilas is at the upper level of the Bundi Fort complex, conveniently located just below Taragarh and its stored water. The proximity of the two afforded the Rang Vilas with access to large amounts of water and explains the position of the bath house in the garden courtyard's northwest corner. But the palace needed water for more than ornamental usage and, like other Rajasthani palaces, it required multiple and overlapping systems to ensure uninterrupted hydraulic supply. Therefore, it had an additional system to raise water from the storage tanks at its foot that

collected the water that ran down from the slopes of the hill (see chapter 2 by Catania, Petruccioli and Rubini).

Bundi's chaharbagh follows a well-known plan that was introduced to Hindustan from Iran and Central Asia with the arrival of the Mughals in the 16th century. The Mughals embraced it in their dynastic tombs, beginning with the majestic tomb of Humayun (begun 1565 or 1569, Delhi) that stands in an enormous chaharbagh that was subdivided into 36 units, with the tomb occupying four of them (figures 7.10 and 7.11), and subsequent imperial and subimperial tombs: of Akbar (1612–14, Sikandra), of Itimad-ud-daula (1622–28, Agra), of Jahangir (1627–37, Lahore), the Taj Mahal (1632–43, Agra), of Asaf Khan (c. 1641, Lahore), of Nur Jahan (c.1645, Lahore) and others. They used it with equal enthusiasm in their palace gardens such as the Bagh-i Nur Afshan (known today as the Ram Bagh, built just before 1621, Agra), Jahangiri Quadrangle in the Lahore Fort (second quarter of the 17th century) (figure 7.12), Anguri Bagh in the Agra Fort (1628–37), Shalimar Bagh (1640s, Lahore) and various gardens in the mountains of Kashmir where the chaharbagh form was often multiplied sequentially, one quadripartite module following another in a series of stepped terraces.

There is no evidence that the quadripartite garden plan was used prior to the arrival of the Mughals or has any precedents in Hindu temples or palaces. However, it comes as no surprise that a form with Islamic origins should have been adopted by Hindu patrons. There were a great many formal and cultural exchanges between Muslim and Hindu patrons, from the bangla roof and chhatri (a small dome on columns) that found their way from Indic sources into Mughal architecture, to the proliferation of commemorative monuments and the adoption of the chaharbagh among Hindu patrons.

7.10 Humayun's Tomb, Delhi, begun 1565 or 1569. Photograph courtesy of Aga Khan Trust for Culture.

7.11 Plan of Humayun's Tomb. Drawn by Lobsan Chodon and D. Fairchild Ruggles, after ASI.

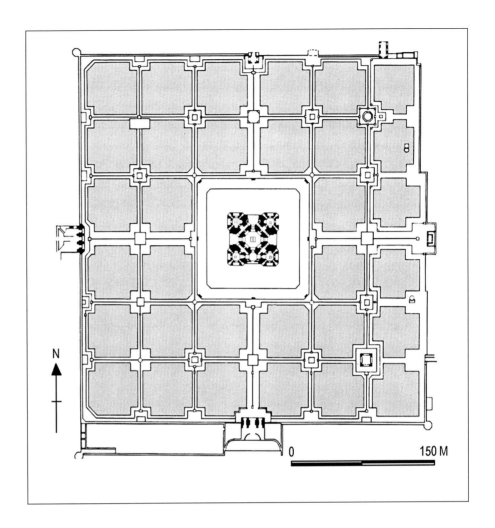

7.12 Jahangiri Quadrangle, Lahore Fort, second quarter of the 17th century. Photograph courtesy of James L. Wescoat, Jr.

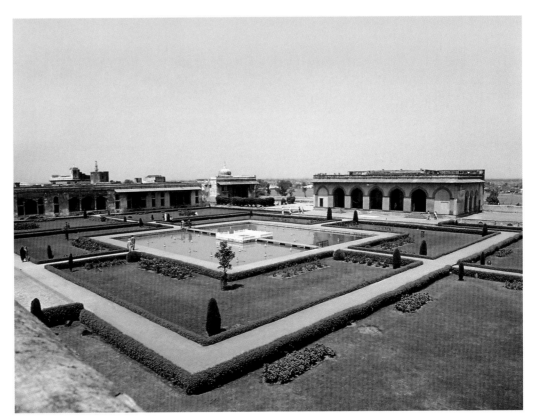

A chaharbagh appears in the Rajput palaces of the Amber Fort (the garden built 1623–67/8), Orchha's Phul Bagh (first half of the 17th century) and Ahhichatragarh at Nagaur (mid-17th century), and in the Jat Palace at Dig (1722–68). At Amber, in the courtyard enclosed by the Sukh Nivas and Jai Mandir pavilions, the simple four-part scheme of a sunken garden with raised walkways is elaborated into an intricate geometrical figure that emanates from an eight-pointed star in the form of the central pool (figure 7.13). Orchha's Phul Bagh sublimates the garden style of the earlier Anand Mahal garden (built either in 1672–75 or 1605–27)—organized as a grid of relatively small, sunken octagonal cavities—within a larger chaharbagh plan. The Nagaur Fort has an array of gardens, some adhering to the traditional quadripartite plan, and others where the four-part plan contains a grid of sunken planting cavities, as seen at Orchha.[8] The Dig Palace adheres most closely to the classic chaharbagh, with multiple gardens divided into quarters by water channels lined with water jets, evoking the Mughal gardens of Kashmir.

Architectural and garden forms were highly visible and migrated relatively easily in the fluid stream of visual culture because there were trained artisans available to make them for any paying patron. Just as the Rajputs were assimilated into Indic culture when they

7.13 Courtyard garden, Amber Fort, 1623–67/8. Photograph: D. Fairchild Ruggles.

arrived from Central Asia in the late 5th century,[9] they also acquired cultural ideas and practices from the Mughals whom they variously served and fought. Aniruddha, the most likely patron for the garden courtyard in Bundi, would have been fully steeped in Mughal artistic style through his service in the Mughal court, defending its territorial interests in the Deccan and the northwest.[10]

But what about the meanings of the architectural forms that they adopted? Islamic gardens have a well-recognized set of meanings that have evolved historically, changing gradually along with the social practices of the patrons who employ them. The link between the form and meaning seems evident when both emerge from the same cultural and religious context, as occurred with the chaharbagh. But it is more complicated when a form is transferred from one context to another one because the new audience does not regard it through the same cultural or religious lens. To give an example: whereas in India and much of Asia, the lotus gained special spiritual meaning through its association with the Buddha, in pharaonic Egypt the flower was associated with the cult of Osiris and symbolized Upper Egypt. Meaning occurs when symbolic associations are read into the form by human beings; an object itself does not *make* meaning and can only *contain* meaning insofar as it is asked to do so by its human viewer.[11]

The cross-axial garden was a type that may have existed prior to Islam (although I have argued elsewhere that it did not formalize into a distinct type until it was adopted by Muslim gardeners).[12] It was widely used and recognized during the Mughal period in South Asia and because of its ubiquity, was available for adoption into other contexts where the form was employed but relieved of its specifically Muslim meanings.

When Rajput patrons adopted the chaharbagh for use in a Hindu cultural context, what meaning did they read into it, and what—if any—connection did their new inflection have with the Muslim understanding of the chaharbagh?

In the Mughal tombs cited above, the paradisial theme of the chaharbagh resonated clearly. Paradise, as the Quran describes it, is a place of green, shady, fruitful gardens with four running streams of water, milk, wine and honey. This vision of paradise as a garden—so attractive in climates with extreme heat and seasonal aridity—was projected onto earthly gardens, so that eventually the four-part plan divided by four running channels was understood to be an anticipation of paradise. The metaphor suggests that as the soul of the deceased enjoyed eternal rest in heaven, so too the body reposed in an earthly garden that mirrored its heavenly model.

However, as I have explained elsewhere, the earliest quadripartite Islamic gardens appeared at palaces like Rusafa in Syria and Madinat al-Zahra in Spain and were divided by walkways rather than water channels. Their context was decidedly one that emphasized sensuous pleasure and political centrality rather than piety.[13] I have pointed out that there is no evidence that the very early cross-axial, four-part gardens were built with the specific intention of evoking the paradise of the Quran, and instead have proposed that the Islamic garden began as an expression of a domesticated and irrigated landscape of farmed plots. In this sense, the garden was as much about humankind's existence on earth as its hopes for the afterlife, and it retained this richly nuanced double sense even during the Mughal period, by which time the paradise motif infused not only garden-making, but also art and poetry. The key consideration here is that the Islamic garden

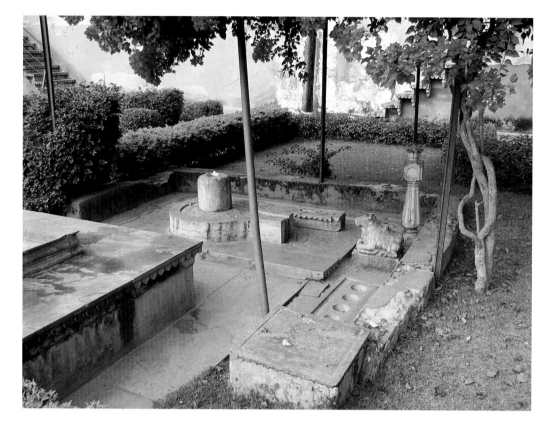

7.14 View of the shrine in the garden in front of the Rang Vilas, Bundi Fort. Photograph: D. Fairchild Ruggles.

was not limited to a single meaning, an important point when we consider its use in non-Muslim contexts.

Just as artistic and architectural techniques and motifs were exchanged between Hindus and Muslims during their centuries of close association in South Asia, so too were garden forms embraced and repurposed. In both cases, symbolic meaning was not necessarily adopted along with the form that gave rise to that symbolism.

Bundi was such a case, for the Chitrashala garden was quite clearly not a symbolic reference to the Quran's four rivers, and its owner did not yearn for an afterlife in paradise. Instead, the Rajput identity of the patron who built the palace was displayed by the platform in the garden's northwest quadrant where a stone linga is attended by a stone sculpture of a bull (figure 7.14). The figure is Nandi, the sacred white bull who is the mount and the protector of Shiva, god of creation and destruction, represented symbolically by the linga. The mural painting in the Rang Vilas that represents the garden clearly shows this sculptural ensemble, further pinning the image to its architectural setting (figure 7.6). The purpose of the ensemble is for worship and to suggest the devotion of the patron, for Nandi is also identified as Shiva's principal disciple. Additionally, the specific presence of Nandi, whose name means "bringer of joy", may have been an allusion to the garden as a place of pleasure.

At Bundi, the chaharbagh was employed as a garden form that had become familiar and popular among both Muslim and Hindu patrons in the Mughal empire. Instead of alluding to paradise, it evoked its own set of symbolic meanings, one of which was as a place of beauty, ease and pleasure that celebrated nature in a form that was subordinated and domesticated—like the monsoon rainfall at Taragarh that was captured and put to

productive use in the palace and city below. If water was meaningful, so too was land, the agriculture producing rents that were the Hara Chauhans' primary source of income. However, even among Rajput palaces, many of which, as we have seen, embraced some form of quadripartite garden plan, the Bundi garden is unusual because it did not strip the chaharbagh of religious meaning, but rather imbued it with a specifically Hindu meaning through the inclusion of the shrine.

NOTES

1 Attilio Petruccioli with V. Di Bari, R. Liso, L. Maddalena, D. Marrone, L. Spaccavento, and A. Stallo in Rubini 2006. This narrows the dates given in Beach 2008, pp.101–43**.**

2 Fergusson 1876, p. 476.

3 Kipling 1919, I, pp. 171–72.

4 Beach 2008, p. 114, figure 6.

5 Tillotson 1987.

6 My thanks to Amita Sinha and Priyaleen Singh for identifying the species.

7 Ruggles 2013, p. 7.

8 These gardens and Rajput garden style more generally are discussed at greater length in Ruggles 2013, pp. 95–118. See also Joffee and Ruggles 2007.
 For Orchha's architectural history, the best source is Edward Leland Rothfarb, *Orchha and Beyond: Design at the Court of Raja Bir Singh Dev Bundela*, Mumbai: Marg, 2012. For Nagaur, see Minakshi Jain, *Architecture of a Royal Camp*, Ahmedabad: AADI Centre, 2009.

9 Hooja 2006, pp. 177–81.

10 Ibid., p. 635.

11 On this separation of form and meaning, see the closing argument in D. Fairchild Ruggles. "Mothers of a Hybrid Dynasty: Race, Genealogy, and Acculturation in al-Andalus," *The Journal of Medieval and Early Modern Studies* 34 (2004), pp. 65–94.

12 D. Fairchild Ruggles, *Islamic Gardens and Landscapes*, Philadelphia: University of Pennsylvania Press, 2008, pp. 40–49.

13 D. Fairchild Ruggles, *Gardens, Landscape and Vision in the Palaces of Islamic Spain*, University Park: Penn State University Press, 2000, pp. 215–20.

Bibliography

ART-HISTORICAL (including specific studies of Bundi painting)

Agrawala, R.A. 1996. *Bundi: City of Painted Walls*. Delhi: Agam Kala Prakashan.

Andhare, S.K. 1984. *Bundi Painting*. New Delhi: Lalit Kala Akademi.

Archer, W.G. 1959. *Indian Painting in Bundi and Kota*. London: HMSO.

Bautze, Joachim. 1985. "Portraits of Bhao Singh Hara", *Berliner Indologische Studien* 1, pp. 107–22.

——. 1986. "Portraits of Rao Ratan and Madho Singh Hara", *Berliner Indologische Studien* 2, pp. 87–106.

——. 1987a. *Drei "Bundi"-Ragamalas: Ein Beitrag zur Geschichte der rajputischen Wandmalerei*. Stuttgart: Franz Steiner Verlag.

——. 1987b. "Mughal and Deccani Influence on Early 17th Century Murals of Bundi", in Robert Skelton, Andrew Topsfield, Susan Stronge and Rosemary Crill, eds., *Facets of Indian Art*, New Delhi: Heritage Publishers, pp. 168–75.

——. 2000. "Early Painting at Bundi", in Topsfield, ed., pp. 12–25.

——. 2009. "On Some Elephants in the Badal Mahal, Bundi", in *Dazzling and Spirited: Indian Court Paintings 1400–1900*, catalogue of an exhibition and sale held at Asia House, London. London: Prahlad Bubbar Ltd., pp. 6–11.

Beach, Milo Cleveland. 1974. *Rajput Painting at Bundi and Kota*. Ascona: Artibus Asiae.

——. 1987. "The Study of Fatehpur Sikri", in Michael Brand and Glenn D. Lowry, eds., *Fatehpur Sikri*. Bombay: Marg, pp. 13–24.

——. 2008. "Wall-Paintings at Bundi: Comments and a New Discovery", *Artibus Asiae* LXVIII, pp. 101–43.

——. 2011. "The Masters of the Chunar Ragamala and the Hada Master", in Beach, Fischer and Goswamy, eds., vol. 1, pp. 291–304.

Beach, Milo Cleveland, Eberhard Fischer and B.N. Goswamy, eds. 2011. *Masters of Indian Painting 1100–1650*. Zurich: Artibus Asiae Publishers. Two volumes.

Beach, Milo Cleveland and Hilde Lauwaert. 2014. *The Bundi Wall-Paintings in Rajasthan*. Brussels: Mercator Fonds, and New Haven and London: Yale University Press.

Chandra, Pramod. 1959. *Bundi Painting*. New Delhi: Lalit Kala Akademi.

——. 1960. "Ustad Salivahana and the Development of Popular Mughal Art", *Lalit Kala* 8, pp. 25–46.

Desai, Vishakha. 1985. *Life at Court: Art for India's Rulers, 16th–19th Centuries*. Boston: Museum of Fine Arts.

Glynn, Catherine. 2011. "The 'Stipple Master'", in Beach, Fischer and Goswamy, eds., 2011, vol. 2, pp. 519–21.

Joffee, Jennifer and D. Fairchild Ruggles. 2007. "Rajput Gardens and Landscapes", in Michel Conan, ed. *Middle East Garden Traditions*, Cambridge, MA: Dumbarton Oaks and Harvard University Press, pp. 269–85.

Khandalavala, Karl J. 1952–53. "A Group of Bundi Miniatures in the Prince of Wales Museum", *Bulletin of the Prince of Wales Museum of Western India* 3, pp. 25–35.

——. 1955–57. "Five Bundi Paintings of the Late 17th Century", *Bulletin of the Prince of Wales Museum of Western India* 5, pp. 50–56.

Koch, Ebba. 2001. *Mughal Art and Imperial Ideology: Collected Essays*. Oxford: Oxford University Press.

Krishna, Anand, ed. 1981. *Chhavi II: Rai Krishnadasa Felicitation Volume*. Varanasi: Bharat Kala Bhavan.

Losty, Jeremiah P. 2013. *A Prince's Eye: Imperial Paintings from a Princely Collection, Art from Indian Courts*. London: Francesca Galloway.

Losty, Jeremiah and Malini Roy. 2012. *Mughal India: Art, Culture and Empire*. London: British Library.

Pal, Pratapaditya. 1993. *Indian Painting: A Catalogue of the Los Angeles County Museum of Art Collection*. Los Angeles: Los Angeles County Museum of Art.

Randhawa, M.S. n.d. "Painting in Bundi", *Roopa-Lekha* XXXV(1&2), pp. 6–14.

Rubini, Claudio, ed. 2006. *Bundi/India. Il Palazzo e gli Haveli. XVI–XIX secolo*. Bari: Politecnico di Bari.

Ruggles, D. Fairchild. 2013. "At the Margins of Architectural and Landscape History: The Rajputs of South Asia", *Muqarnas* 30, pp. 95–118.

Sen, Geeti. 1984. *Paintings from the Akbar Nama: A Visual Chronicle of Mughal India*. Varanasi: Lustre Press.

Seth, Mira. 2003. *Wall-Paintings of Rajasthan*. New Delhi: National Museum of Art.

Skelton, Robert. 1981. "Shaykh Phul and the Origins of Bundi Painting", in Krishna, ed., pp. 123–29.

Sodhi, Jiwan. 1999. *Bundi Painting*. New Delhi: Abhinav Publications.

Tillotson, G.H.R. 1987. *The Rajput Palaces: The Development of an Architectural Style, 1450–1750*. New Haven and London: Yale University Press.

——. 2006. *Jaipur Nama*. Delhi: Penguin Books.

Topsfield, Andrew, ed. 2000. *Court Painting in Rajasthan*. Mumbai: Marg.

Vatsyayan, Kapila. 1981. *The Bundi Gita-Govinda*. Varanasi: Bharat Kala Bhavan.

Vyas, Lakshmi Dutt. 2002. "Dating the Bundi-style Chunar Ragamala: A New Approach", *Marg* 54(1), pp. 48–53.

——. 2004–05. "A Symbolic Representation in Kamoda Ragini of Chunar-Ragamala of Bundi Style", *Bharati: Bulletin of the Department of Ancient Indian History, Culture and Archaeology, Banaras Hindu University* 29, pp. 115–28.

Welch, Stuart Cary. 1963. "Review, *Bundi Painting*, by Pramod Chandra", *Ars Orientalis* V, pp. 290–95.

Wright, Elaine, Susan Stronge and Wheeler M. Thackston. 2008. *Muraqqa': Imperial Mughal Albums from the Chester Beatty Library*. Alexandria, VA: Art Services International.

HISTORICAL AND ANECDOTAL

Abu'l Fazl 'Allami, *A'in-i-Akbari*. 1965/1989. Trans. H. Blochmann. Reprinted Delhi: Aadiesh Book Depot in 1965/Low Price Publications in 1989.

——. *Akbarnama*. In press. Trans. Wheeler M. Thackston. Three volumes. (References are given to original manuscript notations.)

Binhairaso of Maheshdas. 1966. Ed. Saubhagyasingh Shekhavat. Jodhpur: Rajasthan Oriental Research Institute.

Busch, Allison. 2011. *Poetry of Kings: The Classical Hindi Literature of Mughal India*. New York: Oxford University Press.

della Valle, Pietro. 1989. *The Pilgrim: The Journeys of Pietro della Valle*. Trans. George Bull. London: The Folio Society.

Dhoundiyal, B.N. 1964. *Rajasthan District Gazetteers: Bundi*. Jaipur: Government Central Press.

Fergusson, James. 1876. *History of Indian and Eastern Architecture*. London: John Murray.

Foster, William. 1967. *The Embassy of Sir Thomas Roe to the Court of the Great Mogul, 1615–1619*. Nendeln/Liechtenstein: Kraus Reprint Limited (with permission of The Hakluyt Society).

Gahlot, Jagdish. 1960. *"Bundi Rajya"*, in *Rajputane ka Itihas*, vol. 2. Jodhpur: Hindi Sahitya Mandir, pp. 72–74.

Hooja, Rima. 2006. *A History of Rajasthan*. New Delhi: Rupa & Co.

The Jahangirnama: Memoirs of Jahangir, Emperor of India. 1999. Trans. Wheeler M. Thackston. Washington, DC: Freer Gallery of Art and Arthur M. Sackler Gallery, and New York and Oxford: Oxford University Press.

Khan, Nawwab Samsam-ud-daula Shah Nawaz and Abdul-Hayy. 1911–14. *The Maathir-ul-Umara*. Trans. H. Beveridge, and ed. Baini Prasad. Three volumes. Patna: Janaki Prakashan (reprint).

Kipling, Rudyard. 1919. *From Sea to Sea and Other Sketches*. London: Macmillan and Co.

Lalitlalam of Matiram Tripathi. 1983. Ed. Omprakash Sharma. Delhi: Sanmarg Prakashan.

Ma'athir-ul-umara of Shahnavaz Khan Awrangabadi, Vol. 2. 1952. Trans. H. Beveridge, revised by B. Prashad. Calcutta: Asiatic Society.

Mahakavi Vishvanatha. 1996. *Shatrushalya-charita-Mahakavya, Part 1*. Ed. Dr

Bholashankar Vyas. Jodhpur: Rajasthan Oriental Research Institute. (References are given to the original canto and verse numbers.)

Mathur, R.S. 1986. *Relations of Hadas with Mughal Emperors, 1568–1720 AD*, Delhi: Deputy Publications.

Mundy, Peter. 1914. *The Travels of Peter Mundy in Europe and Asia, 1608–1667, Volume 2: Travels in Asia 1628–34*. London: Hakluyt Society.

The Shah Jahan Nama of Inayat Khan. 1990. Trans. A.R. Fuller, ed. W.E. Begley and Z.A. Desai. Delhi: Oxford University Press.

Strachan, Michael. 1989. *Sir Thomas Roe 1581–1644: A Life*. Salisbury: Michael Russell.

Talbot, Cynthia. 2012. "Justifying Defeat: A Rajput Perspective on the Age of Akbar", *Journal of the Economic and Social History of the Orient* 45, 2–3, pp. 329–68.

Tod, James. 1957/1997 (1829). *Annals and Antiquities of Rajasthan*. Two volumes. Reprinted London: Routledge & Kegan Paul Ltd. in 1957/Calcutta: Rupa & Co. in 1997 (for Bundi, see vol. 2, pp. 355–408).

INDEX

CONTRIBUTORS

Milo Cleveland Beach held curatorial positions at the Museum of Fine Arts, Boston, and the Fogg Art Museum, Harvard University, before serving as Professor and Chairman of the Department of Art, Williams College, Williamstown, Massachusetts, and then as Director of the Freer Gallery of Art and the Arthur M. Sackler Gallery, Smithsonian Institution, Washington, DC. His recent books include *The Bundi Wall-Paintings in Rajasthan* (2014), with photographs by Hilde Lauwaert, and *Masters of Indian Painting* (2011), edited jointly with Eberhard Fischer and B.N. Goswamy.

Domenico Catania has a Masters in architecture from the Polytechnic University of Bari, Italy, and a PhD in comparative art, civilizations and cultures of Mediterranean countries from the University of Bari. He is a practising architect and carries out scientific research. Since 2003 he has spoken at international conferences on traditional architecture, typology, urban morphology and worked on research projects in Asian and Mediterranean countries.

Attilio Petruccioli is Professor of Architecture at the Department of Architecture and Urban Planning, Qatar University. He has provided professional advice in the field of heritage and development in Islamic countries. His books include *Ilgiardinoislamico: Architettura, Natura, Paesaggio* (1994); *Bukhara: The Eastern Dome of Islam* (2004) with Anette Gangler and Heinz Gaube; and *After Amnesia: Learning from the Islamic Mediterranean Urban Fabric* (2007).

Claudio Rubini has a PhD in landscape architecture and is a researcher on Islamic architecture, urban morphology and landscapes. He has spoken at international conferences on Middle East, North Africa, India and Central Asia Studies. After a ten-year scholarship at the Polytechnic University of Bari, Italy, tutoring MSc theses and teaching courses on the history of Islamic architecture and urban design, he is currently a freelance scholar and licensed architect.

Cynthia Talbot is Associate Professor of History at the University of Texas at Austin and focuses on late medieval and early modern India. She is the author of *Precolonial India in Practice: Society, Region and Identity in Medieval Andhra* (2001) and *The Last Hindu Emperor: Prithviraj Chauhan and the Indian Past, 1200–2000* (2016); co-author, with Catherine B. Asher, of *India before Europe* (2006); and editor of *Knowing India: Colonial and Modern Constructions of the Past* (2011).

Allison Busch is Associate Professor of Hindi Literature at the Department of Middle Eastern, South Asian, and African Studies at Columbia University, New York. Her expertise is in the courtly traditions of India, with a special interest in Mughal and Rajput literary cultures. Her current research includes several projects on Hindi historical poetry. She is also interested in the aesthetic intersections between painting and poetry.

Edward Leland Rothfarb is an independent scholar based in Los Angeles, working in the field of Indian art and architecture. His research has focused on the Orchha kingdom and the interaction of Rajput and Mughal styles at Rajput courts. His most recent book is *Beyond Orchha: Design at the Court of Raja Bir Singh Dev Bundela* (2012).

D. Fairchild Ruggles is Professor of Art, Architecture and Landscape History at the University of Illinois, Urbana-Champaign. Her books include the two award-winning *Gardens, Landscape, and Vision in the Palaces of Islamic Spain* (2000) and *Islamic Gardens and Landscapes* (2008), as well as eight authored, edited and co-edited volumes on Islamic art, cultural heritage, landscape history and theory, and the arts patronage of women.